EXPOSING
THE WILDERNESS

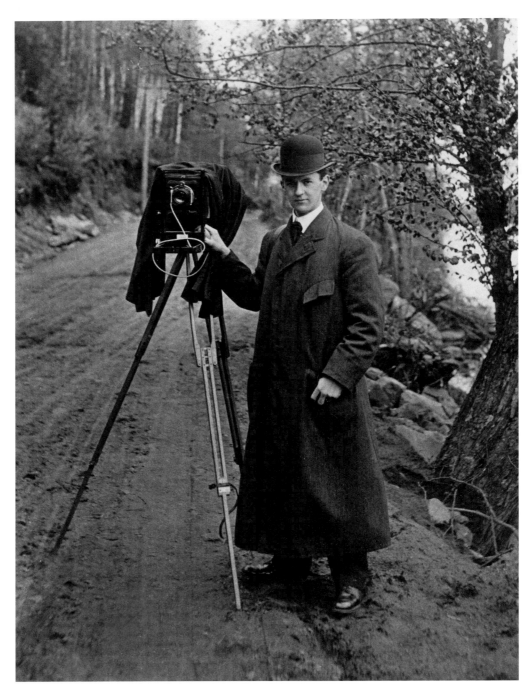

William Kollecker standing beside camera, c. 1906. Courtesy of the Saranac Lake Free Library.

EXPOSING THE WILDERNESS

Early-Twentieth-Century Adirondack Postcard Photographers

Robert Bogdan

Syracuse University Press

This book is published with the assistance of a grant from the John Ben Snow Foundation.

The paper used in this publication meets the minimum requirements of American
National Standard for Information Sciences—Permanence of Paper for Printed Library
Materials, ANSI Z39.48-1984. ∞™

Library of Congress Cataloging-in-Publication Data

Bogdan, Robert.
 Exposing the wilderness : early twentieth-century Adirondack
postcard photographers / Robert Bogdan — 1st ed.
 p. cm.
 Includes bibliographical references (p.) and index.
 ISBN 0-8156-0608-7 (alk. paper)
 1. Adirondack Mountains (N.Y.) — History — 20th century Pictorial works.
2. Postcards — New York (State) — Adirondack Mountains — History — 20th century.
3. Photographers — New York (State) — Adirondack Mountains Biography. 4. Adirondack
Mountains (N.Y.) Biography. I. Title.
F127.A2B64 1999
974.7'5 — dc21 99-35857

Manufactured in the United States of America

Remembering

camping at

Brown Tract Pond

Dedicated to Janet

Robert Bogdan is professor of sociology and cultural foundations of education at Syracuse University. He serves as director of the interdisciplinary Social Science Doctoral Program at the Maxwell School. He was awarded the Syracuse University Chancellor's Citation for Distinguished Academic Achievement in 1990. In 1996, he was a Visiting Fulbright Scholar at the University of Stockholm. He is the author of *Freak Show: Presenting Human Oddities for Amusement and Profit* (1988) and coauthor of *Qualitative Research for Education* (1998), *Introduction to Qualitative Research* (1998), and *The Social Meaning of Mental Retardation* (1994). He has also written more than ninety articles.

Contents

Illustrations

Preface
In Search of the Photographers

RESEARCHING THIS BOOK about early-twentieth-century Adirondack photographers was exhilarating. When I began, my subjects were just names printed on the backs of photo postcards I admired. Whether writing letters or talking on the phone to strangers, knocking on doors in places where I had never been, or trekking through graveyards seeking clues, I felt like a detective hunting for missing persons. In addition to fieldwork, I visited archives around New York State, but surprisingly they yielded only a few bits of biographical information. In public and private postcard collections I was more successful in my quest for a visual record of the photographers' works. Gradually, the photographers came to life. I hope they will take a place in the written history of the Adirondacks and that they will come alive for you.

In pursuing this topic I made new friends and built a network of acquaintances from many walks of life. Because there were so few secondary sources, I had to rely heavily on the generosity and labor of many more people than are normally required in a project of this type. Although some people hoard information and artifacts for themselves, others collect to share. The latter made this project possible. I am deeply grateful to them, and I thoroughly enjoyed my time in their company.

George Davis, a senior amateur historian of Lowville, was a steadfast guide who led me with good humor and enthusiasm to material about William Mandeville. He and Eleanor Brown, both longtime residents of Lewis County, shared their memories of William Mandeville as well as their postcard collections. Dorothy Callahan, Mandeville's daughter, was a delightful and articulate source of information. In addition to consenting to long interviews, she shared her family papers, including photograph albums. Her son, Wayne, allowed me to read the diaries his grandfather kept during the years 1885 to 1887. Don DuFlo and Gloria Brown shared their recollections of their father, Frank DuFlo, and the Mandeville studio, as well as family albums. I also thank Dale Green of the Chenango County Historian's Office for his research on the Norwich part of the Mandeville story.

George Davis was an important escort in my pursuit of Henry Beach. With George in the Beach's Bridge cemetery I started putting together the pieces of Henry Beach's story. Camilla Zeller and Grace Bailey, who were neighbors of the Beach family on Chase's Lake Road, shared their reminiscences with me. Clayton Bailey provided first-hand knowledge of the Beaches, as well as tips and leads to other sources. His wife,

Bertha Bailey, Beach's granddaughter, shared information about the family, including family albums. Edward J. Beiderbecke and Ted Comstock provided early leads, photographs, and their knowledge of the photographer. Pat Hill helped find information on the Beaches during the Remsen years. David Gorton provided access to examples of Beach's nineteenth-century work.

Barbara Parnass was my most important ally in researching William Kollecker. She helped in many ways, including suggesting people to interview, sharing her extensive knowledge of Kollecker and photography, and guiding me through the collection of his material that she has preserved with devotion and skill at the Saranac Lake Free Library. She also read the Kollecker chapter in an early draft and made helpful suggestions. Other people at the library who helped were Shirley Morgan, Janet Decker, and Michelle Tucker. Those from the Saranac Lake area who shared their firsthand accounts of Kollecker include Catherine Cullen, Lucille Dodd, Marjorie McLaughlin, Eleanor Munn, Elise Chapin, Jean DeMattos, Robert McKillip, and Charles Keough. Edith E. Watkins, the daughter of Hugo Franz, Kollecker's longtime employee, was exceptionally helpful in providing information about her father.

Bob and Florencetta Saverie, owners of the Board 'n Batten Antique Shop in Olmstedville, New York, introduced me to Ernest Ameden's work and started me on my journey into his life. They allowed me access to their holdings of Ameden's negatives. I benefited greatly from the extensive work by Nancy Mullen (Ernest's great-granddaughter) on the family history. Leona Ameden, the widow of Ernest's grandson, Preston Ameden, related her reminiscences of the family and shared the family papers. Although I never met Alden Ameden, Ernest's grandson, face-to-face, I benefited from phone interviews as well as E-mail chats with him. Milda Burns and Helen Donohue, who knew Ernest Ameden, allowed me to interview them. Doris Patton, the Town of Johnsburg historian, was also helpful.

The research of Bernhard Puckhaber and Annabelle H. MacMillin contributed greatly to the chapter about Jesse Wooley. Marilyn Meyers, a relative of Wooley's wife, shared her research on the family. Jennifer Ley and her staff and volunteers at Brookside, the Saratoga County History Center, facilitated my early research and were helpful in locating photographs by and of Wooley. Chris Morley, a historian of Ballston Spa and volunteer at Brookside, and Charlie Livermore shared their recollections of Jesse with me. Karen Campola, historian at the Saratoga County Historian's Office provided me with additional sources. Mark Johnson, executive director of the Silver Bay Association, was gracious and cooperative in allowing me access to the organization's archives. Association members Mary Sharp, Jill Brown, and Jules Holm guided me through the archives and allowed me to look at their postcard collections. Eugene F. Provenzo, Jr., and William Brown of the University of Miami, Coral Gables, shared their knowledge of Jesse Wooley's experiences in Florida with me. I am particularly grateful to Eugene for his insights.

For the chapter on Herman Cassens and the Eastern Illustrating and Publishing Company, I am grateful to Brewster Harding, who wrote a book about the company.

He was helpful in suggesting people to contact, and he lent me rare photo postcards. Roger Rhoades, Cassens's nephew, shared his recollections over the phone as did Margaret Jardine, Herman's niece. The following librarians helped gather material on the Cassens family: Jeffrey E. Brown, Maine State Archives; Karen Wyman, Rockland Public Library; and Terry Cole, Belfast Free Library. When I contacted Tim Hughes of Belfast he was working on a biography of Edgar F. Hanson, Cassens's father-in-law, and went out of his way to share his research.

Others helped in a more general way. Early in the project I was lucky to meet Ted Comstock. His knowledge of the Adirondacks and the literature on the North Country and his suggestions, leads, and ideas were valuable at all stages of the project. Edward J. Beiderbecke served similarly in the area of Adirondack postcards. Both provided access to their extensive postcard collections. Walter Miller, director of the Museum of Automobile History in Syracuse, helped date some of the photographs.

The professional staff at the Adirondack Museum in Blue Mountain Lake was encouraging, enlightening, and supportive. Although each member assisted in more than one dimension of the project, Jerry Pepper was particularly helpful with references and library material. Jim Meehan and Jane MacKintoch guided me through the photographic collection.

There are friends and colleagues in my more immediate circle to whom I owe a great deal. Those in the various departments and offices at Syracuse University with whom I discussed this project and who assisted in other ways deserve commendation, including Walt Aikman, Diana Biro, Joan Burstyn, Loretta Denhart, Marj DeVault, Harriet Hanlon, Julia Loughlin, Mary Lou Marion, Mary Olszewski, John Palmer, Arthur Paris, Gary Spencer, David Tatham, Bianca Wulf, and Janet Zinn. Robert Mandel, Cynthia Maude-Gembler, and Andrea Pflug of Syracuse University Press were enthusiastic supporters. Ben Ware of the university's Division of Research and Computing helped find funds to defray the cost of reproducing the images. David Broda of the Photo and Imaging Center provided advice and services in copying the illustrations. He also shared his knowledge of the history of photography and photo processing.

A special thanks to my longtime friends and supporters Sari Knopp Biklen, Doug Biklen, Jerry Grant, Diane Murphy, Peggy Hanousek, Dixie Carlisle, Linda Yenkin, Burt Knopp, and my four children, Yinka, Meg, Chet, and Jono, and their friends and partners. For more than three decades Janet Bogdan has continued to give me support, encouragement, friendship, good ideas, and much more in amounts and with consistency that empower me.

The manuscript has been improved from earlier drafts because of the careful reading and extensive feedback from Walt Aikman, Janet Bogdan, Ted Comstock, Peggy Hanousek, Geoffrey Poister, Marshall Battani, John Fuller, and Andrejs Ozolins. Although they provided valuable service, I am solely responsible for what you may find lacking.

People who write biographies have biographies of their own, and their past influences what they write. The first time I heard of the Adirondacks I was thirteen years old. I

practice. They had many of the characteristics of folk artists, and some of the photographs they produced might accurately be termed *folk photography.*[4] Those photographers who produced photo postcards went unnoticed and unrecognized in their own time and have remained so. Because of the photographers' low station, information about them and their work is obscure.

More on Photography

Chester Gillette, the young man introduced at the beginning of the chapter, was carrying something besides postcards on his trip to Big Moose Lake. He had a Kodak camera in his bag (Brandon 1986). His snapshots were used as evidence in his murder trial. By 1906, taking snapshots when traveling was as commonplace as sending postcards (illus. 1.3).

The popularity of unskilled amateur photography was mostly due to George Eastman and his Kodak Company (Brayer 1996).[5] In 1888, he introduced the No. 1 Kodak camera with the slogan "You Press the Button, We Do the Rest" (Nickel 1998, 10). The invention of the dry plate and other innovations had already greatly simplified the photographic process. Many consumers had been lured into taking amateur photos, but photography was still too complicated and cumbersome to attract a mass market. The No. 1 camera and its successors changed that reality. Not only was the camera easy to operate, but the photographer also did not have to worry about the messy, delicate, and complicated process of transforming the film or glass plates into trustworthy negatives and then printing high-quality pictures. Instead, one sent the unopened camera to the factory where the prints were made and returned along with the reloaded instrument.

With the marketing of the new technology, thousands of people who had shunned photography joined the ranks of the snapshot amateur. By 1900, these changes created a tremendous boom in the manufacture of cameras, film, and photographic supplies. It also produced a challenge for the small-town commercial photographer. Scenic views had been part of early photographers' trade, but their bread and butter was studio work: local people posing for portraits (Darrah 1981). By the turn of the century, many potential customers were taking informal portraits and scenic photographs themselves, thus undercutting a substantial part of the professionals' business.

Interestingly, the influx of amateurs into picture taking did not reduce the number of practicing professional photographers (Nye 1985). But it did change the nature of their work, how they thought about themselves, and the kinds of pictures they produced. Industry, newspapers, magazines, and other commercial enterprises hired some

4. Although photography has gained the stature of "art," people never refer to early photographs produced by local practitioners for local people as folk art or even folk photography. When I have discussed this deficiency with people involved with folk art, they dismiss photographs either as mechanically produced and involving little skill or as too recent (part of mass culture) to be considered folk art.

5. Note the distinction between "unskilled amateurs" and "skilled amateurs." Some noncommercial photographers, many of whom belonged to photography clubs, were very skilled. The dry plate glass negative brought more amateurs into photography long before this time, but they were the more serious amateurs. I am referring here to the snapshot photographer entering the scene.

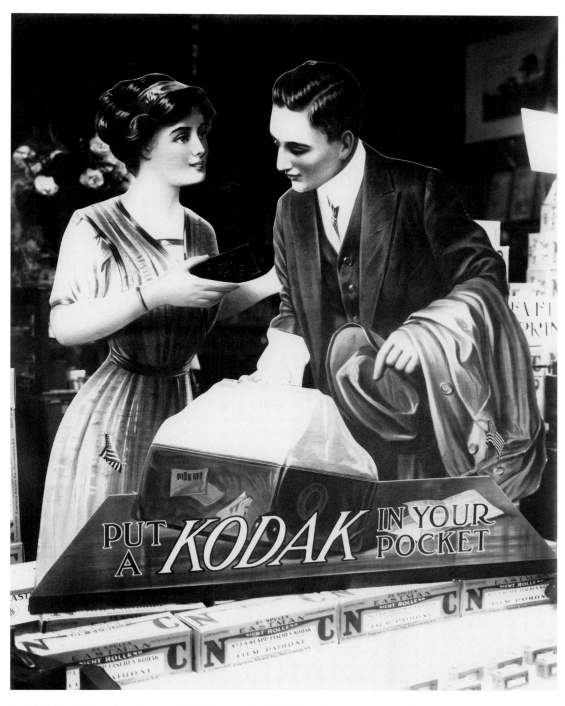

1.3. Kodak window advertisement in William Kollecker's photo shop in Saranac Lake.
The ad features a man packing for a trip and the phrase: "Put a Kodak in Your Pocket."
Photo by Kollecker, c. 1912. Saranac Lake Free Lib.

of them (Nye 1985). Self-employed photographers began to rely more on jobs in which they were paid to capture formal family events, such as weddings and anniversaries. In addition, they became more dependent on regular assignments as the official photographers for organizations such as schools (elementary schools, high schools, colleges, and trade schools), voluntary associations (Masonic and other fraternal organizations, ethnic associations, and political clubs), and companies (manufacturing and service). Customers still posed for studio portraits because professionals took superior pictures at reasonable prices, but the portraits and the new work were often not enough to sustain a business.

Part of being a studio photographer had always involved being a merchant. In addition to selling portraits and photographs, photographers always sold frames and other accessories. With snapshot amateurs on the rise, there was an opportunity to become more aggressive in retailing and to expand their product lines to include cameras, equipment, and supplies (illus. 1.4). Because photographers were getting into the retail business anyway, many sold specialty items such as paper and pens or, if they were in a tourist area, souvenirs.

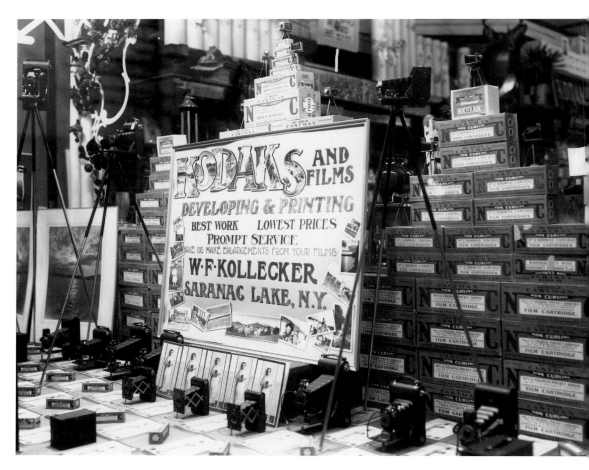

1.4. Window display in Kollecker's shop in Saranac Lake. Features Kodak cameras and promotes the developing and printing aspect of the business. Photo by Kollecker, c. 1915. Saranac Lake Free Lib.

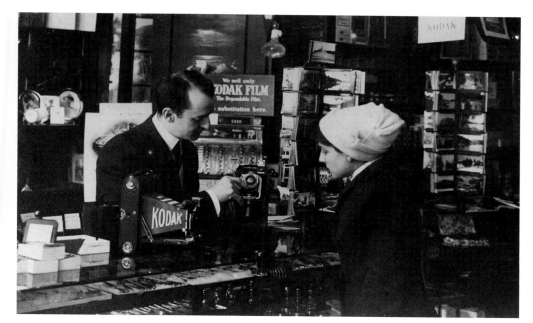

1.5. William Kollecker behind the counter in his photography shop in Saranac Lake. Note postcard racks. Photographer unknown, c. 1920. Saranac Lake Free Lib.

Camera and film manufacturers encouraged customers to send their film to them, but amateurs also had other options. They could process the film themselves or have a local person do it. Many professional photographers began offering that service at their stores.

With all these changes, then, rather than fighting the snapshot amateur trend, some professional photographers became allies of the do-it-yourselfers by selling them products, processing their film, and even providing instruction and advice about their picture-taking problems. Although most people who made a living as photographers in the nineteenth century embraced the title and demeanor of "photographic artist" (Battani 1997) and called their establishments "galleries" and "studios," in the twentieth century they switched to being businesspeople or "commercial photographers" and operating "businesses," "shops," and "stores."[6]

Photo postcards, a turn-of-the-century innovation in the United States, provided another opportunity for the small-time commercial photographer.[7] Although Kodak was soon making cameras for amateurs to take postcards (Morgan and Brown 1981), the convenience of buying quality views on the spot created a demand for postcards from the rack. Many professionals embraced photo postcards as a way to give a lagging business a boost (illus. 1.5). Although many incorporated the postcard into what they were already doing, making only modest alterations in their practice, others seized this new format in a more enterprising way. They began traveling for their work, marketing to larger audiences, and in some cases neglecting individual customers who were seeking studio portraits.

6. Some kept the name "studio," which is still used today.
7. Postcards were widely used earlier in Europe.

The Automobile Age

In August 1906, one month after Grace and Chester started their journey to *An American Tragedy* by train, two brothers began a different Adirondack trip. Their excursion foreshadowed important trends in the North Woods's landscape as well as in the subject matter and consumption of postcards.

Brothers Norman and Howard Scholle left Williamstown, Massachusetts, bound for Blue Mountain Lake in the remote central Adirondacks (Hochschild 1962b, 97–98). Their mode of transport was not a train or a steamer, nor did they navigate the rough Adirondack stagecoach roads by horse-drawn transportation. The trip was in a 1905 Winton touring car.

Their jaunt to the edge of the park was relatively uneventful.[8] The roads were easily negotiable, and no one paid them much attention. Adversity and spectator curiosity characterized the rest of the trip, though. Between North Creek and North River they startled a man and woman who were driving a horse-drawn buggy. The brothers stopped the car, allowing the pair and their animal to scramble to shelter in the bushes where they waited until the vehicle passed. The frightened couple, like most of the people they encountered on the Adirondack part of their journey, had never seen a horseless carriage (Hochschild 1962b, 98). As the motorists proceeded, the roads became so bad that, in order to make progress, they resorted to unloading the car and carrying the gear by foot. When they arrived at their destination, they were heralded as the first to reach the central Adirondacks by motorcar from the East.[9]

This event, which appears comical now, was a serious benchmark in the history of the North Country (White 1985, 230). Starting slowly at the turn of the century and rapidly accelerating with the advent of the mass-produced automobile in 1907, Americans took to the roads as commuters, businesspeople, vacationers, and tourists (Jakle 1985). By 1920, there were more than 8 million automobiles in the United States, and in the next decade the number tripled. Because of its geographic isolation and rough, mountainous terrain, New York's North Woods lagged behind parts of the United States in embracing the automobile, but the invasion had been launched.

In the eighteenth and early nineteenth centuries, transportation into and around the Adirondacks was by foot or by animals on crude woods roads, hunting and game trails, and other paths or by small portable craft on rivers and lakes. In the late nineteenth century, the railroad penetrated the North Country and provided access to many areas. Stagecoaches and other forms of horse- and oxen-drawn wagons made their way on rugged roads. Steamers provided transportation on the large lakes and extensive waterways to a variety of ports. In the twentieth century, the automobile and highways came to dominate.

Before the turn of the century, in addition to permanent residents scattered in modest hamlets, the Adirondacks had largely been the domain of wealthy camp owners and

8. I am referring to the boundary as it is presently drawn.

9. A honeymooning couple from Buffalo is alleged to have reached Saranac Lake by a less hazardous route in 1902 (Donaldson 1977, 296). In 1908 the first car owned by a central Adirondacker was shipped to the Old Forge area by train (Higby 1974, 104).

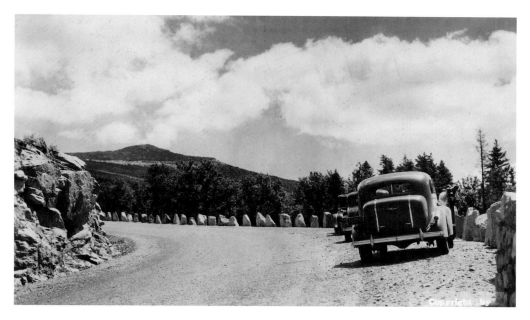

1.6. Mount Whiteface Memorial Highway. Photo postcard by Roger Moore, c. 1938. Author's Coll.

affluent people who could afford long hotel vacations. Part of the nineteenth-century lure of the North Woods had been its exclusiveness. As trains and steamers improved access, a growing number of tourists and summer people of more modest means were visiting. The automobile accelerated that trend, bringing more transients who had less money to spend and who wanted a different kind of experience from earlier visitors.

By 1915, the roads were improved, and some were even paved.[10] In that year Seneca Ray Stoddard, the well-known photographer and North Woods tourist promoter, published an automobile tour guide for the Adirondacks. With typical Stoddard flare, he declared: "It is truly a new Adirondacks. From the early days, when travel was undertaken in devious ways by primitive means; it has become a wilderness traversed by magnificent state highways, forming a network of roads as fine—the major portion, at least—as the boulevards of our cities" (Stoddard 1915, 2).

Although we should take into account Stoddard's tendency to exaggerate, by the early 1920s automobile travel to many places in the Adirondacks was common.[11] General stores and liveries were selling gasoline. Filling stations and service stations soon ap-

10. Townships began paving first. The road from North River to Indian Lake was paved in 1916 (Johnsburg Historical Society 1994, 67). State highway construction was not approved until 1918 (Van-Valkenburgh 1979, 123). It is not clear if early state-highway construction was limited to rock, gravel, and sand roads or when asphalt was used. The Raquette Lake to Blue Mountain road was not paved until 1929 (Timm 1989, 254). See Hochschild 1952 (458) for details of macadam roads in the central region. Hochschild points to the 1920s as the period of building "hard-surfaced highways" (103).

11. Although by 1920 a paved road connected Utica to Old Forge, it was another ten years before it was extended to Blue Mountain. Many of the major roads that traversed the Adirondacks were not modern highways by 1915. Stoddard's proclamation of the Adirondacks as paved was premature at best.

peared (Margolies 1981). By the mid-1930s, when the photographers discussed in *Exposing the Wilderness* were concluding their careers, there was an extensive system of good roads in the North Woods. Even the road to the summit of Whiteface Mountain had been paved (Terrie 1997, 140) (illus. 1.6).

Hotels, lodges, and inns near train stations and ferry docks were once the customary sleeping quarters for vacationers. When automobiles appeared, locals all along the roadside began hanging out shingles announcing tourist homes with overnight accommodations for motorists. Campsites sprang up, cabins and bungalows followed, then tourist courts, and finally the individual units joined into large single buildings called motels (Baeder 1982, 115; Margolies 1995, 153).[12]

Prior to the automobile, travelers ate leisurely meals at hotels, lodges, and inns. These places were joined by short-order eateries such as teahouses, diners, and take-out establishments selling hot dogs, hamburgers, and ice cream. Many of the new generation of tourists were on the go and wanted to eat and run. Forerunners of Santa's Workshop, Frontier Town, and the Enchanted Forest, rudiments of roadside entertainment such as small zoos, museums, playgrounds, miniature golf, and picnic and bathing parks began appearing (Margolies 1998).[13] By the 1940s, the automobile had made the roadside Adirondacks a "people's park" (Timm 1989, 198).

During the time the photographers in *Exposing the Wilderness* were taking photo postcards, the tourist industry remained small—mom-and-pop operations. As the cars came in greater numbers, these fledgling businesses competed for customers with signs proclaiming "the biggest hot dogs," "the cheapest gas and accommodations," and "the best views of the mountains and lakes" (Margolies and Gwathmey 1993).

An indicator of what was happening to the roadside was the 1924 "signboard law" (VanValkenburgh 1979, 137). Enacted by the New York state legislature, the law was aimed at limiting the visual pollution caused by roadside advertising in the park. It did not restrict owners from displaying signs on their own premises, but it did ban roadside billboards and advertising off business grounds. Within a year, the Conservation Commission reported that it had removed 1,332 signs and that an additional 89 had been taken down voluntarily from Adirondack highways (VanValkenburgh 1979, 137) (illus. 1.7).

More than the immediate roadside changed. Once the less wealthy became familiar with the North Woods and had the means to get there easily, some became eager to purchase property—to have a place of their own. Some of the large hotel resorts and estates were divided and sold to buyers of lesser means (Hochschild 1952, 103). The summer population of the Adirondacks increased, presenting new business arrangements for small local entrepreneurs (Timm 1989, 257) and a new class of second-home seasonal residents.

12. In 1920, the state began opening roadside campgrounds designed with motoring tourists in mind (Terrie 1997, 127). By 1932, there were nineteen large state campgrounds in the Adirondacks adjacent to public highways (Landon 1932, 479).

13. Although the first Adirondack theme park (and the first in America), Santa's Workshop at the foot of Whiteface Mountain, did not appear until the 1940s, the roadside was in transition (Timm 1989, 1940).

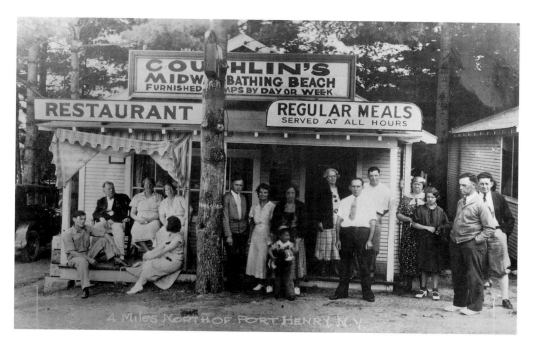

1.7. Coughlin's Midway Bathing Beach, "4 Miles North of Port Henry, N.Y."
Photo by Eastern Illustrating, c. 1932. Adirondack Museum.

The Lake Placid Winter Olympics in 1932 brought another change to the Adirondacks: winter tourists in numbers. Not only were the villages around the Olympic site affected, but Old Forge, North Creek, and places around Lake George also became year-round resorts. Although most of the increase can be attributed to "ski trains," the gasoline engine improved access to and around the sites and provided power for the lifts.

Automobiles changed the lives of year-round residents in ways that were tied not just to the tourist trade. When roads improved and the cost of automobiles fell within the locals' price range, cars contributed to the withering of hamlets. People could drive to villages for shopping, services, schooling, and social life (Bond 1995, 199), undercutting the viability of smaller communities. Having convenient transportation also meant changes in the way work was organized. For example, logging camps became obsolete when workers could commute to harvest sites (Bethke 1981). Local hunters also approached their sport differently.

During the early twentieth century, not all large landholdings in the Adirondacks were broken up and sold. Some stayed in the hands of the original owners, others were purchased by the state, and still others were consolidated into large private preserves. Although not significant in terms of acreage, parts of some holdings were transformed into summer camps for children (White 1985, 233) and convention sites and retreats for religious and civic organizations (Hale et al. 1984), bringing people to the Adirondacks who had a more circumscribed relationship with the park. The automobile contributed to these changes also.

The Adirondacks had changed, at least along the roads most people traveled. But through the thirties, and even today, an older Adirondacks remained, a North Woods of secluded hotels, camps, and clubs as well as backwoods lumber operations and pristine forests. The postcard and the automobile appeared on the scene at approximately the same time. All the photographers featured in this book were taking photo postcards immediately before and during the coming of the automobile-consumer age to the North Country. After that era began, they photographed the range of Adirondack scenes, from the highway diner to the backwoods camp. They did not all court the same customers. Some catered more to local people, others to the tourists, still others to the summer people, and some tried to cover the gamut of buyers. They took a broad sweep of views.

Postcards had a coactive relationship to the car and the changes that surrounded the automobile's movement into Adirondack life. Postcard creators profited from the changes the automobile brought and in turn promoted car travel. In addition to their local use, postcards were purchased by travelers to create a visual diary of their trip and to send to tell friends and relatives where they were, what it was like there, when they would be home, and to say, "Wish you were here."[14] Year-round residents bought them to document their own communities and to keep in touch with relations who had left the North Woods to seek lives elsewhere—a phenomenon the automobile also promoted. Postcards celebrated, publicized, and documented the changing Adirondacks.

Postcards as Representation

A photograph is not just an accurate or an inaccurate view of reality; it is a distinct rendition of the world produced by a person with a specific biography and a particular social position and culture, at a definite historical moment, for a certain purpose (Fox and Lawrence 1988; Tagg 1988; Bolton 1989; Sekula 1989; Goldberg 1991). Although early viewers of photography tended to see photographs as the truth, modern theorists approach them as visual rhetoric. A photo postcard, like any picture, is an interpretation, a particular rendition, and a representation of the world. Photographs create reality as much as they capture it.

Although there are similarities in the photographers' photo postcards in this book, there are also differences. With a desire to write a more satisfying book, one that might provide insights into a wider range of experience, I searched for women postcard photographers as well as photographers from other underrepresented groups. My efforts were unsuccessful. All the photographers I included are white, Protestant, heterosexual men of European backgrounds. At first glance they are a homogenous group, but a closer look will reveal variety in their lifestyles, social-class backgrounds, and world-

14. Approximately one-half of the cards examined for this project had written messages. Because the emphasis here is the photographers and their pictures, a detailed analysis of the messages is beyond the scope of the work. Most of the text consists of reporting of events, information about arrivals and departures, descriptions of the locations, and expressions of affection. The writing on many cards refers to the content of the picture side of the card.

views. In addition to telling the photographers' stories, I compared their exposures and how they represent New York's northern wilderness and the people who lived and visited there. As you will see, there are different Adirondacks (Terrie 1997), and there are many ways of exposing the wilderness.

The Adirondacks

Although the "Adirondacks" may seem like a clear and uncontested designation referring to the large forest area of northern New York State (larger than the state of Connecticut), officially specified as the Adirondack Park, and circled on maps with a blue line, it is not (Terrie 1997, xvi). Some people think of the Adirondacks in different terms. During the period the photographers in this book were active, the Adirondack Park was not something many local people paid much attention to. The official "Adirondacks" had not been codified into law when some of them started their careers. Even after the park, or preserve as it was first called, was created in 1892, some people stuck to a more expansive definition of the Adirondacks. A 1916 major automobile tour guide defined the Adirondacks as the territory in upper New York State covered by mountains and extending from the Mohawk River to the Canadian border and from Lake Champlain almost to Lake Ontario (Automobile Blue Book Publishing 1916, 453). During and after the period the photographers in this book worked, the official boundaries of the park expanded (Cobb 1990). Some people hold on to an understanding of the Adirondacks as the area that existed when the park was first established, what some people call the central Adirondacks. Dissidents of current state-forest-management policy challenge the notion that the park is the Adirondacks by arguing that the boundary is an arbitrary and imposed political designation that has no geological or natural integrity.

A number of the photographers in this book lived in communities immediately outside what is now the park boundary. Even though the people living in these communities are not officially within the "Blue Line," many of them, as did their parents and grandparents, think of themselves as Adirondackers. Although I use the term *Adirondacks* to refer to the land roughly within the present park, I also use it to include some communities on the periphery of the Blue Line. Many New Yorkers use "North Country" and "North Woods" interchangeably with the "Adirondacks," as do I.

The Wilderness

The "wilderness" concept is contentious in environmental, political, and academic circles. I considered distancing myself from the term by putting it in quotation marks, which was too awkward, especially in the title. In a strict and concrete sense, wilderness refers to a large, densely wooded area unaltered by human activity. Bill McKibben, an Adirondack resident and an influential writer about the environment, and others point out that the pervasive impact of people on the ecological system makes the word *wilderness* a misnomer. Some people say that if the term is used in relation to the Adirondacks, it should be reserved for the isolated areas far from roads and human habitation. Oth-

2

William Garrett Mandeville, Jr.
Lowville Village Photographer

Lowville was the home of talented and prolific photographers at the turn of the century. This agricultural village of approximately three thousand in the western foothills of the Adirondack Mountains, eight miles from the Blue Line, is where George W. Carter, Frank R. DuFlo, Henry M. Beach, and William G. Mandeville ran studios.[1] Although Mandeville produced a lifetime of outstanding work and his photographic postcards are among the best of the genre created anywhere, he died relatively unrecognized (illus. 2.1).[2]

During Mandeville's time, Lowville was a western port for launching trips into the Adirondack forests (Donaldson 1921; Bowen 1970). The Lowville area had some tourists, summer residents, and hotels that catered to people traveling onward, but it was never primarily a tourist or summer town. A profile of the Adirondack mountains is visible from Lowville, but the land surrounding the village, especially to the west, is relatively flat and fertile. The fields and pastures supported dairy herds, and the cattle provided the backbone of the area's commerce. The town itself was primarily the governmental, transportation, and commerce center of rural Lewis County, the western end of which extends into the park. From Lowville, there was easy access to the Mohawk Valley via the Black River Canal and the railroad. There were shops, professional offices, small factories manufacturing cheese and wood products, government buildings, and social service, health, and educational institutions—all potential subjects for photo postcards (illus. 2.2, 2.3).

Lowville residents hunted, fished, camped, picnicked, boated, and summered in the mountains. Although Lowville is not officially part of the Adirondack Park and is not economically dominated by it, the townspeople consider themselves part of the Adiron-

1. When cartographers included the Adirondack Park on maps, they showed its border as a blue line. Although some maps do not use that color now, people still refer to the "Blue Line" as the border of the park.

2. Almost all the photographs in this chapter are the work of the Mandeville Studio. Rather than repeat that information in the captions, the attribution is included only if the photographer is someone other than Mandeville Studio. I will continue a similar convention for the other chapters, designating the photograph only if it is by someone other than the photographer who is the focus of the chapter.

2.1. William Mandeville, c. 1924. DuFlo-Brown Coll.

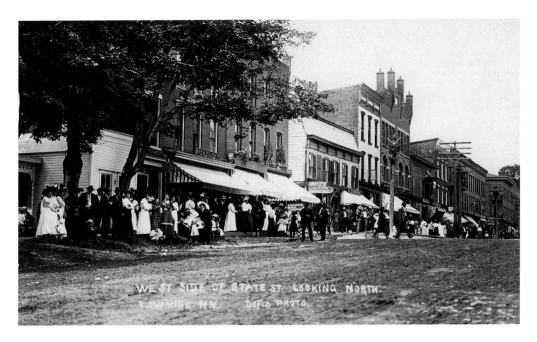

2.2. Postcard view of west side of State Street looking north. Mandeville's studio is on the left, before the first awning, where the sign protrudes over the doorway. Photo by DuFlo, c. 1908. Author's Coll.

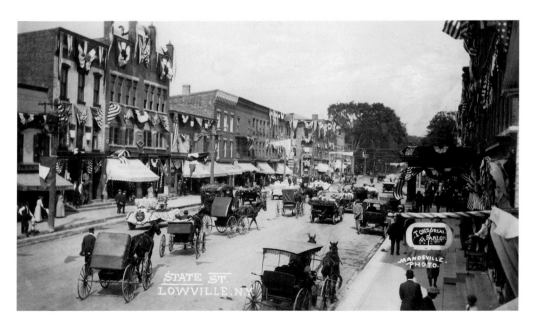

2.3. Postcard view of South State Street looking north. A busy day on Lowville's main street, c. 1913. Author's Coll.

dacks. There are many family and commercial connections between Lowville and the southwest and central Adirondacks (Hochschild 1952, 456; Higby 1974, 17, 38). The building that housed Mandeville's studio is now the office of the weekly newspaper, the *Adirondack Sun.*

Some Lowville photographers ventured into the mountains for their postcard images. They shot Adirondack scenes—hotels, landscapes, and wildlife—and sold their wares to the travelers and summer people. Mandeville, however, remained close to home and sold his products to locals. He captured a variety of village scenes, and some of his most memorable photos were of local merchants at work and in front of their stores (illus. 2.4, 2.5, 2.6). William was a respected craftsman, and local people preferred his images, so he had enough work to keep him and his assistant, Frank DuFlo, busy without seeking customers from other communities or courting outsiders.

Early Life

William Mandeville was born during the Civil War, on June 28, 1864, in Norwich, a bustling village of fifty-five hundred in Chenango County, New York, approximately one hundred miles south of Lowville. His father was William Garrett Mandeville, a hardworking man known for his honesty and neighborly ways. A hatmaker by trade, his business succeeded until the year before William Jr. was born, when a fire devastated the shop and Mandeville Sr.'s health. Mercy Jane Knapp Mandeville, young William's mother, was an enterprising businesswoman and a kind and supportive parent. She op-

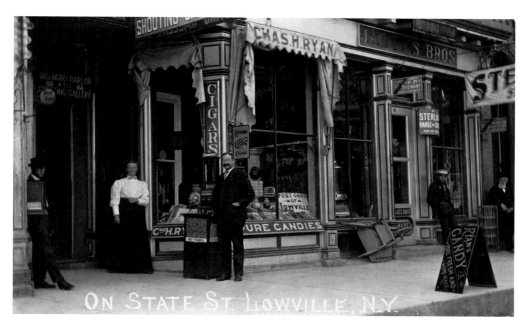

2.4. Ryan's Shop on State Street. Mr. and Mrs. Ryan are in front. "Pure fresh and homemade candy" was the specialty. A sign in the window advertises Mandeville's "Post Cards of Lowville," c. 1907. Davis Coll.

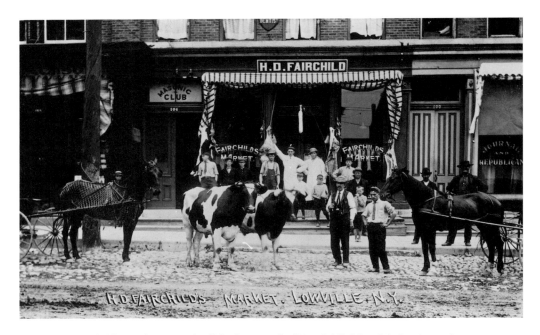

2.5. H. D. Fairchild's Market. Mandeville's photo card of Fairchild's Meat Market is another example of his local emphasis, c. 1908. Eleanor Brown Coll.

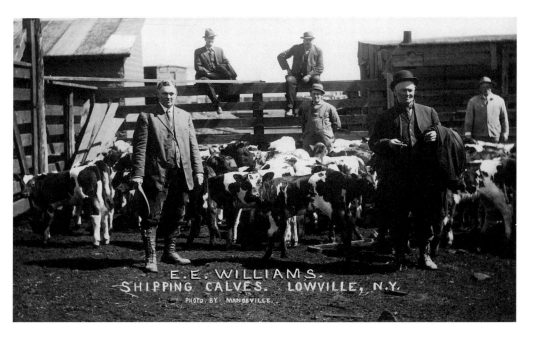

2.6. E. E. Williams, shipping calves, c. 1909. Author's Coll.

erated a florist shop and gardening business long before her husband's tragedy. After the fire, William Sr. joined her in the trade, making it a family enterprise.

Both of William's parents were English, albeit generations removed from the homeland. He had two brothers and two sisters. William was the second born. George was seven years older, and Henry was four years younger. The girls were born last. One died as a child. The family's social life revolved around Masonic organizations and the church (Smith n.d.).

Two anecdotes survive about William as a child. The first captures the family's understanding of the origins of William's photographic skills. When his mother worked in the greenhouse, she often took young William with her, placing him in a high chair so she could work. To occupy his attention, she gave him crayons and paper. William apparently showed an early talent for drawing and in the greenhouse developed his understanding of arrangement and perspective. The long rows of plants provided an atmosphere to experiment with depth. He composed simple, well-ordered pictures of the leaves and flowers that surrounded him and stretched out down the rows. Later in his life, this perspective was echoed in the photographic postcard images he created.

The second story serves as the family's explanation for the quiet man's controlled disposition. When William was a boy, he became furious with another playmate and hit him so hard with a baseball bat that the child nearly died. William, terribly upset by the incident, decided to conquer his bad temper. For the rest of his life, or at least until close to his death, he suppressed his anger and other strong feelings.

William stopped attending school at the age of sixteen. He worked for two different businesses before he landed a job with Alston E. Hotchkiss, a photographer who ran the most popular photo gallery in Norwich.[3] Hotchkiss styled himself after early gallery photographers, taking on the persona of the artistic cultured gentleman (Battani 1997). He advertised his business as an "art, photography studio" and did portraits in crayon, ink, and pastel over photographs in addition to regular, formally posed prints. In the three years Mandeville worked for him, the business grew. When William started with the firm in March 1883, Hotchkiss employed only a few workers, but by the time Mandeville left, the number had reached twenty. During the first year, he clerked and retouched photos. Later, he moved on to printing, framing, finishing, and mounting. Eventually, he took pictures. While with Hotchkiss, he learned the basics of good nineteenth-century photography.

After one and one-half years with Hotchkiss, Mandeville's wages were raised from twenty-four dollars a month to thirty-five. For that wage, he worked ten to eleven hours a day and often on Saturdays. He continued to live at his parents' home, contributing two dollars a week to the family budget and helping out in the greenhouses. By carefully monitoring his expenses, he was able to save two hundred dollars within the first few years.

3. Hotchkiss (d. 1907) came to Norwich in 1872 at the age of twenty-six. His business was located on the second and third floors of 234–36 North Broad Street. Although the business was named A. E. Hotchkiss, his wife played a major role in it.

During the time he was employed as a photographer's assistant, Mandeville enjoyed a full social life, attending many church functions, lectures, and plays. In addition to religious tracts, he read Shakespeare, novels, *Harper's Weekly,* and literature about photography, some of which he ordered by mail from E. & H. T. Anthony and Company of New York (Marder and Marder 1982, 197). Using the Anthony catalog, he ordered an amateur photographers' kit for fifteen dollars and began taking pictures on his own. In efforts at self-improvement, he took crayoning, drawing, and music lessons. He was politically, socially, and religiously conservative, an orientation he held for the rest of his life. In 1885, he voted in his first election—for the Prohibition Party. He attended temperance and religious revival meetings.

At times Mandeville was a distraught young man. Plagued with ill-defined health problems, he regularly consulted the local doctor. He suffered from acne, cold sores, eyesores, fatigue, tooth extractions, and a 120-pound body on a five-foot-eight-inch frame. Tormented by fears that he was not living up to religious teaching and that he would never amount to anything, he had trouble sleeping.

Photography and drawing were satisfying to Mandeville and gave him a vocational goal. Not long after he went to work in the photography gallery, he wrote in his diary: "I intend to learn photographing and crayoning and ink work and then endeavor to make a living at it. 'Tis my present intention to become as near as possible the best crayon portrait artist; quite an undertaking but if I have 50 yrs of healthy life and no extraordinary accidents I mean to come somewhere near the mark at which I aim." Although he abandoned crayon portraits, he lived longer than he projected and always remained committed to excellence in his photography and in his vision of himself as an artist.

At about the same time that Mandeville started his gallery job, he met his future wife, Bertha Davis, at the Baptist church during a music recital. She was a year younger than William. A somewhat sickly young woman, Bertha was frequently indisposed because of headaches. Although they saw each other daily during the three years of courtship, theirs was not a passionate romance. They had similar backgrounds and beliefs and were kind and supportive of each other. Early in their relationship they developed an understanding that they would eventually marry.

Late in his second year at the Hotchkiss Gallery, Mandeville became frustrated with his job. He believed he had no future with the company, and he found the work repetitious and both Hotchkiss and his wife irritating. William began placing ads in a national photographic trade newspaper, introducing himself as experienced in photographic production and looking for employment.

Starting Out in Lowville

On March 26, 1886, Mandeville received a letter from George W. Carter of Lowville with a job offer. William, who was determined to leave Hotchkiss's gallery, did not know much about Lowville, but he heard that Carter was a good photographer. Carter, who had only recently opened his photograph gallery, had been creating cartes de visite and cabinet card portraits of Lowville citizens and larger-format scenery and village

2.7. William and Bertha Mandeville,
c. 1900. Callahan Coll.

scenes for ten years.[4] Aside from his career as a photographer, Carter also maintained a farm, and he needed someone to help meet the demands of his growing photography business.

A few days after receiving Carter's offer, Mandeville boarded the train for Lowville where he started work in the Carter gallery and found a place to live in a rooming house. After a successful month, he returned to Norwich and discussed marriage with Bertha's parents. They were not keen on the idea but mellowed, and on July 27, 1886, Bertha and William were married. Their honeymoon, in keeping with their meager finances, was a three-day trip to nearby Binghamton (illus. 2.7).

The newlyweds moved to Lowville and took up residence in the boardinghouse where William had been staying. They joined the Baptist church and found friends in the congregation whom they accompanied on excursions to Brantingham Lake and other nearby spots in the Adirondacks. William enjoyed going to town events and had a special fondness for local baseball games in which Lowville squared off against teams from neighboring towns.

4. A carte de visite is a small photograph mounted on a stiff card, approximately 2½ by 3½ inches. They were most popular from around 1860 through the turn of the century. Cabinet cards are similar to cartes de visite, but are twice as large. They came into widespread use in the 1870s.

In October, William and Bertha visited Norwich. William returned to Lowville, but Bertha remained with her parents, helping them move to a new house. She joined William a few weeks later but returned to Norwich when she began suffering from rheumatism. This pattern of separation characterized the early years of their marriage.

In March 1887, only one year after his move to Lowville, Mandeville, for reasons unknown, severed his business connections with Carter. Bertha, whom he had not seen in seven weeks, was with her parents. He packed up and returned home. Rather than compete with Hotchkiss, who dominated the Norwich market, Mandeville opened a small studio in nearby Oxford. He was just getting started when he learned that Frank Slocum, a Lowville photographer who had a studio on State Street, was interested in selling his business (Sullivan 1927, 232). Mandeville purchased Slocum's gallery, and he and Bertha moved back north.

Mandeville threw himself into his work and established a pattern of long hours and devotion to his craft that lasted for the rest of his life. He admired quality photographs and held himself to the highest technical standards. He attracted customers in the competitive Lowville market and did well enough financially to support himself and his wife and to improve his work space and equipment. Sometime before 1895, Mandeville moved his studio to the Keller Building at 89 State Street where he worked for approximately forty years.

Children and Family Life

In the fall of 1888, the same year William opened his own studio in Lowville, the young couple was thrilled to learn they would become parents. They rented a house on Cascade Street. The joy at the birth of their son, Albert Dewitt Mandeville, in the spring of 1889 turned to tragedy when the infant died in his fourth month. This devastating event remained with William and Bertha the rest of their lives.

At the time of Albert's death, William created a pencil drawing of the child's small form lying on a settee, fully covered with a blanket, with the caption, "Albert's death, August 1889." For at least twenty years, William regularly visited the Lowville Rural Cemetery to place flowers on his son's grave. The already somber young man withdrew further. Bertha, who was always shy, stayed at home more than other women of the town and participated only marginally in the social life of the community. At about the time of her child's death she began regularly getting migraine headaches, as she would for the rest of her life.

One day while Mandeville was working in his studio, a county official brought two young sisters to have their pictures taken. The official was removing them from their home because of alleged neglect and placing them in the county home and orphanage. Still mourning the death of his son, Mandeville was moved by the girls' plight and developed an immediate attachment. Although Bertha was at first reluctant, they adopted the two. Maude, who was born in 1895, was the oldest. She adjusted well to her new home, but her sister, Effie, never settled in and was a constant problem to the couple. As she entered her teens, she became more difficult to control and was committed to the State Institution for Feeble-Minded Women of Childbearing Age at Newark,

2.8. From left to right: Bertha, Dorothy, Maude, and William Mandeville, c. 1911. Callahan Coll.

New York. Afterward, she is absent from the family records.[5] Maude finished high school and became a musician at a silent movie theater in Albany and later at a cocktail lounge. She visited often and remained close to the family.

In 1908, when Maude was thirteen and Bertha was forty-three, Bertha gave birth to a daughter, Dorothy. Embarrassed by her late pregnancy, she kept it a secret from her neighbors by wearing loose dresses. Seven months after the birth, the family moved to a modest home on Dayan Street, a block away from the center of Lowville and around the corner from William's photography studio.

When Dorothy was young, William, as he had done for so many Lowville families, turned his camera on his own kin. Most of the pictures in the Mandeville family albums are photo postcards. Dorothy was at the center of the family photographic record. Included in the album are pictures of Bertha and Maude and a few poses of the whole family, even William (illus. 2.8).

Family life was not unpleasant, but it was not gay either. To Dorothy, William and Bertha seemed more like grandparents than parents. The family was not socially active. They had no close friends. William's and Bertha's parents died, and contact with fam-

5. At the time of Mandeville's death she was believed to be living in Rochester.

practicalities of the shop. It was the craft that was important, not the money. When people ordered a certain number of prints, he threw in extras. The quality of his photographs and the care he put into his work never matched the price he charged. Although it is difficult to say whether he would have covered a larger geographic territory if he could have turned a profit and afforded an automobile, his mobility was severely limited by not owning a car.

Around 1936, well after he stopped manufacturing photo postcards, Mandeville was told that Coahn's Clothing Store was going to expand to the upper two floors and he would have to move. With the help of his longtime employee, Frank DuFlo, William found a vacancy on Shady Avenue, close to State Street, and relocated.

Frank DuFlo

Frank DuFlo worked for Mandeville for three decades, from 1915 to 1945. He was a talented and accomplished photographer and photo processor, and it is impossible to determine which photographs were done by him and which by Mandeville during these years.

Born in Watson on October 26, 1884, DuFlo was twenty years younger than Mandeville, but in many ways they were kindred spirits. In the thirty years they worked together, they spent untold hours in each other's presence in the studio, shooting, printing, finishing, enlarging, and framing photographs as well as attending customers.

According to family accounts, the two men got along well, enjoyed each other's company, and respected each other's work. They even had some laughs. In one picture of them together outside the State Street studio, they posed on either side of a hand-printed advertising sign hanging in their store window that used the indirect approach in pushing their services: "We Do Not Take Pictures of Dead Folks, Only Live Ones. Have You Had a Recent Photograph Taken?" (illus. 2.14). But the sign was not altogether accurate (Burns 1990); although by the 1930s the demand for postmortem photographs had declined, it had always been part of Mandeville's business, as it had for most small-town photographers.

Mandeville and DuFlo had much in common, but there were obvious differences. William was quieter and more serious and intense than Frank, who was easygoing and outwardly friendly. Frank enjoyed photographing wildlife in the Adirondacks and compiled an album of photo postcards he had taken of local animals for his and his family's own pleasure (illus. 2.15). William did not photograph animals except for his cats, Tinker and Rolly.

One difference between the two was that although Frank worked for William, he was better off financially. Although he was certainly not wealthy, he owned a home, which was nicely decorated. The DuFlos owned a used automobile. Stored in the barn from mid-October until spring, it was used for summertime family outings.[6]

6. It is not known when Frank first bought a car. The first hard surfaced roads in Lewis County were completed in 1910. State Street was paved in 1913 and Shady Avenue in 1916 (Bowen 1970, 77–78). Bowen says Dayan Street was paved in 1914. The photo postcards that are used as illustrations in this chapter give October 17, 1913, as the date.

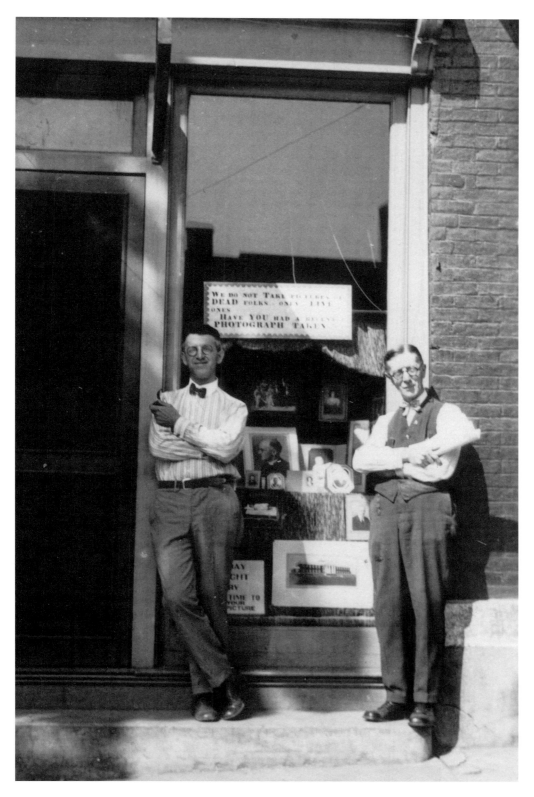

2.14. DuFlo and Mandeville outside the State Street studio, c. 1930. DuFlo-Brown Coll.

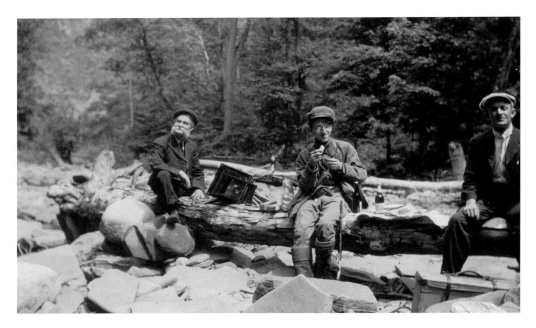

2.15. DuFlo (center) with camera in Adirondack forest. Date unknown. DuFlo-Brown Coll.

Sometimes tension arose between the two men because of the car. Frank did not want to use it for business, but William had no vehicle of his own. Mandeville received requests from customers to travel to photograph their homes, farms, or gardens or from people in nearby towns who wanted his services. In these situations Mandeville had to either arrange for patrons to provide the transportation, go by train, or hire a friend who owned a taxi. None of these was as desirable as using Frank's vehicle, but Frank resisted.

On the backs of some of the postcards there is a DuFlo logo, which he used when he operated his own studio, consisting of a palette with his name superimposed. William used a similar logo on stickers that he attached to business envelopes (illus. 2.16). On the last page of a family album, Mandeville penciled a self-portrait with the caption "artist." However, all these associations with "art" must be understood in the contexts of their small-town world and the history of photography. They referred to themselves as artists, but they were never linked to any fine-art movements of aspiring photographers in American urban centers. They had inherited their artist identities from their nineteenth-century predecessors who were fighting the commonly held notion that photographers were merely technicians (Battani 1997).

Mandeville's and DuFlo's artistic identities were not solely linked to photography. Both occasionally produced oil paintings of scenery, animals, and still lifes as a hobby. Although most were done on canvas or board, DuFlo decorated furniture with paint. Both also engaged in other decorative arts. Frank created stylized reverse glass paintings and used profile photographs to cut silhouette portraits from black paper that he mounted and framed (illus. 2.17). William did pencil sketches all of his adult life. Although Mandeville took drawing lessons as a youth, the artwork he produced gives

2.16. Mandeville logo, c. 1916. Davis Coll.

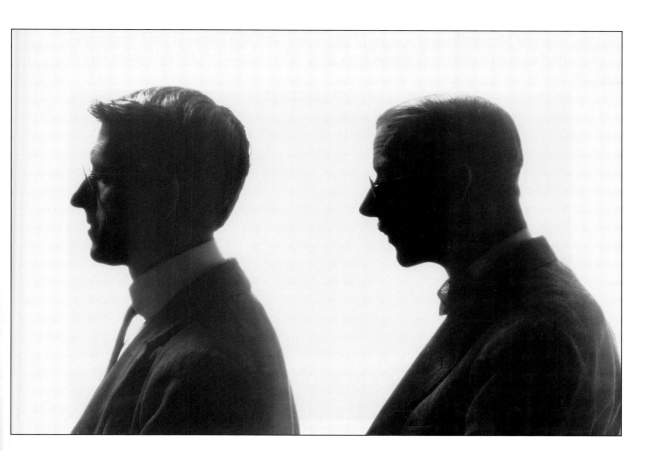

2.17. DuFlo and Mandeville silhouette photograph, c. 1927. DuFlo-Brown Coll.

views at the annual Lewis County Fair, an event that was held in conjunction with Lowville's Homecoming (illus. 2.21). There are pictures of the decorated automobiles and other parts of the parade, horse races, the grounds, and individual booths, including an image of "Ryan's Warm Taffy Stand," the same Ryan who owned the shop on Main Street (illus. 2.22). The yearly visit of the circus, army reserve troops arriving at Pine Camp (now Fort Drum) for summer training, Lowville Academy graduation, and Independence Day were all Mandeville's subjects.

Mandeville also documented one-time events, such as the grand opening of the Bijou Movie Theater (illus. 2.23). On February 28, 1917, sixty-five men built a makeshift tabernacle with a seating capacity of more than thirteen hundred in eight hours to provide a place to hear McCombe, a popular Irish evangelist, spread the gospel. William photographed the structure both inside and out (illus. 2.24).

Mandeville did not have a car, but he provided a comprehensive record of the coming of the automobile to Lowville. When Dayan Street was paved in October 1913, he was at the scene, photographing the road construction crew and their equipment (illus. 2.25, 2.26). L. C. Miner, probably one of the first automobile salespeople in the area, had his portrait taken by Mandeville as he sat demonstrating the "Metz Runabout" (illus. 2.27).

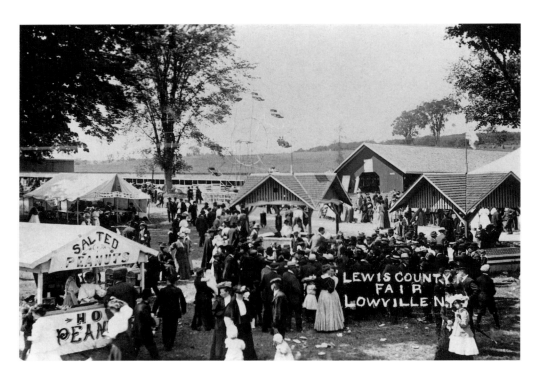

2.21. Lewis County Fair, c. 1914. Brown Coll.

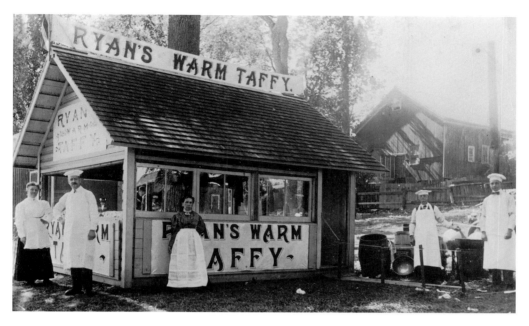

2.22. Ryan's Warm Taffy, c. 1911. Czerwinski Coll.

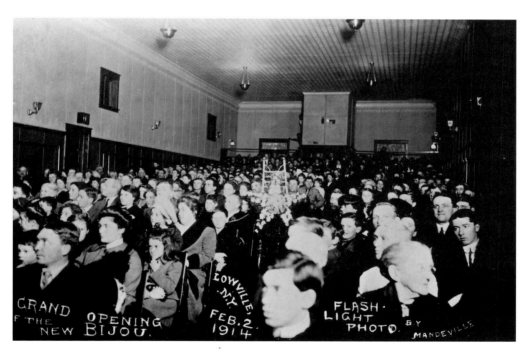

2.23. Grand opening of Bijou, 1914. Davis Coll.

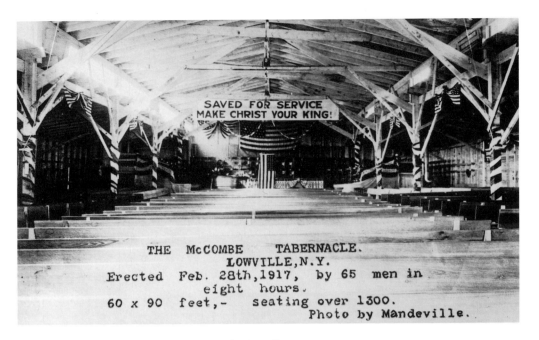

2.24. Inside McCombe tabernacle, 1917. Author's Coll.

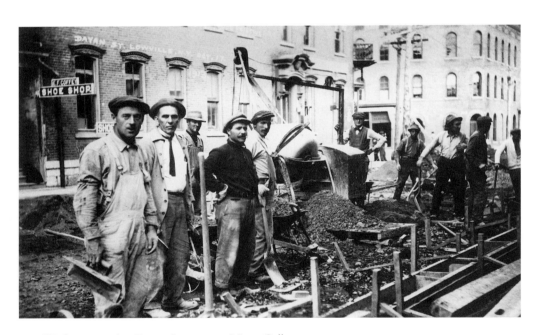

2.25. Work crew paving Dayan Street, 1913. Myers Coll.

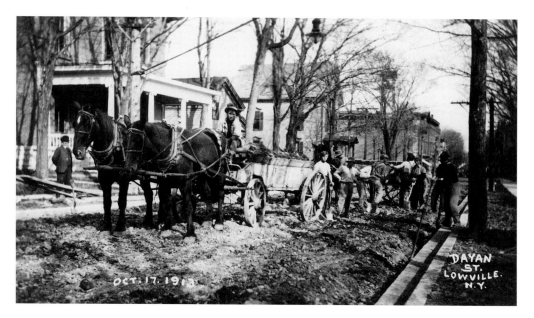

2.26. Team of horses and men paving Dayan Street, 1913. Myers Coll.

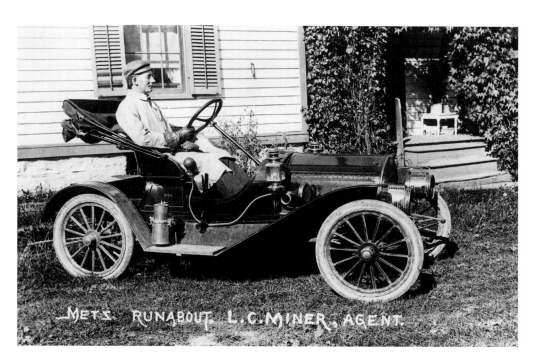

2.27. Metz Runabout. L. C. Miner, agent, c. 1913. Myers Coll.

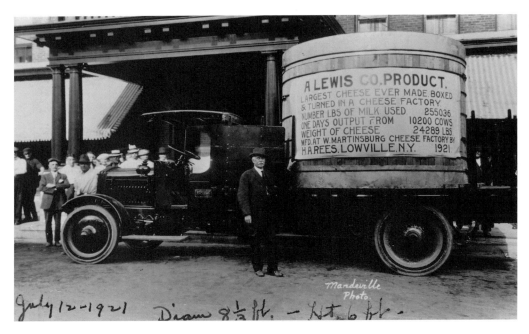

2.28. Giant cheese headed for the New York State Fair in Syracuse, 1921. Davis Coll.

Lewis County was known for its cheese factories. These establishments competed for bragging rights for "the largest cheese ever made." The huge cheeses were shipped to national expositions (such as the 1915 San Francisco Exposition) and state fairs, and Mandeville captured the candidates on photo cards (illus. 2.28).

Lowville is known for its snowstorms. Located in the path of "lake-effect" snow from Lake Ontario, the village could boast of some of the highest yearly snow accumulations in the nation. After each of the major storms in 1908, 1912, 1916, and 1924, Mandeville took to the streets to capture the snow piled high in Lowville (illus. 2.29).

Mandeville also photographed train wrecks and other disasters. Croghan, a small town a few miles north, is one location outside of Lowville where Mandeville regularly took photographic postcards. The two towns were connected by rail, and trains went back and forth twice a day. In April 1912, a fire swept down the main street of Croghan, burning more than forty buildings and killing two children. Firemen from Lowville fought the fire. Mandeville took a series of superb photo postcards of the devastation. In one, a man in an overcoat is on the left, looking at the camera. In the background people are sorting through the rubble. In the far distance, clouded by thin smoke, are the rescued buildings (illus. 2.30).

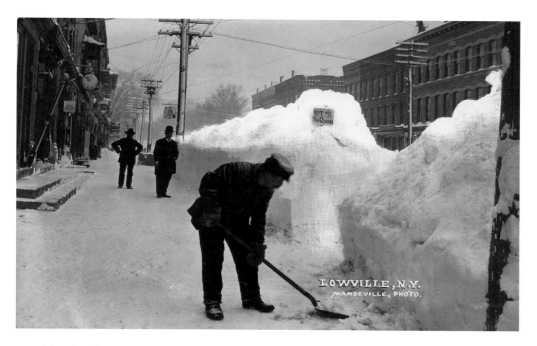

2.29. Man shoveling snow on State Street, c. 1912. Author's Coll.

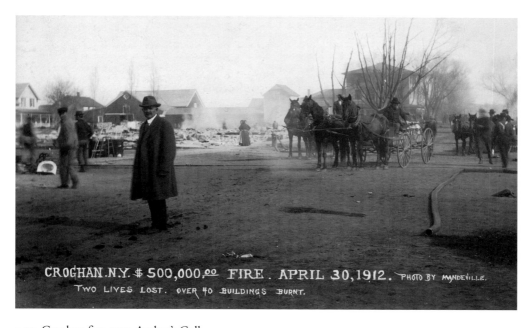

2.30. Croghan fire, 1912. Author's Coll.

There are group photo cards of the popular Lowville Band (illus. 2.31). Mandeville rounded out his portfolio with pictures of the Active Hose Company and its equipment, schoolchildren, hotel owners, the Lowville baseball team, churches, other town landmarks, and scenery outside of the town, especially along the Black and Beaver Rivers.

During the photo postcard era, George Carter, Mandeville's former employer, still took commercial photographs, some in photo postcard format. He died in 1928. There are also Lowville cards produced by a Lowville pharmacy owner, Shepard. Apparently, Shepard took photos as a hobby, but Mandeville printed some on postcard backs so he could sell them in his store. For years William had a barter relationship with an amateur photographer, Dr. Hunt, who was a dentist. In exchange for dental work, Mandeville printed Hunt's pictures and in other ways helped him with his hobby. The processing of other amateurs' film did not seem to be part of the business nor did selling photographic equipment or supplies. There were other shops in the village that handled Kodak and other brands of photographic merchandise. There were also other photographers who produced photo postcards, including E. A. Agens, J. J. Domser, Church, and Karl Lederle. Henry Beach, the subject of the next profile, also took and sold views of the village.

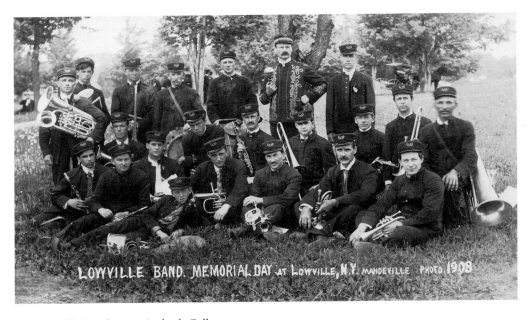

2.31. Lowville Band, 1908. Author's Coll.

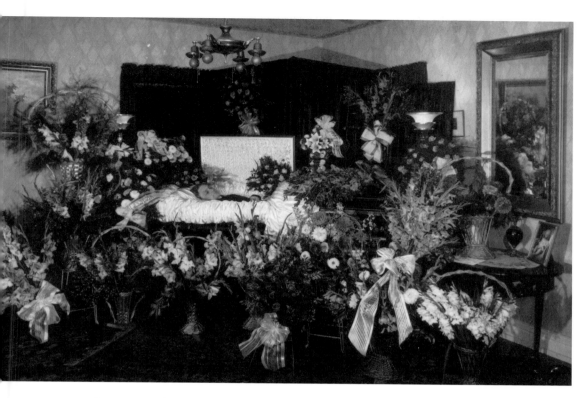

2.32. Postmortem photograph of Bertha Mandeville, 1938. Callahan Coll.

Toward the End

As reported in "Woman Found Dead in Bed" in the Lowville *Journal and Republican,* on the evening of September 6, 1938, at 6:15 P.M., when William Mandeville came home for dinner and entered the Dayan Street house he knew something was wrong. The table had not been set, and there was no smell of dinner cooking. He found Bertha dead on the davenport in the parlor, the victim, it turned out, of a heart attack. It was two years after they had marked their golden anniversary. As was the custom, her wake was held in the Mandeville home, and, as William had done on other such occasions, he photographed the deceased in the open casket (Burns 1990) (illus. 2.32).

After Bertha's death, William, with Frank's assistance, remained active in the business. In 1941, when he was in his late seventies, he still took the class pictures for the Lowville Academy. His photographic competence and ability to work began to fade. All his life he had been lucid and physically active. He became extremely forgetful and had difficulty getting around. Dorothy Mandeville, who had married and become a mother, moved home and watched over William and the house. In November 1944, Frank DuFlo was diagnosed with cancer and died weeks later.

After Frank's death, William went to the studio less frequently. In June 1946, unable to perform the craft he had loved and practiced with such skill for so many years,

3

Henry M. Beach
Remsen's Roaming Photographer

HENRY BEACH was the most prolific and one of the most talented and innovative of all Adirondack postcard photographers (illus. 3.1). Although he took more images in the Adirondacks than any other locale, his range was well beyond the North Woods. Photo postcards were his specialty, and his name is well known to collectors. In spite of his circumscribed fame, he is an elusive character who has never received official recognition.

Collectors and historians recognize "Beach" because it appears on so many postcard images, but it is rare to find anyone who knows anything about the man. He had a son, Harry, who was also a photographer, and people often mistake the two. Local historians and even professional archivists and academics frequently confuse Henry's work with Harry's (Mackintosh 1996; Terrie 1997). More often, writers use Henry's postcard images as illustrations without identifying who took them (Bowen 1970; Brandon 1986; Schneider 1997, 267).[1]

There are legitimate reasons for this confusion. For instance, Henry's and Harry's first and middle initials are the same, and when Henry put his name on his pictures he used "H. M. Beach."[2] Not knowing that Henry existed or that he had a son with the same initials, folks assume that the "H" stands for Harry. Some, knowing of Henry, think he used "Harry" as a nickname and therefore interchange the two names at will. To add to the bafflement, Harry probably printed some of Henry's negatives on postcard stock before and after his father died.

There are other explanations for the tangle and for the lack of information on Henry Beach. He had four children, all of whom died without leaving an account of Henry's story. Two of his children had heirs, but they were too young when their grandfather died to remember him. During his middle years, Henry lived a rather nomadic life, and in his later years he lived in a relatively isolated rural community. He was a reserved man, not a public figure, so aside from some immediate neighbors, not many people knew him. Because he died in the early 1940s, there are few people alive who can pro-

1. Many, if not most, of the photographs illustrating the logging exhibit at the Adirondack Museum are by Beach, but they are not attributed to him in the captions.

2. I was not able to determine what "M" stands for.

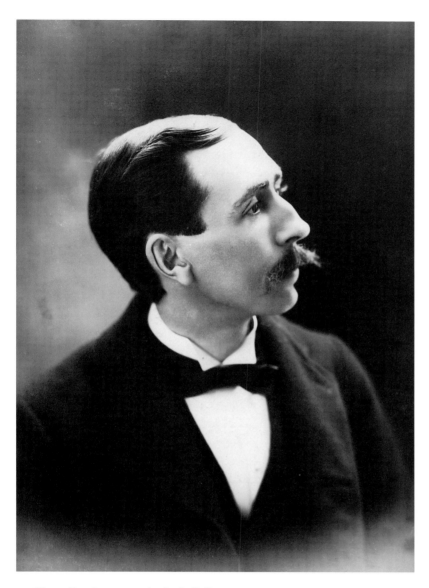

3.1. Henry Beach, c. 1900. Author's Coll.

vide first-person accounts. Finally, no one was interested enough in Henry to do the bi-ographical work when more sources were available. Thus, the published and unpub-lished material about him is limited (Light Work 1983).

There are many legitimate reasons for not giving Beach credit for his work and leav-ing his life undocumented. But people do not bother providing attribution even when his name is clearly printed on the backs of his photographs. This unfortunate practice applies to the reproduction of many images of photo postcard photographers, rein-forcing their marginal status in the history of the Adirondacks as well as in the history of photography.

Watson and the Beach Family Line

There is confusion about where Henry Beach was born and where he carried out his work. Although Remsen, New York, is printed on the backs of most of his cards, he spent much of his life in the township of Watson.

Watson straddles the Blue Line on the western extreme of the Adirondack Park. Most of its land lies within the park, but the site of Beach's home was three miles outside of what is now the boundary. Farmers and lumbermen first settled the region at the beginning of the nineteenth century. The development of the territory, and neighboring Lowville, was enhanced by the construction of the Black River Canal that stretched from Carthage to Boonville and south to the Erie Canal. Agricultural goods produced on the cleared, cultivated land and lumber products taken from the nearby forests were shipped to market via the waterway (Landon 1932).

The Watson landscape is dotted with references to Henry's relatives. There is Beach's Landing (misnamed on many maps as Bushes Landing), Beach's Bridge, Beach's Cemetery, and Beach Mill Pond. The Beaches were among the first settlers. Some farmed, but their contribution to the area and profits came largely from the development of commerce on the Black River Canal and from the lumber industry. Nelson J. Beach, a relative, served in the New York State Assembly and from 1847 to 1851 was a canal commissioner and supervised its construction on the Black River. One of Henry's uncles owned and logged large timber holdings on the Adirondack side of Watson. Henry's cousin Andrew J. Beach was in the lumber business nearly all of his life and owned Beach's Mill. The Beaches were among the best-known barge builders in the area, and they used the vessels they built to ship the lumber they produced at their mills to the markets in Rome, Utica, Troy, and Albany (Bowen 1970).

Henry M. Beach's family lineage has been traced to 1635, fifteen years after the *Mayflower* arrived, when the Beaches came from England and settled in what is now Connecticut (Beach 1923). Henry's grandfather Ralph Beach was one of the early settlers of Watson. He prospered, eventually farming fifty acres, owning and managing three thousand acres of timber in addition to a saw and shingle mill (Hough 1883, xxix). When he was in his nineties, he was still physically powerful and could read without glasses. A great part of his life was spent in the Adirondack woods in the lumbering industry.

Ralph's second son, George Nelson Beach, was Henry's father. He was also a lumberman and a farmer. Henry's mother was Esther E. Hall Beach. George and Esther married in Watson in 1855.

Henry was born on August 10, 1863, in Watson in the vicinity of Chase's Lake Road, not far from Lowville.[3] Henry's older sister drowned when she was twenty and he was

3. The 1900 census states he was born in 1863, as does his gravestone. The family genealogy gives his year of birth as 1862 (Beach 1923). His January 7, 1943, obituary in the Lowville *Journal and Republican* states that he was eighty at the time of his death. Actually, he was seventy-nine, approaching his eightieth birthday. The Beach family occupied three different houses on Chase's Lake Road at various times.

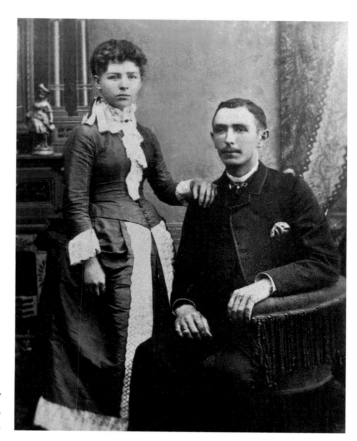

3.2. Bertha and Henry
Beach, wedding picture,
1886. Bailey Coll.

seventeen. He had another sister who was four years younger and a brother who was sixteen years younger.[4]

Henry's childhood was spent in Watson, surrounded by family. He attended school until he was sixteen, helping his family by working on their farm, on the canal, and in the woods. He hunted and fished around Chase's Lake, which was a short distance from where he lived. Although later in life he gave up hunting, he continued to be an avid trout fisherman.

On September 4, 1886, at age twenty-three, Henry married Bertha W. Brown, the adopted daughter of B. F. Brown.[5] The wedding was held in Philadelphia, New York, her hometown, thirty miles north of Watson (illus. 3.2). Bertha was five years younger than Henry. The couple had four children. The first, Harry, was born in 1889. The succeeding children—Wellington, Welta, and Lyle—were born approximately five years apart (illus. 3.3).

4. Cora, Henry's sister, married, had a son, and was widowed early. She lived in Lowville most of her adult life. Louis became a contractor and builder in Eagle Bay near Inlet, New York.

5. The family genealogy gives September 4, 1887, as the date of their marriage. The party invitation for their fiftieth anniversary gives 1886 as the year.

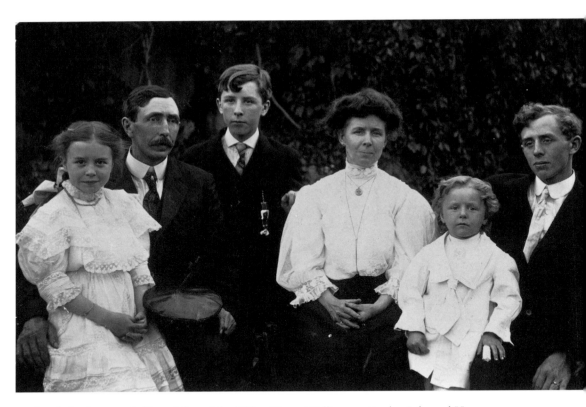

3.3. Beach family portrait. From left to right: Welta, Henry, Wellington, Bertha, Lyle, and Harry, c. 1907. Bailey Coll.

Henry and Bertha

Henry was more than six feet tall and slender, a gangly figure with a long, narrow face and a slim nose. His ears stuck out from the sides of his head like small angel wings. In Bertha and Henry's marriage photograph Henry sported a trace of a mustache. In a few years it grew thick, dark, and long—a defining feature that dominated his profile. Like his grandfather, he never wore glasses, and even toward the end of his life he read without difficulty.

When engaged in his business, Beach wore suits, ties, and stiff-collared shirts. Around the homestead he loosened his tie, took off his formal jacket, and generally dressed more casually, but never outfitted himself in farmers' or woodsmen's clothes. He smoked a pipe and read with exuberance, a passion Bertha and Harry shared. Although not normally prone to idle talk, Henry liked to discuss exploration and the wonders of the non-Western world. Later in life, he drew upon his love for *National Geographic,* often discussing lands far beyond the reaches of Watson.

Beach attended church socials but was subdued in groups, a better listener than a talker. People who knew him describe him as "a real individual." When pressed to elaborate, they characterize him as opinionated and not easily persuaded to see others' view-

points. He also did what he liked in spite of what others thought. People mention that he was "real smart" and always inventing something. They also say he was intense and focused when doing his photography.

Knowing that Beach's photographic output was enormous, we can only imagine the hard, long hours he worked at his trade. But in the world of rural men who made their living by physical labor, in the woods with an ax and on the farm with the plow, Henry was cast by some as effete. One person said disparagingly that he was a typical Englishman. (The English are still thought of as dandies in the rural northeastern United States.) Others said that he never really worked. Although it may not have been apparent or acknowledged to his male neighbors, Beach had an enterprising attitude toward his calling and was aggressive in pursuit of his photographic business.

Part of Beach's reputation for not being a hard worker may have resulted because he did not take well to physical labor. He did not do chores around the house or other things that involved muscle and sweat, such as chopping wood. Much of the work fell on Bertha's shoulders or to a hired hand. Although Bertha ran the house, Henry fostered the impression that he was the boss.

Beach liked to travel. This inclination did not transpose into long and exotic *National Geographic* kinds of adventures, but rather was customarily confined to frequent sojourns around northern and western New York State where he took pictures. In the early years, his transport was either a horse and buggy or a train. Sometime after 1912, he owned automobiles, and cars became his conveyance of choice. He domesticated his travel lust into a business. In addition to his New York travel, he occasionally visited other states, taking pictures and visiting his son Harry in Colorado and Florida. These treks are not well documented.

When Henry was on his frequent excursions, Bertha stayed home and took care of the household and the children. Occasionally, he left home without notice and was gone for weeks, even months, at a time. As a neighbor explained, "When Henry got it into his mind to go some place, he just went." Bertha never traveled with him while the children were still at home.

Bertha Beach was about five-feet-three-inches tall and close to average build. She wore her hair long, well kept, and on the top of her head with fluffy curls in the front (illus. 3.4). In her youth, her locks were dark brown, but they grayed with age. She always wore aprons over a plain cotton dress around the house but had dressier outfits for special occasions. She kept a neat and clean appearance. A bubbly personality, she had much energy and a positive attitude. She is remembered as kind and warm to family and friends. After her own children moved from the area, she served as a surrogate mother to the neighbors' children. The few that are still living remember her with much tenderness.

Bertha is described as "one of a kind" and "quite a gal." Her granddaughter recalls a visit to the Beach home when she was a teenager. She and friends were attempting cartwheels on the lawn in back of the house when Bertha appeared by the screen door. She declared that she would show them how and proceeded to do a skirt-flying, head-over-heels maneuver that amazed the spectators. She was a spry eighty-five at the time. One of Bertha's ankles was slightly larger than the other, causing her to have a pro-

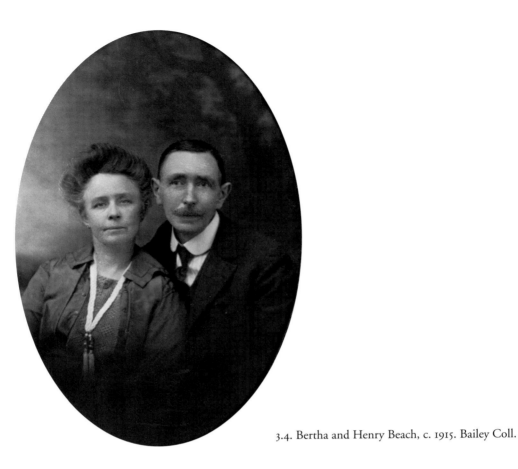

3.4. Bertha and Henry Beach, c. 1915. Bailey Coll.

nounced limp later in life, but that did not slow her down. She died twelve years after Henry.

There were fourteen years between the birth of the first and the last Beach child, so Bertha had more than twenty-five years of child rearing before the last reached puberty. Always busy, she had an extensive garden and raised turkeys, chickens, rabbits, and geese. She canned enough fruits and vegetables to feed the family through the winter. She, along with her own and the neighbors' children, harvested the berries around their Chase's Lake Road farm to make jam. Water was drawn from the well in the front of the house, but it was often dry in the summer months, necessitating trips to a spring down the road. Bertha was a good cook and prepared all the meals for the family and their frequent guests.

Bertha never complained, and was not easily provoked to anger. She was sociable with the other women in the area and was a member of the Watson Friendship Club, a church group that cooked communal suppers in the Pinegrove church kitchen. She was a member of the women's auxiliary and held meetings at the house. Henry was indifferent to church, but Bertha went to the Methodist church regularly. Although neither Bertha nor Henry was a prohibitionist, they did not drink.

Beach's Early Years as a Photographer

There were a number of photographers operating in the Lowville area when Beach was growing up. George Carter, William Mandeville's boss, was the most experienced and was likely Beach's mentor. I could not find a connection between the two men or between Henry and any other photographer.

A few late-nineteenth-century and 1902 photographs in private collections have "L. E. Beach, Lowville, N.Y." printed on them. That photographer was likely Henry's younger brother, Louis. The logo on L. E. Beach's work is similar to Henry's, and both men marked their work "Beach's Studio," not giving their initials (illus. 3.5). The two Beaches might have been in business together. A picture taken about 1894 shows a photography studio in Lowville (illus. 3.6). "Beach" appears on the display case in the front of the shop. The building was small, one story (about twelve-by-twenty-five feet), with a skylight. As it had no foundation, it was either a portable building or constructed

3.5. Early Beach logo, c. 1889. Author's Coll.

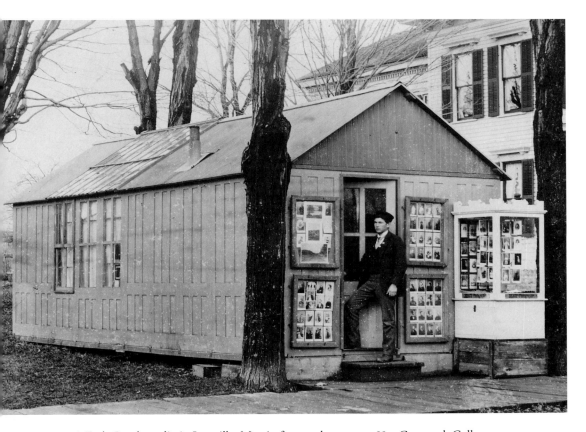

3.6. Early Beach studio in Lowville. Man in front unknown, c. 1889. Comstock Coll.

for temporary use. Whether this building was Henry Beach's or L. E. Beach's or jointly owned is unknown. The young man in front of the building is not Henry, but there is a good possibility that it is Louis. If "L. E." was Henry's brother, he did not remain a photographer for long, for Louis became a contractor in Eagle Bay.

There are pictures with Henry's name on them dating back to the 1880s. Most are portraits. Although studio work was probably his mainstay, he also took many outdoor pictures in his early career. Particularly notable are his early photographs of lumber camps.

Henry started his career as a photographer in Lowville about the same time that Mandeville moved to town. The two men were approximately the same age, worked in the same community, and engaged in the same craft. In spite of these overlaps, there is no evidence that they worked together, were friends, or had any kind of a relationship.

Apparently, Henry and his nuclear family moved from the family homestead in Watson to Lowville in the early part of his career. On June 4, 1900, when the Census Bureau enumerator came to the Beach home, Henry and Bertha and three children, ages one through eleven, were living in a rented house on Rail Road Street in town (illus. 3.7). Soon afterward, they bought a house on Pineland Grove Road, in Watson. Lyle, their last child, was born there.

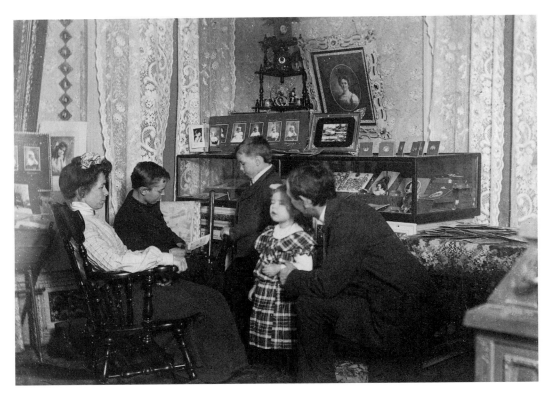

3.7. Beach family. From left to right: Bertha, Harry, Wellington, Welta, and Henry, c. 1901. Comstock Coll.

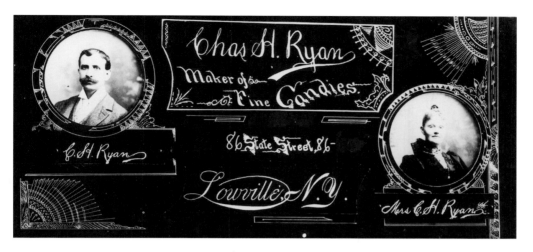

3.8. "Chas. H. Ryan, Maker of Fine Candies." Advertising card produced for Ryan of Lowville, c. 1904. Adirondack Museum.

Beach started off as a studio photographer but was restless in the confines of that role. He began producing photo postcards by 1904. Rather than catering only to walk-in traffic, he courted local business and church leaders, selling them multiple copies of photographic advertising cards with their names and likenesses on them (illus. 3.8).

During the first decade of the century, competition among photographers in Lowville must have been considerable, with George Carter, Frank DuFlo, and William Mandeville all active. Whether this was a factor in Beach's departure is not known. Given his assertive, entrepreneurial spirit and inclination to travel, it is more likely that he moved because he wanted to be in a place with easier access to the tourist market in the central Adirondacks and the urban clientele in the more densely populated Mohawk Valley. He had postcards on his mind.

Remsen

Around 1906, when Henry was forty-three years old, he closed his studio in Watson and he and his family moved thirty-five miles and three stops southeast on the railroad to Remsen. There he started out anew with photo postcards as his major product. Printed on the address side of most Beach photographic postcards is the notation that they were made in Remsen (illus. 3.9).[6] Henry lived and operated his photographic business for approximately ten years, his most prolific postcard years, in this village on the

6. "Stamp Here, Made at Remsen, N.Y." appears in the upper right corner of the address side of his earlier Remsen cards. In approximately 1912 "Stamp Here One Cent" was printed in the upper right corner, and "Made from Any Photo at Remsen N.Y." was placed in the upper left corner. The heading "Beach Series, Post Card, Genuine Hand-Finished Photograph" can be found on both his early and his later Remsen postcards. The heading "Beach's Real Photograph Post Card, Genuine Hand-Finished" appears on his later Remsen work. Although most of his work includes his imprint on the address side, there are many examples of Beach's work printed on plain postcard stock.

BEACH'S REAL PHOTOGRAPH
POST CARD
GENUINE HAND-FINISHED

MADE FROM
ANY PHOTO
AT REMSEN
N. Y.

STAMP
HERE
ONE
CENT

MESSAGE

B
E
A
C
H
Q
U
A
L
I
T
Y

ADDRESS

3.9. Back of Beach postcard, c. 1914. Author's Coll.

southwestern edge of the Adirondack Park, north of Utica. It is not known where the family lived or where Beach had his office and photo production facilities in the early Remsen years. In 1910, when a Census Bureau enumerator made his rounds of Remsen, the Beaches were living at 71 Maple Avenue. On April 30, 1914, the Beaches bought a home next to the New York Central, Adirondack Division (formerly the Adirondack and St. Lawrence), rail line near Maple Avenue.[7]

At the time Beach moved from Watson, Remsen was a small but thriving business and transportation center (Kudish 1996, 390). Trains coming from four directions used the busy Remsen railroad station. There were small factories and storage facilities for milk products, including a large Dairylea Creamery. By the time the Beaches arrived, the railroad that lined Henry's property was the preferred route to reach the central Adirondacks.[8] Although the year is unknown, Beach bought his first automobile while living in Remsen. His car provided the mobility to photograph the wide geographic area he covered during his Remsen years, but many of the locations he photographed were conveniently accessible by rail, suggesting that he might have also used the train.

Beach struck the pose of an artist-gentleman photographer in the portraits of himself that he used in his advertising (illus. 3.10). He also included drawings on his cards and in other ways included nonphotographic elements in his photographs.[9] Nonethe-

7. The transfer of property was in Bertha's name.
8. The Adirondack and St. Lawrence Railroad was the only railroad that actually went through the mountains. It opened in 1892.
9. He might have done some drawing on his cards. One source claimed he had seen oil paintings by Henry.

3.10. Henry Beach advertising card, c. 1907. Adirondack Museum.

less, Henry appears to have considered himself more as an entrepreneur and inventor than as an artist. He used the word *factory* to refer to his postcard operation in Remsen. When the enumerator from the census visited in 1910, Henry's occupation was given as traveling photographer.

At the height of his photographic production, Beach's workshop in Remsen must have been large, considering the number of cards available today on the antique postcard market. Henry had assistants (Light Work 1983), but there is no information on how many. Mr. Thomas was a Remsen photographer who was said to have worked for Beach as a supervisor. Jud Davis, another Remsen resident, also claimed to have worked for him. Henry's children helped out as well, which is how his two sons learned the photography trade and went on to become commercial photographers. Henry certainly did not personally click the shutter for every photo produced by the Beach Studio, nor did he do all the developing and printing himself. But he must have been involved in most of the work, given the uniformity of style and consistent quality of the products (Light Work 1983). It is not clear whether all the prints that Beach made were done by hand or with the aid of the printing machines that became available around 1912.

Examples of Beach's Work

Beach was so productive and his photo postcards cover such a broad range of topics and divisions of the North Woods and elsewhere during his Remsen years that it is difficult to choose illustrations that inclusively typify his work. His images are technically good—well focused and properly exposed. What is striking is their down-to-earth

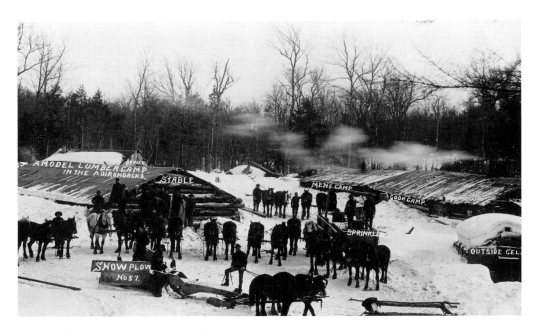

3.24. Lumber camp, c. 1913. Davis Coll.

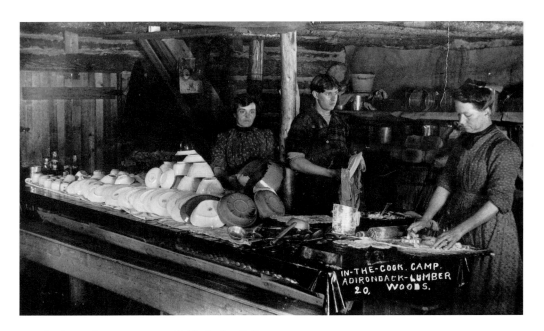

3.25. In the cook camp, c. 1910. Beiderbecke Coll.

Henry Beach's relatives were lumbermen. Although he abandoned that trade early in his life, he was at home in the forest and often pointed his camera toward North Woods loggers. All aspects of logging were captured in his prints. On one postcard, men and horses pose with the snowplow and sprinkler rig in the center of what Beach captions "A Model Lumber Camp in the Adirondacks" (illus. 3.24). In a rare picture of a camp kitchen, we see women baking (illus. 3.25). Another interior view reveals the dining room setup in the lumber camp with part of the caption pointing out that "fifteen seconds after the call every place is occupied and everybody is busy" (illus. 3.26). The last example of a view of a lumber-camp interior is of the sleeping quarters. Captioned "An Up to Date Sleeping Camp," the accommodations appear roomy (illus. 3.27).

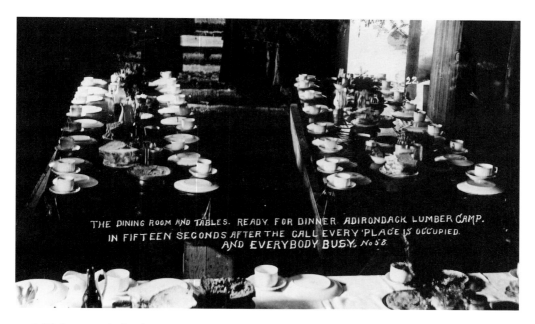

3.26. Dining room in lumber camp, c. 1909. Beiderbecke Coll.

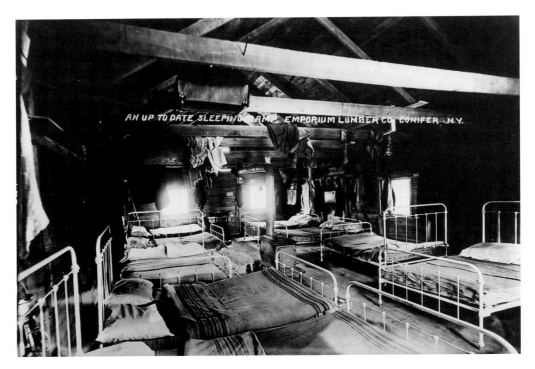

3.27. An up-to-date sleeping camp, Emporium Lumber Company, Conifer, N.Y.,
c. 1911. Adirondack Museum.

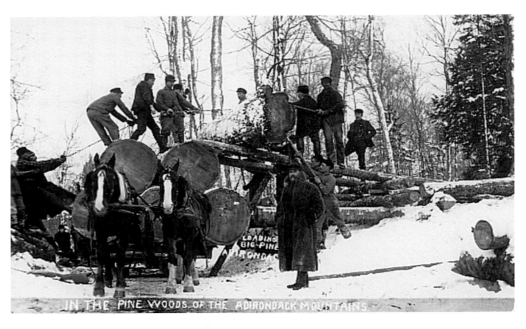

3.28. Loading big pine, c. 1913. Author's Coll.

Beach took clear, vivid shots of such procedures as using a skidway to load the big timber onto a horse-drawn sled, or bobsled (illus. 3.28). In another shot, Henry provides a front view of a horse-drawn sled with a tremendous load of thirteen-foot logs with a driver sitting on top and two men posing alongside (illus. 3.29). Henry took pictures of the banking grounds where the logs waited on the frozen surface of the headwater until the spring flood provided the water to start their passage downstream to the mill (illus. 3.30). Other pictures include logjams (illus. 3.31), the mill at Newton Falls (illus. 3.32), the interior of the mill at Childwold (illus. 3.33), and the Newton Falls Paper Company store (illus. 3.34).

Beach did not take all his logging pictures in one season, and, although his images of the enterprise appear to be taken chiefly in the western Adirondacks, not all were of the same company or crew. As a result, the body of his work on this important Adirondack occupation is scattered among different collectors who specialize in various Adirondack locations as well as assorted archives. With the exception of my attempt to pull together examples of Beach's logging photographs, no one has attempted to assemble his substantial documentation of this important aspect of Adirondack life. If this were ever done, I am confident Henry's work would emerge as one of the most important photographic documentaries ever produced of early-twentieth-century North Woods lumbering.

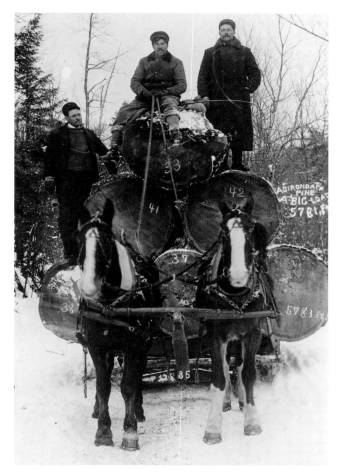

3.29. A big load of timber, c. 1914. Davis Coll.

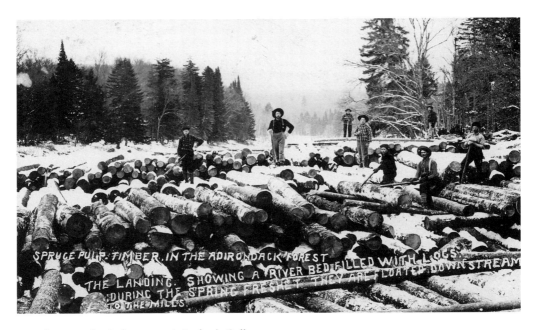

3.30. Spruce pulp timber, c. 1916. Author's Coll.

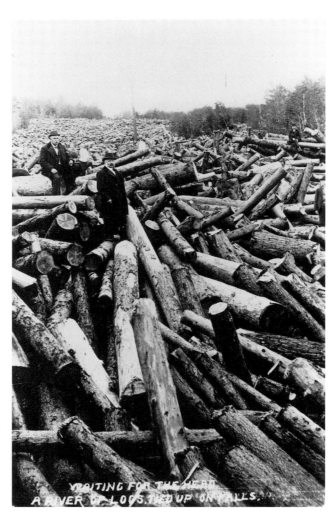

3.31. Waiting for the head. A
river of logs tied up on the
falls, c. 1914. Davis Coll.

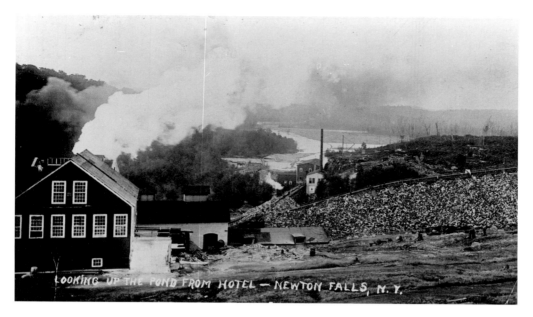

3.32. Looking up the pond from hotel, Newton Falls, c. 1910. Beiderbecke Coll.

3.33. Emporium Company, Childwold, N.Y., c. 1910. Beiderbecke Coll.

4

William Kollecker
Saranac Lake's Kodak Man

IT IS DIFFICULT TO IMAGINE that the healthy, smiling, strapping, well-dressed William Kollecker who appears in Saranac Lake photographs from the 1920s was once an impoverished, emaciated teenager living in a Brooklyn tenement (illus. 4.1). Like the history of Saranac Lake, the life of Kollecker is closely linked to tuberculosis (TB) (Gallos 1985; Taylor 1986; Caldwell 1988; Rothman 1994). Consumption, as pulmonary tuberculosis was called in the nineteenth century, was the leading cause of death in the United States well into the twentieth century. The term *consumption* captures the frightful portrayal people had of the disease: wasted bodies with the appearance of being consumed from the inside out. During the late nineteenth century, the mystique of the Adirondacks as tranquil therapy for the human spirit was adapted to include a treatment for infected lungs. People believed that the pure, fresh balsamic air found in the North Woods (Yepsen 1990, 50) added a special element to the customary prescription of rest, mild recreation, and plenty of plain food. That belief is what brought Kollecker there.

If it were not for Dr. Edward Livingston Trudeau, Saranac Lake would never have become the mecca for cure seekers. Having experienced firsthand the curative powers of the North Woods, he established the first cottages in the area and went on to be the central figure in the development of Saranac Lake as a cure center. His son and grandson continued in his footsteps.

The patients came mainly from eastern urban centers, most commonly New York City. TB had become a disease of the urban immigrant poor living in tenements. Many people who came to Saranac Lake roughly fit that description, but wealthy people and celebrities were drawn there as well (Caldwell 1993). In addition, the town recruited medical personnel and other professionals. People from surrounding communities were lured to the town because of the robust economy. The mixture of newcomers and locals created a unique social environment (Caldwell 1988).

Friends, neighbors, and even family often shunned people with tuberculosis. But in Saranac Lake they were not stigmatized or ostracized; they were accepted and included in the community (Caldwell 1988). Further, although many North Woods locations had distinct divisions between the locals and the outsiders, the unusual situation created by the influx of the sick and their caretakers somewhat altered that pattern. Although Saranac Lake was an isolated northern town, its residents were diverse and its aura cos-

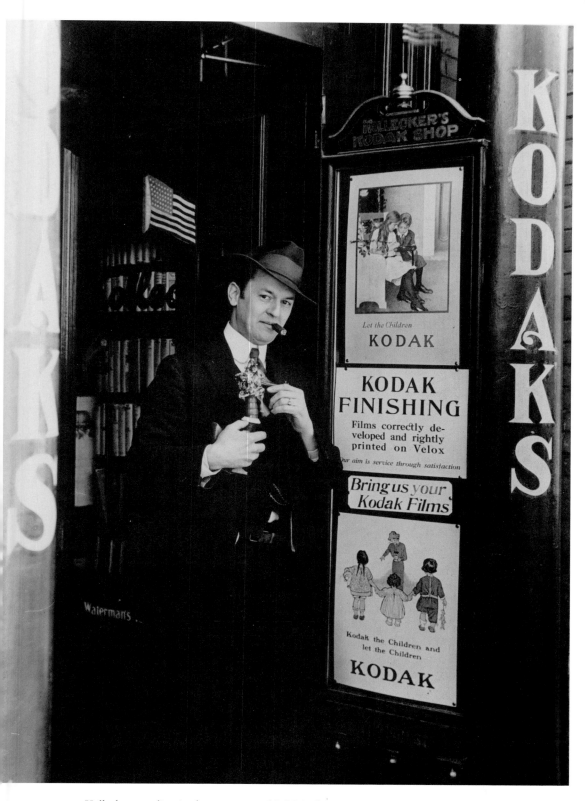

4.1. Kollecker standing in the entrance to his Main Street store, c. 1920. Saranac Lake Free Lib.

mopolitan.[1] It became, and still is, the most populous town with the most urban milieu in the Adirondack Park.

Ironically, the years of the pestilence were good years for Kollecker as well as for Saranac Lake. Although Saranac Lake was not the only site to go for the treatment, no location had such a concentration of care facilities, had achieved such an international reputation, or had such a large influx of strangers. Saranac Lake's status as a cure center, or "health resort," as Saranac Lakers preferred to call it, affected every aspect of the town. A wilderness outpost in the 1880s with a population of a few hundred, by 1930 it was a bustling municipality of more than eight thousand (Caldwell 1988). (In 1999 its population was approximately fifty-four hundred.) Businesses prospered, and in spite of the high death rate and the presence of so many sick people, the spirit in the town, on the surface at least, remained high.

If the beauty of a landscape could cure, Saranac Lake would have been an even more desirable destination for TB refugees. Built on hills, the village is surrounded by clear lakes and striking views of the mountains.[2] It is one of the most scenic areas in the North Country (illus. 4.2). Some people said that the beauty of the land did help in the curative process, or at least it provided uplifting surroundings for people whose situation in life had taken a decided turn for the worse. This may have been true in the summers, but the beautiful natural surroundings also provided severe winters in which temperatures dropped to forty below zero. The frigid climate, combined with short days and long nights and an abundance of cloudy weather, provided an invitation to melancholy.

Kollecker contracted the deadly TB and went to Saranac Lake in search of help. In time his health improved, but he did not move home. As the town prospered, so did he. He became an accepted member of the community, contributing to it as a shopkeeper, citizen, and photographer. Some permanent residents of Saranac Lake, Kollecker included, had been cured, others were caretakers, and still others were just townspeople. He was befriended, reached out to others, and went about his life taking pictures. He documented the life in this unusual community where locals and the relocated lived side by side in a relationship that was as complex as it was interesting. He died at the age of eighty-three, well after the white plague had passed and the town had seen more prosperous days.

Self-discipline and concern with details were part of Kollecker's character. My writing of his biography is easier because he kept a detailed diary, beginning with his arrival in Saranac Lake. A few of the volumes survived, and they helped me construct his early years in the North Country.[3]

1. Although there was some integration in the large sanatoriums, there were separate cure cottages for Greeks, African Americans, Latinos, and Jews. Other ethnic groups either tended to be segregated or chose to live separately. There were also special facilities for particular occupational groups, such as members of the entertainment industry, and two large cottages for Endicott-Johnson employees as well as Stonywold, a facility for young working women.

2. It is situated on the banks of the Saranac River and the shore of Lake Flower and surrounded by lofty mountains ranging in height from two to five thousand feet.

3. They are in the Adirondack Museum archives at Blue Mountain Lake.

4.2. Kollecker photographing Saranac Lake village, c. 1920. Saranac Lake Free Lib.

The Boy from Brooklyn

William F. Kollecker was born in Brooklyn on April 15, 1879, to struggling German immigrant parents, Auguste and Edward. He was the youngest of four. He had a brother, Edward Jr., and two sisters, Gussie and Ida. His mother died at age forty-two, five days after William's birth. The announcement of her death and funeral appeared in a New York City German-language newspaper, a copy of which Kollecker kept all his life tucked away in his Bible.[4] William grew up in the tenements of Brooklyn on St. Marks Place, not far from Manhattan. It was an area where death from tuberculosis was common. His brother died in 1893, when William was just fourteen, probably from the disease.[5]

4. Kollecker's Bible is in the William F. Kollecker and Hannah Clark Collection at the Adirondack Museum in Blue Mountain Lake.

5. Kollecker's Bible contains a page in the back where he listed the dates of the deaths of his brother, Edward, Jr., and his sister, Augusta. The date of Edward's death is given as February 3, 1893. The Saranac Lake Free Library Kollecker Collection includes a cabinet card photograph of a man. "To Brother William from Edward," dated May 1899, is handwritten on the back of it. I assume that 1893 was the correct year of his brother's death because William never refers to Edward in his diary.

In his midteens, Kollecker began work as a messenger boy for a Wall Street broker-age house. He was reliable, efficient, polite, intelligent, and headed for promotion. Al-though it sounds like the beginning of a Horatio Alger story, William's life did not work out that way, at least not while he was in New York. He was sixteen when he began to feel weak and tired. His weight dropped, and a chronic cough developed, along with aches and pains in various parts of his body. A doctor confirmed William's fear: he had consumption.

By the mid-1890s, the word had spread in New York City, especially in the German community, that the hope for victims of the dreaded disease lay in the Adirondack wild-ness. In addition to the mountain air, Dr. Edward Livingston Trudeau had instituted a regime of care at Saranac Lake that he had adapted from a popular German cure (Teller 1988). In his sanatorium, and in cure cottages that surrounded it, the disease could be curtailed. William's doctor told him that there was hope for him in the North Woods.

Neither Kollecker nor his family had the money for the trip or the treatment. Whether he was a friend of his father or William's employer is unclear, but William found a sponsor: Mr. Bottome agreed to support him. Although the cost of room and board and treatment was too great for a poor person, the rates were reasonable. Pro-fessionals worked for wages below the going rate, which also accounted for low fees. Space in private cure cottages was available at a range of prices (Trudeau 1951). People such as young Kollecker were not turned away when they came seeking help, especially if they came with some financial backing, even if the amount was modest. The wealthy subsidized Trudeau's sanatorium through donations, including its outpatient services.

Early Years in Saranac Lake

In the early morning of January 21, 1896, sixteen-year-old William Kollecker went to Grand Central Depot to board the New York Central train to Saranac Lake. (Train serv-ice to Saranac Lake was established in 1887 [Kudish 1996].) His father had helped him pack his trunk the night before. In addition to two sets of underwear and socks and the other basics, he had a small rifle that had been given to him as a gift to use in the North Woods.[6] He had only the vaguest notion of where he was going and what he might find. Having lived in the big city all of his life, he must have been apprehensive, if not in-tensely scared. He was five feet, nine inches tall. He got on the penny scale at the sta-tion and weighed himself: 111 pounds. His sister Gussie, who was twenty-three at the time, waved to him as the train pulled out of the station. He would never see her again; she died the next year.

Kollecker headed north along the Hudson to Albany, then west to Utica, and into the mountains, where William disembarked at Lake Clear Junction to catch another train to Lower Saranac Lake (Kudish 1996).[7] He arrived after the sun had set. The snow

6. William did not mention the rifle in his diary, but he described a gun case and ammunition. When he got to Saranac Lake, he had a gun that he used for target shooting. Because he does not men-tion buying the gun I am assuming he brought it with him.

7. Kollecker referred to Lake Clear Junction as "Clear Junction" in his diary.

was piled high along the sidewalks and buildings, and the roads were packed with the squeaky white covering. Livery drivers lined up their sleighs at the station to transport passengers to their destinations. The Reverend Mr. Parsons from a Saranac Lake Church was there to greet William and take him to Mrs. Lobdell's cure cottage on one of the hills overlooking the town.[8] Exhausted from the trip, he went to bed at eight o'clock. He was up at seven the next morning, greeted with a breakfast of pancakes, eggs, milk, coffee, oatmeal, and potatoes. Later that afternoon, the reverend took him by sleigh to Lake Flower to watch the skating races. He was so thankful for Parsons's help that he dedicated the first volume of his diary to him. He settled into the treatment as an ambulatory patient: lots of rest, including "sitting out" (sitting or lying outdoors in the fresh subfreezing air in reclining chairs, covered with blankets), and large amounts of plain food and modest activity (target shooting and snow-house building).

Kollecker responded well to the treatment. After a short time, he was out and about town on his own, watching skating races on the lake; visiting stores, the post office, and the sawmill; joining the public library; and even hiking and hunting for small birds with a friend.

In March a doctor told Kollecker he was doing well and to take plenty of cod-liver oil and stay at Saranac Lake on the treatment at least through the summer.[9] Although the timing of his moves is unclear, he stayed at another cure cottage in the village and then transferred to Fletcher Farm near Vermontville, just six miles north of Saranac Lake. It was a cure facility, but he was not just a patient: he also worked for room and board. He continued to regain his strength and gain weight. In 1898, he was still living in the area, working as a bellhop at the Loon Lake Hotel.[10]

It was around this time that Kollecker began taking photographs. Later he constructed a photo album of the pictures he took, intermittently documenting his life from 1898 to 1904.[11] In the front of the album there is a picture of young William in his room at Loon Lake, standing, looking straight at the camera with an artist's easel in hand.

Lake Placid

By 1901, Kollecker was twenty-two and living in Lake Placid, eight miles east of Saranac Lake. Charles and Maillie Stickney and their two sons befriended William and took him into their home. Charles was twenty-four years older than William and was a surrogate father to him. Although William was socially active, he described his loneliness in his diary. The Stickney family provided some comfort and a partial substitute for the ravaged family he had left behind.

8. The diary does not state specifically that Parsons met Kollecker, but given his role in William's adjustment to Saranac Lake and that Kollecker refers to him in the first diary reference as the minister, the inference is well founded.

9. Although Kollecker's August 22, 1962, obituary in the *Adirondack Daily Enterprise* states that he was a patient of Edward Livingston Trudeau, there is no evidence to that effect in Kollecker's diary.

10. It appears that he stayed at Loon Lake from May 23, 1898, until October 1898.

11. The album is at the Saranac Lake Free Library, called "Book of William Kollecker's Photos."

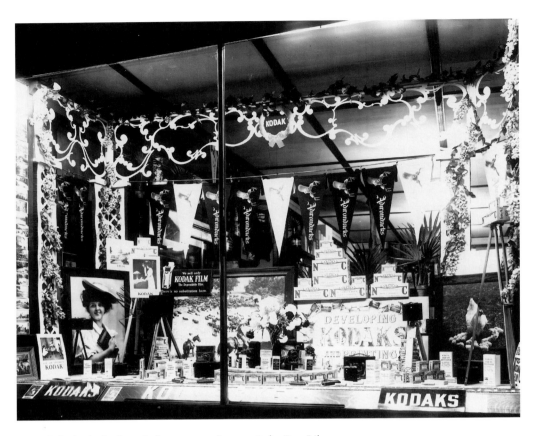

4.10. Kollecker's display window, c. 1915. Saranac Lake Free Lib.

ment. When it became vacant, William moved in.[20] This location was his home and business for the rest of his life. His shop became a village landmark, and he became a well-known local personality (illus. 4.9).

Facing Kollecker's store from the street, a large, lavishly decorated display window dominated the view (illus. 4.10). The main entrance was to the right. The sales area was large, twenty-four feet wide and sixty feet deep, with waist-high display cases on both sides and across the back (illus. 4.11). There was a six-foot-wide walkway down the middle. Shelves and storage cabinets covered much of the wall space. On the left side, near the front, was a counter with the cash register. Directly overhead, high on the wall, hung an impressive mounted whitetail buck head. Two similar trophies were displayed in other spots. The remaining wall space was decked with merchandise for sale, such as framed reproductions and other wall decorations.

The new store was expansive and elegant. The inside walls and cabinets were beautifully finished in arts-and-crafts-style stained oak and natural burlap paneling. The mission motif was carried out in all the details, including the chandeliers and electric lights.

20. I am not sure exactly when he moved into the apartment. He lived for a time at the Saranac Lake home of his former boss, Charles Stickney, at 36 Margaret Street.

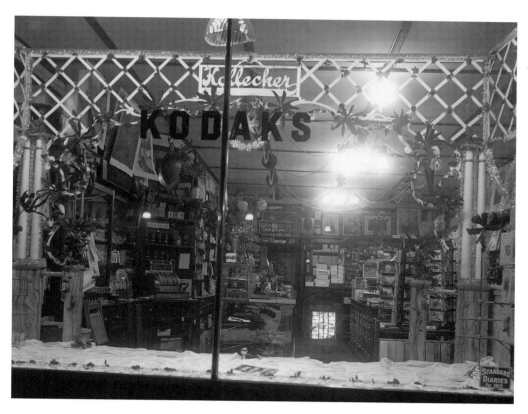

4.11. View of inside of Kollecker's shop taken through the front window. Display had been removed, giving an open view of the interior, c. 1914. Saranac Lake Free Lib.

A drape hung in the doorway in the back of the salesroom. Kollecker had to pull it aside to reach his narrow office, which extended the width of the back of the sales area. His desk was well organized. His office, like the rest of the establishment, was neat— everything in its place. A door led from Kollecker's office to the processing area in the far back. Approximately a third of that space was devoted to the darkroom; the rest was for other aspects of production. There was additional work and storage space in the basement. In designing the new store, William gave special attention to the workrooms. In addition to processing his own photographic work, he needed space for handling the film that amateur photographers turned in as well as for framing (illus. 4.12). These aspects of his trade became a considerable source of income and served as an enticement for selling other products. The work space was not only large but also equipped with the latest and best appliances for photo processing.

The window displays at Kollecker's store were something to behold. A border of incandescent lights around the fifteen-foot front window provided illumination at night. William took a great deal of time and care with his displays. He considered them his primary form of advertising. Merchandise dominated the displays—Kodak products especially—but the window sometimes included the handiwork of the TB patients. As patients moved toward recovery, they engaged in various recreation and

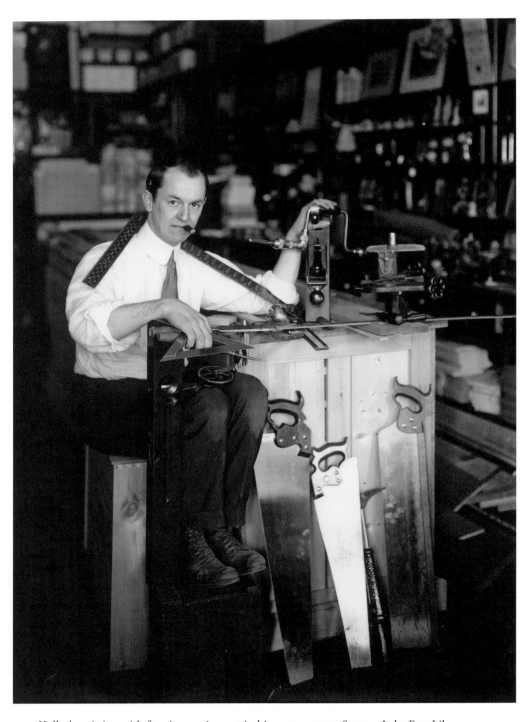

4.12. Kollecker sitting with framing equipment in his store, c. 1917. Saranac Lake Free Lib.

craft projects at the guild down the street. One of the members made a large, complex match-stick model of the Saranac Lake Town Hall that was exhibited for a while. At Christmas, William featured his calendars and had a rotating, decorated Christmas tree. The array was changed regularly and always included holiday greetings and other seasonally appropriate items. During the wars, the window featured patriotic themes.

Over the years, Kollecker expanded his merchandise. Kodak cameras, film, and other supplies and souvenirs were staples. William also dabbled in stationery, fountain pens, greeting cards, frames, framed prints, trinkets, cups, plates, Kewpie dolls, Hummel figures, and a variety of other knickknacks. Although the store enjoyed an active year-round trade, his best sales months were in the summer tourist season. The small objects he sold were designed to appeal to the visitors who walked the streets of the resort town, but he also courted the year-round residents and the sanatorium patients and their visitors as well.

Among Kollecker's photographic offerings, photo postcards became a mainstay, a vital commodity in an expanding line of products that included calendars, albums, scenic folders, and larger-format photos. He continued his sales practice of displaying his best photographs in large sample books that customers could peruse at their leisure while visiting the shop. Patrons chose the images they wanted and picked from two formats, either large for ten cents or postcard for five. Many of the more popular cards were preprinted, so they could be bought from the store postcard racks. Other merchants sold his cards in their stores as well. William sent some of his best-selling scenery photo cards to a manufacturer to have them made into colored printed cards with his name on the back.

Kollecker also took and sold large-format panoramic photographs (Caudell 1996; Parnass 1996). Although his expansive scenery shots are the most celebrated, group portraits of club members, civic organizations, and people attending conventions were also part of his trade. He discontinued taking panoramics in the 1920s.[21]

In addition to the commercial photographic work already described, William took pictures for the local newspaper, the *Adirondack Daily Enterprise.* His work was credited as "photo by Kollecker." He was also the official photographer for the Saranac Lake High School yearbook, the *Canaras.* This work, in addition to taking class and individual pictures of students, kept his staff busy in the back room in the spring (Duquette 1992).

Sometime in the 1920s, Kollecker became interested in movie production. There are more than sixty reels of his films, including extensive footage of Saranac Lake, in the Saranac Lake Free Library. In the thirties, William began taking traveling vacations. There is no written record of his trips, but he documented a visit to Florida in the 1930s on film. In 1939 and then again in 1940, he went to the World's Fair in New York City, again making home movies.

21. The latest example I have seen is 1923.

4.13. Valentine's Day get-together at Ray Brook, c. 1918. Saranac Lake Free Lib.

Kollecker's TB Photographs

The sign outside the shop did not say "studio" or "gallery," designations usually associated with photographic establishments where portraits were taken on the premises. Kollecker did not create studio portraits, but he did go to cure cottages and sanatoriums where patients and staff posed before his lens. With the eye of an insider who had experienced TB firsthand, he captured the social life of the young patients at the sprawling state facility at Ray Brook.[22] One photograph shows six couples around a table, apparently celebrating Valentine's Day (illus. 4.13). In another, a young woman, with flowers on her bosom, sits in bed with a soldier-friend, a visitor, standing beside her. The subjects' smiles, elicited by Kollecker's camera (illus. 4.14), are frail. In another example of Kollecker's Ray Brook portraits, three smiling women sit, wrapped in blankets, in deck chairs, taking the cure on a porch (illus. 4.15).

As Kollecker knew, there was something other than smiles and gaiety at the cure facilities. Although the subject was painful, one that he did not emphasize in displays, William did include in his Ray Brook work images of isolated, suffering, dying patients (illus. 4.16).[23] He caught the tragedy on the faces of family members visiting the afflicted (illus. 4.17).

22. Ray Brook was officially opened in 1904.
23. There are a few pictures of autopsied infected lungs. It is not clear for whom or in what format these were printed. Some pictures of patients and their families, and more festive cure cottage shots, were likely printed as postcards, but the more clinical views were probably produced under contract for one of the sanatoriums.

4.14. Young TB patient sitting
in bed with soldier, c. 1918.
Saranac Lake Free Lib.

4.15. Women sitting out
at Ray Brook, c. 1918.
Saranac Lake Free Lib.

4.16. Patient with doctor at Ray Brook, c. 1918. Saranac Lake Free Lib.

4.17. Woman patient and visitors in front of a cure cottage, c. 1915. Saranac Lake Free Lib.

The portraits of patients were not a major part of Kollecker's trade, and it is not certain whether he printed them as postcards, but he did a brisk business selling postcard views of the cure cottages themselves. As the photograph of the "Greek cure cottages" at 33-35 Ampersand Avenue shows, the construction of cure cottages produced a unique architectural style (Gallos 1985), with extensive glassed-in porches on which patients could sit and breathe the mountain air (illus. 4.18). A photograph of the inside of a Saranac Lake pharmacy shows a postcard rack on top of the counter on the right, with postcards of cure cottages for sale (illus. 4.19). Patients who frequented the store purchased William's photo cards to send to people at home.

As the picture of the pharmacy illustrates, other subjects of Kollecker's camera were the facades and interiors of the shops of downtown merchants. There are examples of his images of the local cigar store where he was a regular customer. Pictures taken inside the Fortune Furniture Store and an Oriental rug store show high-priced merchandise, evidence of the affluence of some of the Saranac Lake residents.

4.18. Greek cure cottages, which were torn down in 1995, c. 1915. Saranac Lake Free Lib.

4.19. Saranac Lake pharmacy with postcard rack, c. 1916. Saranac Lake Free Lib.

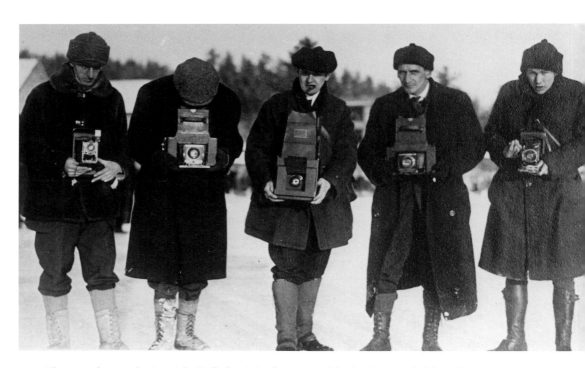

4.20. Photographers at skating rink. Kollecker is in the center with cigar in mouth. Hugo Franz, Kollecker's employee, is on William's left, c. 1918. Saranac Lake Free Lib.

4.21. Workers on top of the ice pyramid in the center of Saranac Lake, preparing for carnival, c. 1921. Saranac Lake Free Lib.

Mid-Winter Carnival Views

Kollecker took photographs in all seasons, but his winter views were a specialty (illus. 4.20). The annual Mid-Winter Carnival held in late January or early February was an exceptional, cathartic, gala event created for and by the citizens of Saranac Lake (Duquette 1987b).[24] The long, harsh, subzero winters made the residents, especially TB patients and staff, suffer from pent-up feelings of isolation and confinement—in short, the community had cabin fever. The Mid-Winter Carnival was their social and emotional release. In addition to a broad range of activities, the merchants and townspeople decked the village with festive banners and ice sculptures (illus. 4.21). Over the years, William regularly chronicled the festival on film (illus. 4.22, 4.23).

Kollecker caught it all on photo postcards. In his display books at his store, there were more photographs of the Mid-Winter Carnival than any other subject (illus. 4.24). Even before he moved to the larger shop at 73 Main Street, sales of his carnival postcards were brisk. In 1907, he sold fifteen hundred during the week of the Mid-Winter Carnival.

The symbol of the carnival was, and still is, the massive ice castle assembled by volunteers with large ice blocks cut from nearby Lake Flower. The sculpture stood tall at the center of festival activities. Each year Kollecker photographed the ice palace at different angles, times of day, and stages of construction. The palace was particularly

24. The first carnival was held in early February 1898.

Pictures of the Parade

And other Carnival Events
at Kollecker's

Come in and look them over

Kodak Developing

And Printing Done Well at Low
Prices. Prompt Attention to
Mail Orders

We sell everything for the
Kodaker

Souvenirs and Post Cards

See our well stocked store on
Main Street, next to postoffice

Look for the name

Kollecker
Everything for the Kodaker

4.22. Kollecker's printed advertisement
for carnival photographs, c. 1917.
Saranac Lake Free Lib.

4.23. Kollecker's display of 1915 Mid-Winter Carnival photographic postcards
for sale, 1915. Saranac Lake Free Lib.

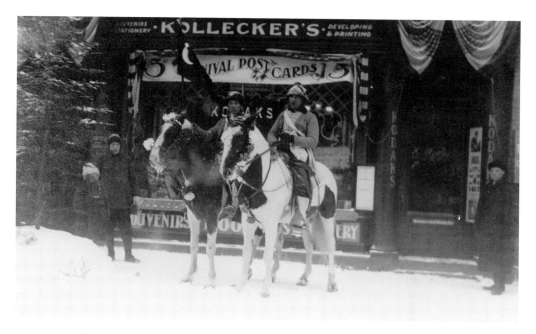

4.24. Men on horses in front of Kollecker's shop during Mid-Winter Carnival. Note the advertisement for carnival postcards for five cents in the window, c. 1913. Saranac Lake Free Lib.

4.25. Day view of the ice palace, c. 1909. Saranac Lake Free Lib.

4.26. Ice palace on the night of the fireworks. Note cameras in foreground, c. 1909. Saranac Lake Free Lib.

striking at night because it glowed from interior illumination. Carnival attendees bought ice-palace postcards avidly—a must for every collector (illus. 4.25, 4.26). In the spirit of the carnival and as a sales promotion, Kollecker sometimes featured a large model of the sculpture in his front display window.

The gala Mid-Winter Carnival parade through the village featured creatively crafted floats and other lavishly decorated vehicles, which created another photographic opportunity. Spectators lined the route, cheering as the procession passed, with participants waving from atop the decorated wagons (illus. 4.27). Prior to 1910, horses or oxen drew the floats (illus. 4.28). Later, motorized transportation was included, until eventually trucks and cars prevailed (illus. 4.29, 4.30). In addition to individual entries, the mobile displays were sponsored and created by various civic, business, and community organizations, including the various TB facilities and associated health organizations (illus. 4.31). Patients and doctors from cure cottages and sanatoriums rode in the parade on floats with "taking the cure" as the theme (illus. 4.32). One year William

4.27. The Village Improvement Society float making its way down spectator-lined streets, c. 1911. Saranac Lake Free Lib.

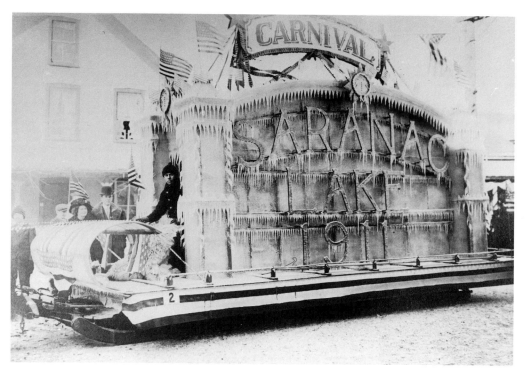

4.28. Horse-drawn carnival float, 1911. Saranac Lake Free Lib.

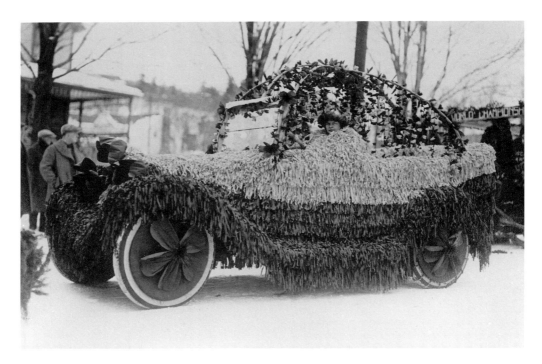

4.29. Woman in a lavishly decorated car, c. 1920. Saranac Lake Free Lib.

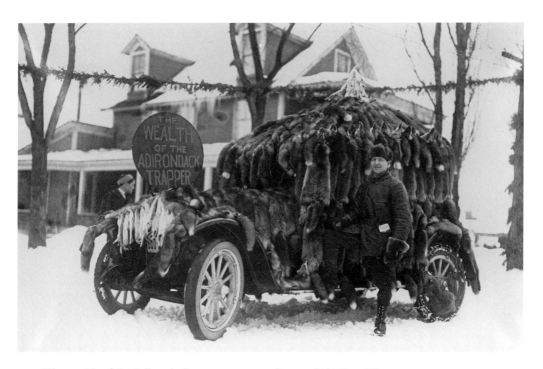

4.30. The wealth of the Adirondack trapper, c. 1920. Saranac Lake Free Lib.

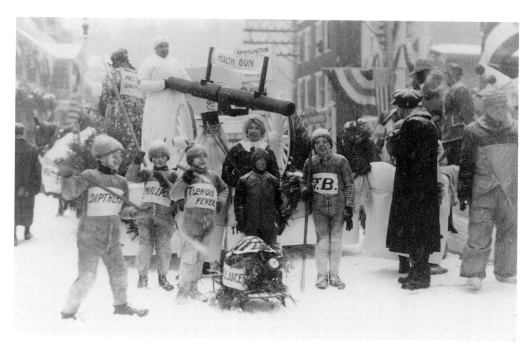

4.31. Health gun float. Probably sponsored by the Red Cross. Children wearing signs designating the various diseases stepped down from the decorated wagon to have their picture taken, c. 1915. Saranac Free Lib.

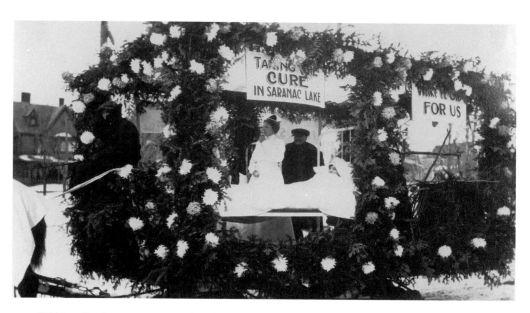

4.32. "Taking the Cure in Saranac Lake" float, 1920. Saranac Lake Free Lib.

No 23 BROWNIES ON PARADE W.F.KOLLECKER'S FLOAT

4.33. Brownies on parade. The children resemble Palmer Cox's popular Brownie fairy tale illustrations. Kollecker's float, 1909. Saranac Lake Free Lib.

4.34. Girl pushing doll in sled, 1909. Saranac Lake Free Lib.

sponsored a parade entry that featured a gigantic facsimile of the Kodak Brownie Camera (illus. 4.33). There were many variations on the Mid-Winter Carnival parade's yearly theme, including a version of the procession featuring sleds with dolls pushed by children (illus. 4.34). In addition to pictures of the crowds and the parade, Kollecker took pictures of each float. Every Saranac Laker either participated in the parade or knew someone who did, ensuring that there were buyers with a personal interest in all the postcard images produced.

Winter sports were also central to the carnival celebration. There were snowshoe races, skiing competitions, and other downhill events, but they were secondary to the ice-skating competitions and demonstrations held at the open-air Pontiac Skating Rink (illus. 4.35). The history of the carnival is interwoven with the careers of local winter sports competitors who rose to international stature. Ed Lamy was the best known. In 1908, at the age of seventeen, he became a world amateur speed-skating champion. His appearances at the Mid-Winter Carnival always drew large crowds. Later in his career he tried barrel jumping, and his world record leap of twelve barrels, more than twenty-seven linear feet, was featured in *Ripley's Believe It or Not* (Duquette 1987a)(illus. 4.36). Although there were serious sports competitions and displays, the skating events included clowns and more frivolous happenings (illus. 4.37). The ice skating was not just for performers and champions. There were costumed free skates in which all Saranac Lakers and visitors were encouraged to participate (illus. 4.38). All the views Kollecker took of the winter sports events were marketable, but he always took a large number of pictures of people in the grandstand at skating events to boost sales (illus. 4.39). He would develop these quickly and have them available in his store within hours. Spectators favored views with their likeness in them, so grandstand shots sold well.

4.35. Woman figure skater, 1923. Saranac Lake Free Lib.

4.36. Ed Lamy barrel jumping, 1923. Saranac Lake Free Lib.

4.37. Skater in shorts with a pipe, 1924. Saranac Lake Free Lib.

4.38. Children with skates and costumes at Pontiac Rink, c. 1922. Saranac Lake Free Lib.

4.39. Grandstand at Pontiac Rink, 1924. Saranac Lake Free Lib.

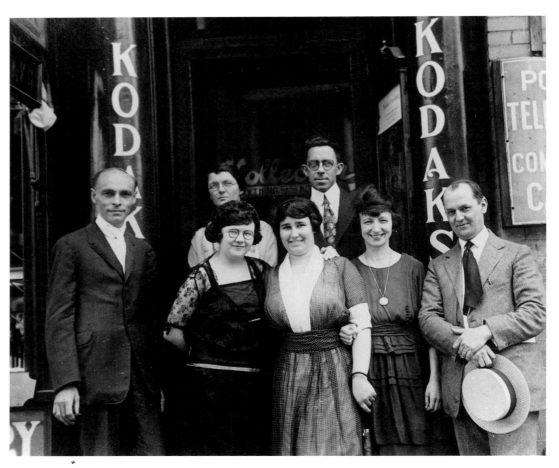

4.40. Kollecker with employees in front of entrance to shop. Hugo Franz is on the left. Kollecker is on the right. Alice Moll is the woman with glasses in the first row. Anita Ballerano is next to William, c. 1928. Saranac Lake Free Lib.

The Staff

Starting with his move to Main Street, Kollecker had hired various workers to assist him, many on a part-time basis. By 1923, William was so busy that he could not handle all the work without reliable, experienced full-time help. That year he hired Hugo Franz to assist him. When he was hired, Franz already enjoyed photography as a hobby and was proficient with a camera. Like William, Hugo was born in New York City, in 1881, to immigrant German parents and was in his midteens when he came for the cure.

Hugo Franz and Alice Moll, another employee with long tenure at the store, did all the developing and printing. Anita Ballerano served as a clerk and stock person.[25] She was the one most likely to greet customers as they entered the store (illus. 4.40). Hugo went out on picture-taking assignments. It is likely that he took some of the pictures

25. Anita's husband had come to Saranac Lake for the cure. He was a salesperson for the Kraft Cheese Company.

attributed to Kollecker. Franz worked for Kollecker for twenty-six years, until his own death in 1949 at age sixty-eight.

Franz liked his boss and thought he treated him fairly. There was always a modest Christmas bonus. By the end of the 1920s, Hugo made forty dollars a week. Although Saranac Lake was somewhat insulated from the Great Depression, Kollecker's business, dependent on tourist dollars, did suffer. Rather than fire Hugo, he reduced his wages to twenty-five dollars until circumstances improved. William had a pleasant joking relationship with Franz's seven children. They called him Uncle William, and he gave them small gifts and humored them when they visited the store.

Kollecker's competent staff freed him from the routine work of processing film and framing. When he was on the premises, he spent his time at his desk doing paperwork, answering employees' questions, helping when they got busy, and attending customers' special problems. William's reputation for being knowledgeable about anything photographic and as an expert troubleshooter for amateur photographers attracted many budding picture takers to the shop. For example, after a roll of film was processed blank, young Bob McKillip took his problem to Kollecker. Bob, who was twelve years old at the time, recalled that William calmly pointed out that the aperture had been inadvertently set on "T" for time exposure. William was generous in giving time to help young people in the craft of photography as he had been tutored in Lake Placid.

Kollecker never had children of his own, but he enjoyed their company and included them in many of his pictures. Sometimes they appear in unexpected locations, such as the front seat of a car with the spoils of a hunt displayed in the back (illus. 4.41). Kol-

4.41. Child sitting at steering wheel with dead bucks in back, c. 1910. Saranac Lake Free Lib.

lecker often portrayed children in a warm, affectionate manner, a reflection perhaps of his unfulfilled desire to have offspring of his own (illus. 4.42, 4.43).

Man about Town

Although work at the store consumed much of Kollecker's time, he was a regular on the village streets and at local events. Always neat, he most often sported a vested suit and tie plus a hat—in summer it was often a white panama. No one can remember ever seeing him without a suit, cigar, or camera. In the winter he wore a handsome wool overcoat as regular attire, but at winter sports events he took on a bearlike appearance when he wore his raccoon coat.

Kollecker started smoking cigars in his early twenties and continued to do so until the end. But those who remember him in later life emphasize that he did not really smoke many of his stogies. He cut each one in half and chewed on each piece until it became soggy. Elise Chapin, who was a cure cottage patient in the thirties, recalls children pestering William on the street to surrender his cigar bands for use as finger rings.

Kollecker never owned a car, which did not restrict his photo taking greatly in that he concentrated on photographing Saranac Lake and its immediate surroundings. He had many acquaintances and associates who provided him with transportation, and when they were not available there were plenty of taxis in town.

4.42. Child with teddy bear, c. 1920. Saranac Lake Free Lib.

4.43. Child with dog, c. 1920. Saranac Lake Free Lib.

Kollecker is remembered as down-to-earth, gentle, well liked, and friendly. When walking down the street, he greeted local customers and regulars by name. On the one hand, he liked to joke and was good in casual conversation; on the other, he was a loner, a private person, not one of the boys. As an adult he did not hunt or fish or engage in other sports activities, although he was often at sports events taking pictures.

Starting in the early 1930s, Kollecker began spending time with Charlotte Dewey (illus. 4.44).[26] She was six years his junior. They were a twosome for thirty years, traveling together on trips to New York City and Florida. She lived in various apartments downtown, sometimes sharing them with female roommates, including her sister Violet. She eventually moved into the same building and on the same floor as William but into separate quarters.

Dewey was the proprietor of Charlotte's Little Shop, located in the same small quarters Kollecker had occupied when he first moved to the downtown, 71 Main Street. Charlotte was a devoted Roman Catholic, and her store was filled with Catholic religious items: statues, rosary beads, books, calendars, and the like. In the window was a large plaster statue of the Christ child, the Infant of Prague (Seidenstein 1997). She was soft-spoken, petite, pale, prim and proper, and religious. William and Charlotte were

26. Dewey (1885–1965) is buried in St. Paul's Cemetery in Bloomington, New York. I was not able to learn much about her background, including whether she was related to Melvil Dewey, who developed the Dewey Decimal system and founded the Lake Placid Club. The people I talked to could not determine exactly when William and Charlotte became a twosome.

4.44. Charlotte Dewey holding Kewpie doll, c. 1932. Saranac Lake Free Lib.

seen about town, went to banquets and dances together, and in the early years of their friendship were regulars at the Pontiac movie house (illus. 4.45). Later in their relationship, William left his store every weekday around one o'clock, after lunch-hour business waned, and picked up Charlotte, and the two went to lunch at the Hotel Saranac, where their regular table with a view of Main Street was waiting. In the 1950s Charlotte and William went to the Hotel Saranac every Sunday for dinner. After dinner they adjourned to the lounge and sat, holding hands, watching programs on one of the first televisions sets to arrive in the resort community.

Kollecker's Last Years

By the end of the 1930s, there were empty beds in the cure cottages and sanatoriums. The death rate from the white plague had been in decline since the turn of the century, and the demand for isolated residential placements was reduced. In the early 1940s, researchers invented streptomycin, an antibiotic that proved effective against tuberculosis. Due to other medical advances by 1954, the nation's leading cause of death became easily and quickly treatable. In that year Trudeau Sanatorium closed its doors to patients.

Kollecker was in his seventies when the sanatoriums began closing. Saranac Lake was in rapid economic decline, as were William and his shop. As a young man newly cured of TB, he had walked with a good stride. In his later years he shuffled. Over the years, William became bald and put on a great deal of weight. He still dressed in a suit and vest, but the gold chain that was attached to his watch draped over a potbelly, and his suits often looked like they needed pressing. He became more withdrawn and a little short with his customers. His shop remained open, and he still dabbled in photography, but his business became primarily a gift shop. He was forced to draw upon his savings from the prosperous years to pay the bills.

On August 12, 1962, Kollecker suffered a stroke and was taken to Saranac Lake General Hospital where he died on August 22. Charlotte was nearby. He was eighty-three years old. His body was taken to Fortune Funeral Home, the same company he had worked for when he was a young man living in Lake Placid and in love with Hannah. Presiding at the funeral was the rector of St. Luke's Episcopal Church.[27] At the time of his death, William had no known surviving relatives. He is buried in the North Elba cemetery in Lake Placid, in the Cheesman family plot. Although he was born in Brooklyn, William was buried as an Adirondacker.

Kollecker's Estate

Kollecker had not planned for his death. He had debts and no heirs. There was no will, and he did not make provisions for the equipment, negatives, prints, and other photographic material he left in his Main Street store and apartment. Dump-truck loads of Kollecker's legacy were shoveled out windows and thrown down the stairs and de-

27. Kollecker's religious affiliation is not clear.

4.45. William Kollecker
and Charlotte Dewey,
c. 1945. Author's Coll.

posited in the Saranac Lake dump.[28] An appointed lawyer in charge of the Kollecker estate allowed a few interested people to pick through the remains. A local historian and a friend of the Saranac Lake Free Library took some items and eventually donated them to the library. The lawyer kept a few boxes, and they also found their way to the library. Another person was allowed to clean out the shop in return for the remaining negatives, photographs, and equipment.[29] He is alleged to have acquired more than one thousand glass plate negatives, more than fifteen 16mm reels of film, about one hundred

28. This information was reported in the Application for Historic Preservation.
29. The information about the estate comes from correspondence about the Kollecker Collection in the Adirondack Museum.

panoramic prints, more than five thousand celluloid negatives, thousands of prints, and approximately twenty cameras. In addition, the collection contained seventeen diaries, two account books, and Kollecker's Bible.[30] The person sold some of the material, including the diaries and the Bible, to a local author and antique dealer who in turn sold the diaries to the Adirondack Museum in 1987. An unknown antique dealer from Florida is alleged to have the rest.

Saranac Lake Today

Saranac Lake is still a special place. Community spirit evolved to rally around the legions of people with tuberculosis and can still be felt. In 1998, the city received the All-American City Award from the National Civic League. The national award recognizes communities whose citizens work together to identify and tackle communitywide challenges and achieve uncommon results. Many of the people who came to the area for the cure remained and are now the town's elderly. Some volunteer at the Saranac Lake Free Library, where an extensive collection of Kollecker's work is housed. Through much determination and work, a group of the citizens banned together in a successful effort to have more than 160 of the buildings in the town designated as historic treasures and put on the National Register of Historic Places. Kollecker's store, 73 Main Street, is on the list; he and his work deserve the designation of national treasures as well.

Conclusion

For William Kollecker, the youth from Brooklyn who became an Adirondacker, photo postcards were an important part of his photographic business. Kollecker, like Mandeville, had many of the attributes of a town photographer. Both were familiar figures on the streets and known by name to most townspeople. Although Kollecker photographed the countryside more than Mandeville did, he too limited most of his photographic work to his village of residence and its immediate surroundings.

Mandeville had Lowville; Kollecker had Saranac Lake. Both were rural population centers, but they were different. Lowville was a parochial village that served as a government and commerce center for an agricultural community, much like hundreds of villages across America. Saranac Lake was one of a kind. As a TB-cure and tourist center amid the beauty of the North Country, the village was both sociologically and visually distinct. Kollecker had a good eye for these singular features. His photographs of scenes in Saranac Lake challenge the notion that there is one conception of the Adirondacks. Saranac Lake is so different from its surroundings that it does not exactly fit, and so unique that it does not belong anywhere else.

30. Two of the diaries were written by Hannah, twelve were by Kollecker, and three included entries by both Hannah and William.

Welcome to North River

The Amedens owned more than just a store in North River. Although not extensive by ordinary standards, their holdings were substantial for the area. Two major structures lined the road. The largest, the store, was a good-sized two-and-one-half-story building with a generous extension on the north side. The front had a porch roof over a recessed main entrance that was flanked by a pair of glass display cases. The second building, the residence, stood ten yards south of the store. It was smaller and had an ornate wraparound Victorian porch. The Victorian furniture, rugs, tapestries, drapes, and formal dinnerware were fancy according to local standards. Ernest's mother apparently accumulated the contents, but they fit Ella and Ernest's tastes just fine. In back of the main structures was a barn that also served as an icehouse. There were also gardens, a shed, a chicken coop, and an outhouse. A small field and a wood lot lay beyond.

The mountainous lands around the hamlet, now heavily wooded, were open pasture and fields in the early part of the century (illus. 5.5). This legacy resulted from an ear-

5.5. Field and mountain view, North River, c. 1920. Author's Coll.

lier settler's clearing in an attempt to make a living by farming the uncooperative land. Sheep and cows pastured on the hills. Small-scale logging was practiced, but much more ambitious timber harvesting went on farther north and to the east. Crews went into lumber camps in the fall and spent the winter cutting and skidding timber to the frozen streams and lakes where it sat on the ice, waiting for spring (Hochschild 1962c). When the ice broke, and melting snow and rain caused the water to rise, the operators opened dams on upper tributaries, which caused the logs to move downstream into the upper Hudson and then onto the big boom at Glens Falls (Hochschild 1962c). North River residents worked on the crews in the camps and on the drives (Johnsburg Historical Society 1994).

The Amedens took over a business that was struggling, but it was paid for and had potential. On the road, in front of the house, the traffic was increasing. The main industry in the North River area became garnet mining (Hochschild 1952, 437–39). "Adirondack Ruby," as garnet was called, became the official New York State gemstone, but it was not mined in North River for its beauty. Garnet crystal is almost as hard as diamond, and when crushed and glued to tough paper it is an excellent industrial abrasive. The Barton Mine operated on the northwest side of Gore Mountain and grew to be a major employer. Frank Hooper was responsible for developing a mechanical process to efficiently recover garnet from crushed ore, thereby making garnet mining profitable. Hooper and his brother formed the North River Garnet Company in 1893 and ran their original mine, the Hooper Mine, four miles from North River, from 1894 until 1904, when they moved their operation to nearby Thirteenth Lake. During its prime, it consisted of six hundred acres, a quarry, a mill, an office, two blacksmith shops, three dams, a boarding- and bunkhouse for one hundred workers, three barns for horses and cows, twenty-five homes for employees, a two-room school, and a store.[7] In 1928, Barton Mines purchased the North River Garnet Company.

The railroad was crucial in the development of the garnet industry as well as for other commercial growth. In 1871, Thomas C. Durant completed a rail line from Saratoga Springs to North Creek (Kudish 1996), five miles short of North River. North Creek was the last town of any consequence in the upper Hudson Valley (Shaughnessy 1997). Some freight and passengers that arrived at the station boarded horse-drawn transportation and passed through North River on their way to the expanding developments in the central Adirondack resorts and estates around Long and Blue Mountain Lakes (Hochschild 1962a, 79). North River became a stopover for travelers and also saw an increase in seasonal visitors who came to summer and hunt and fish. There were hotels along the river, including the North River Hotel, which was one of the largest and best known and only a short distance below the Ameden store (Hochschild 1962a, 79). This hotel first catered to lumbermen but became the regular stop for meals for tourists traveling by stagecoach from the train station at North Creek to the Blue Mountain Lake area and back. Stagecoaches, freight wagons, and sleighs in the winter traveled past the Ameden home. Although certainly not a booming commercial area, the tourist traf-

7. The North River Garnet Company existed until 1928 when Barton Mines Corporation purchased it. The Barton Mines remained in operation until 1984.

fic, in addition to the business generated by mining and logging, meant trade for the Amedens and other local merchants.

The Amedens' general store was not the only one in North River. Towne Grocery, first established in the 1860s, remained a competitor for Ernest and Ella's forty-year tenure as storekeepers. Other small businesses came and went. The Amedens changed their merchandise to adjust to the competition. Although the stagecoach route from North Creek to North River survived until the early 1920s (Hochschild 1962a, 12), the Scholle brothers' motorcar went through North River in August 1906, and in 1916 the road going past the store was paved (illus. 5.6, 5.7, 5.8). Dunlap's Blacksmith Shop, which was fifty yards north of the Amedens' store, opened in 1917 and soon became the thriving North River Garage (illus. 5.9, 5.10). Automobiles brought hunters, fishermen, and summer tourists to the area, and small campgrounds and cottages appeared. Summer visitors who came as tourists bought small parcels of land and built cottages they called camps. In spite of the development, and the fact that access to North River had become easier, the hamlet remained small and relatively isolated.

5.6. Road work in front of the Ameden store, c. 1916. Board 'n Batten Coll.

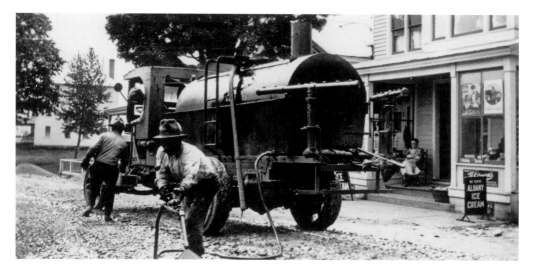

5.7. Asphalting the road in front of Ameden store, Ella sitting on porch, c. 1916. Ameden Coll.

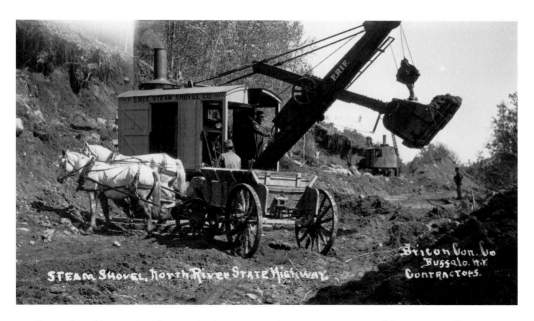

5.8. Steam shovel improving the state highway at North River, c. 1916. Board 'n Batten Coll.

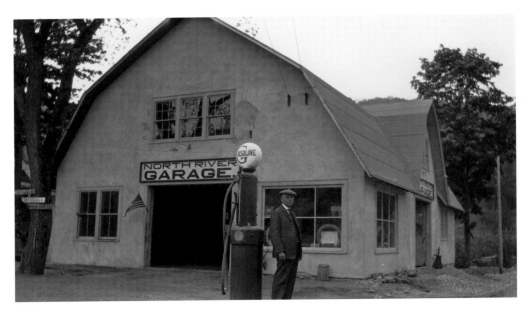

5.9. North River Garage, c. 1922. Board 'n Batten Coll.

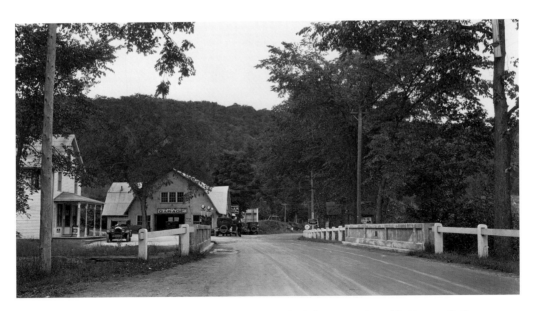

5.10. North River Garage Center. Towne Grocery is on the left, c. 1924. Board 'n Batten Coll.

Ernest and Ella

Ernest had a thick mustache and was of medium height, pleasant looking, and, when he arrived at North River, of average build. As he aged, he developed a potbelly that hung over his belt but was never uniformly heavy. At work he dressed much more formally than other hamlet men—a white shirt, a tie, and a suit—but nothing unusual distinguished him from the other merchants in the nearby village of North Creek. When off-duty doing chores or with his sons in the woods he dressed down, but even then he outfitted himself more formally than was in line with local custom (illus. 5.11). He was a vigorous man more prone to physical activity than to sitting and reading. He was affable with a nice, quiet way about him. Local people were accustomed to being greeted by him with a direct "Good morning" or "Good day," but he did not linger for much conversation. Ernest was not the type to dally, for he always had work to do, whether in the store, around back, at the house, or in his studio or darkroom. More reserved and less social than Ella, he seemed to relish his time alone pursuing his photography.

Ella was approximately five-foot-seven with dark hair that grayed as she got older. Her usual practice was to wear it in a bun on the top of her head. She was stocky when she arrived in North River and put on weight as she aged. Neighbors remember her as more stylish than other local women. As one put it: "Ella was always well dressed—

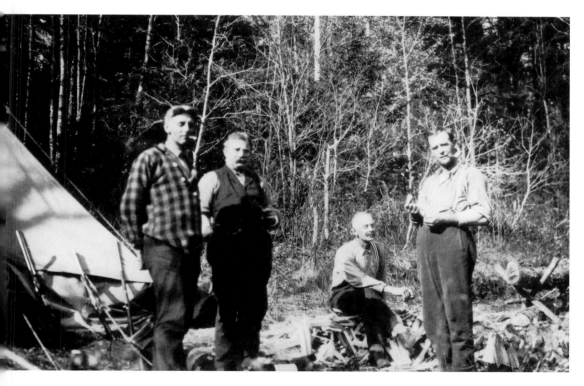

5.11. Ernest Ameden (second from left) with unknown hunters, c. 1933. Ameden Coll.

spiffy. We were used to seeing women with aprons, you know, hardworking women, but she was always immaculately dressed. Never saw her in an apron." Ella wore dark flowing dresses, not the plain cotton ones that were standard fare. Her long wool coats and jewelry and finery made other North River women take note. Befitting her attire was her reputation as "cultured and musical." She was a devout Christian who regularly attended services at the local Methodist church and was active in church affairs.

Anyone who knew Ella describes her as the strong figure in the family—the matriarch who ruled the household. Some say she also managed the store. Although quick to correct others, she was also a generous and social person, a side that shone through in her relations with her family and many friends.

The Ameden Business

In North River, at the turn of the century, no matter how hard you worked, it was difficult to make a living doing just one thing. Like Adirondackers elsewhere, people held different jobs at different times of the year or worked more than one year-round job. Farmers, for example, also had to work in the mines and lumber camps, haul freight, and take up cottage industry. Merchants were no exceptions; they could not count on living off one specialty. Ernest and Ella and their sons worked hard, but not hard enough. The modest success they achieved can be attributed to the fact that they diversified.

Soon after they moved to North River, Ernest applied for the postmaster position. On May 11, 1901, he received an official letter from President William McKinley ap-

5.12. Ameden postcard of post office. Ameden house is first building on the left, and the store and post office are next door, c. 1924. Board 'n Batten Coll.

pointing him to the post (illus. 5.12). Ernest held the position for thirty-nine years. His post office in the store was classified as fourth class, which meant that he drew no regular salary. In addition to reimbursement for expenses, he was paid a percentage of the receipts from stamps and other postal supplies and services he provided. Although the money did not amount to much, it provided an economic base for the business. More important, the post office brought in customers, giving retail sales a boost.

The Amedens' store's twenty-five-foot-wide and fifty-foot-deep salesroom was large enough to provide a wide range of goods and services. Down the right side were the groceries. Toward the back were two sets of bent iron tables and chairs that served as the ice cream parlor, a fixture for years. They served root beer that they made and bottled themselves. Behind the ice cream area was a gun rack where rifles were for sale. Nearby were the fishing supplies. Down the left side the clothing was displayed. Small items that appealed to travelers, such as cigars, cigarettes, chewing tobacco, and candy, were readily available at the counter.

The Amedens handled a variety of specialty items that changed over the years. When electricity came, they began selling electric lights and small electrical appliances. One elderly interviewee remembered a particularly striking lamp in the store that, when lit, produced a firelike image in the glass shade. In the mid-1920s, the beginning of radio's golden age, the Amedens became the sales representatives for Majestic Electric Radios. In those years, a large sign adorned their storefront at Christmas with a Santa Claus and the advertisement: "Majestic Electric Radio, a Real Gift that the Entire Family Can Enjoy All Year Round." Soft music played in the store in the Majestic years.

Ameden was mechanically adept and did some electrical appliance repairs to augment his business. When the North River Garage closed, he installed a gas pump out front to serve motorists.

The switch that controlled the only streetlight in North River in the 1920s was located on the back wall of the store. Beside it was a doorway that led to a small kitchen that was used to serve the ice cream parlor patrons; the Amedens ate most of their meals there as well. Ernest's darkroom and the other space allocated for his developing and printing were next to the kitchen. A staircase in the back led to a spacious second-floor apartment and a room set aside as Ernest's portrait studio.

Ernest the Photographer

Nothing is known about Ameden studying photography or even taking pictures prior to his move to North River. But within a year or two after he arrived, he began taking pictures commercially. Although undoubtedly he did it because he liked it and was good at it, he was probably also motivated to bolster the store's cash flow.

At first Ameden concentrated on portrait photography, confining his work to a few local people who wanted photos of themselves and family members. His portrait business was small and his studio rudimentary. He offered pull-down backdrops, but patrons had no choice of ornate scenes, only black, white, or gray (illus. 5.13, 5.14, 5.15). One older resident of North Creek remembers Ameden making photographic house calls. At least at first, if he profited from his work it was mainly because he was ac-

5.13. Portrait of woman in raccoon coat, c. 1922. Board 'n Batten Coll.

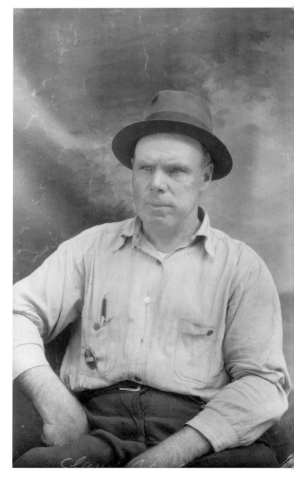

5.14. Man with hat, c. 1922. Board 'n Batten Coll.

5.15. Woman with arms folded, c. 1922. Board 'n Batten Coll.

commodating, had no competition, and his subjects were not privy to sophisticated criteria by which to evaluate the pictures. Unlike his counterparts, he did no custom framing. He sold his work unadorned or in one of a limited assortment of ready-made cardboard holders.

When postcards became popular in around 1905 Ameden jumped on the bandwagon. They were the perfect product for him. He was already set up for photo production, so there was no additional financial investment. The store was a marvelous venue for marketing, with people coming in and out buying stamps and doing other post office business. The postal business was transacted at a counter toward the back left of the store. To the right, standing on the floor, was a large, circular, rotating, heavy-metal wire postcard rack where Ernest displayed his work. As he took more pictures, he became proficient at creating attractive images.

Because of his success with postcards, Ameden decided to offer printing services for amateur photographers. Patrons could conveniently drop off their film on the way to pick up their mail or buy stamps and get their prints the next day.

Ameden's operation was modest. He did not own much photographic equipment and did not follow photographic trends. Not a reader, he did not subscribe to photography periodicals. Experimentation was his teacher. His earliest postcards were made using a view camera that produced five-by-seven-inch glass plate negatives. These were considerably larger than the dimensions of a standard postcard. He chose the part of the negative he wanted, framed it with a cardboard cutout, and printed it on standard stock postcard paper. Another camera used standard postcard-size dry plates. He seemed to favor glass plate negatives until around 1920 when he switched to celluloid film exclusively. After the early 1920s, he used a camera that produced celluloid negatives that were smaller than postcards. With these he used a border around the picture to make up for the part of the developing paper that was not covered by the image. The borders were often decorative—not just plain black, white, or gray but with designs. In keeping with the rustic design that came to stand for the Adirondacks, some had a birch-bark motif. He purchased the borders as well as other photographic supplies through the mail.

What is special about much of Ameden's work is how unprofessional it looks. Aside from the captions on some of his cards, which give them away as a commercial production, the images have a snapshot quality to them. Their appeal is their apparent unself-conscious directness. The lack of sophistication provides a feeling of spontaneous authenticity (Nickel 1998, 11).

Ameden's subjects add to the snapshot quality. The most photographed place on his postcard agenda was his own hamlet, North River. But given the size of the town, there were not many enticing sites to shoot. The state highway, the garage, small mom-and-pop tourist-oriented businesses (illus. 5.16, 5.17), the hotel (illus. 5.18), the river, and his own home and shop (illus. 5.19), in all seasons and in all decades, were his subjects.

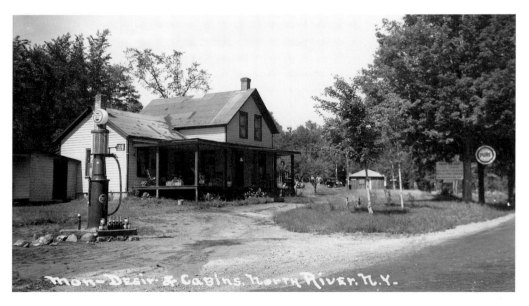

5.16. Mon-Desir main building with gas pumps, c. 1932. Board 'n Batten Coll.

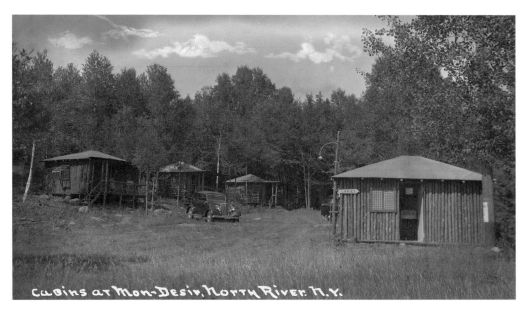

5.17. Cabins at Mon-Desir, c. 1932. Board 'n Batten Coll.

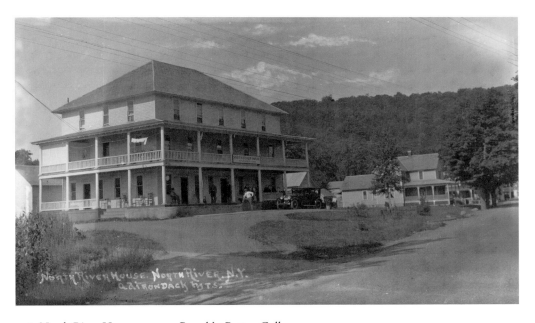

5.18. North River House, c. 1924. Board 'n Batten Coll.

5.19. Gas pump in front of
Ameden store in winter, c. 1924.
Board 'n Batten Coll.

5.20. Steam shovel at Barton Mine, c. 1922. Board 'n Batten Coll.

In search of good views, Ameden went to the garnet mines, where he shot some of his most notable photo postcards. His pictures capture not only the physical mines but also the drama of the men and machines struggling to remove the garnet from the mountains (illus. 5.20, 5.21, 5.22). He photographed in the factory where the workers labored with the crude machines to extract and process the hard gems (illus. 5.23, 5.24). In one postcard he captured the foreman and a mine executive overlooking the operation in pit no. 2 of the Barton Mine (illus. 5.25). Interestingly, the pictures of the mines are not picturesque, and it is unlikely that tourists visited these industrial sites. There was probably a local market for them, and perhaps tourists were drawn to them because they were familiar with garnet. Ernest seemed more conscious of his photographic technique and composition in his garnet photographs, resulting in images that look more like commercial documentary photographs than his hamlet scenes.

5.21. Operating steam drill, Hooper Mine, c. 1925. Board 'n Batten Coll.

5.22. Garnet workers, c. 1915. Board 'n Batten Coll.

5.23. Worker at machine in garnet factory, c. 1915. Board 'n Batten Coll.

5.24. Man by steam dryer, c. 1920.
Board 'n Batten Coll.

5.25. Overseeing pit no. 2, Barton Mine. Board 'n Batten Coll.

Every few years, in the early spring, the Hudson River produced a minor local natural disaster. When the river rose too rapidly and the ice did not have sufficient time to melt and break into small chunks, the river flooded, carrying huge ice slabs onto the road that passed the Ameden store, closing it to traffic. That photographic opportunity was one of Ameden's favorites (illus. 5.26, 5.27). He also photographed the river drivers as they camped on the banks of the Hudson in North River.

The success of the Ameden store is indicated by the vehicles Ernest and Ella owned. They were one of the first families in the area to own a car, a distinction that brought them local notoriety. The Amedens' cars were not small coupes or roadsters but expansive touring cars, Packards. Early cars did not come with a heater—a distinct disadvantage in the Adirondack climate. But rather than store his automobile for the winter, Ernest rigged a kerosene heater in the back of the vehicle.

Ameden's automobiles were not just status symbols. His touring car allowed him to expand his photography business beyond the confines of the immediate North River area. He extended his territory for both taking and selling photographs by driving to Minerva, Wevertown, North Creek, Thirteenth Lake, Olmstedville, Pottersville, Schroon Lake, Chestertown, Loon Lake, and Indian Lake. He took some pictures of town centers, but his best-selling subjects were of local business: hotels, stores, gas stations, and restaurants (illus. 5.28, 5.29, 5.30). With the cooperation of the merchants, he photographed their establishments and provided them with postcards that they sold to tourists who frequented their businesses. In most cases, Ameden sold the cards outright, and the merchants made their profit on the markup. Occasionally, Ernest placed

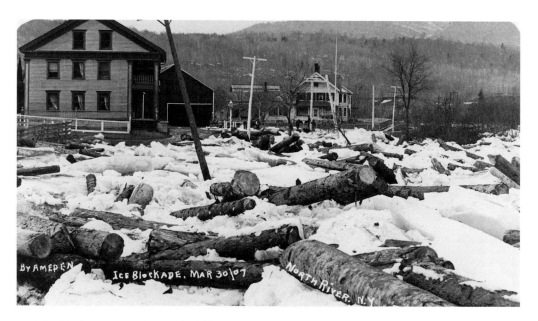

5.26. Ice blockage, 1907. Comstock Coll.

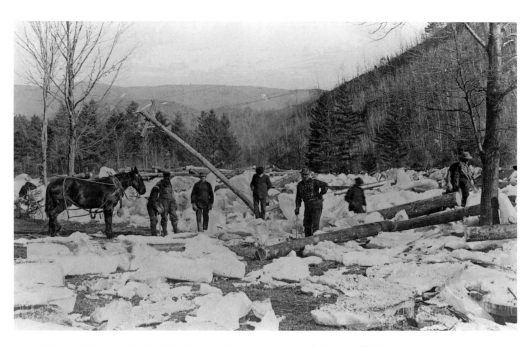

5.27. Men working to clear ice blocking road, c. 1907. Board 'n Batten Coll.

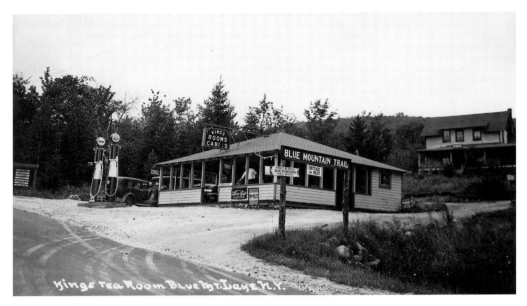

5.28. King's Tea Room, Blue Mountain Lake, c. 1928. Board 'n Batten Coll.

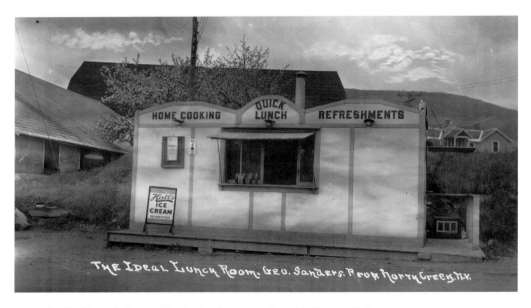

5.29. The Ideal Lunch Room, North Creek, c. 1926. Board 'n Batten Coll.

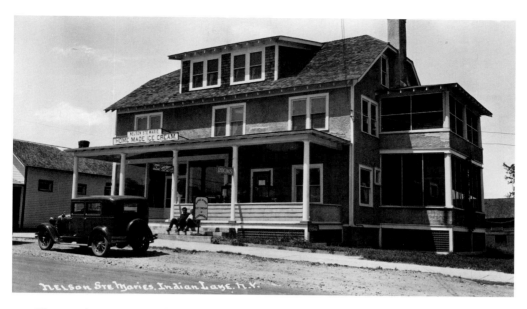

5.30. Homemade ice cream, Nelson Ste. Maries, Indian Lake, c. 1928. Board 'n Batten Coll.

cards in stores on consignment. He worked a radius of approximately forty miles from his shop. Blue Mountain Lake was probably as far west as he photographed. Areas that were farther east—Bolton Landing, Ticondiroga, and other spots on Lake George—were included, but they were a minor part of his itinerary. In that direction there were many competing photographers. Ernest tended to pick up the lower end of the business, the smaller, less established enterprises that tended to place modest orders.

Another event that influenced the North River economy and Ernest's business in the depression-dominated 1930s was the increasing popularity of skiing and the formation of the Gore Mountain Ski Club. Inspired by their visit to the Winter Olympic Games in 1932, would-be club founders converted the abandoned logging roads of Gore Mountain into ski trails. The construction started a chain of events that resulted in making North Creek one of the earliest and most active and financially successful ski areas in America. On March 4, 1934, the first "ski train" arrived in North Creek from Schenectady (Shaughnessy 1997), carrying 378 skiers. The service proved so successful that soon there was a ski train that left Grand Central Station in New York City at 12:45 A.M., arriving in North Creek at 7:20 every Saturday morning. This allowed skiers two full days of snow recreation before they had to catch the train at 5:30 Sunday evening for the ride back.

When the winter sports enthusiasts arrived at the station, local people met them with vehicles that, for a small fee, would take them to Barton Mines. From there they could ski down a four-and-one-half-mile trail to Route 28 and then ride back up in the locally supplied vehicles (Johnsburg Historical Society 1994, 132–39). Within a few years, as many as three thousand skiers were arriving for the weekend by train to make use of

the innovative "ride up–slide down" system. The development of commercial skiing changed the winter face of North Creek and neighboring hamlets such as North River as local residents provided transportation, services, food, and lodging for skiers (Kaplan 1991).

Ameden drove to North Creek when the snow trains arrived. With his photo postcards he documented the development of the ski industry: the skiers disembarking and loading into the local transportation (illus. 5.31), the development of mechanical tows (illus. 5.32, 5.33), and the ski patrol (illus. 5.34), which was alleged to be the first in the country.

Although photography was an important part of Ameden's life, and perhaps one of the more enjoyable things he did, it remained a sideline. "Photographer" was only part of his public and self-identity. In the 1915 census Ernest's occupation was listed as store proprietor. An obituary published in the local paper at the time of his death does not even mention his contribution as a photographer. On his death certificate his occupation is listed as "Post master."

Ameden produced many memorable photographic postcards, but the quality of his work was inconsistent. Some lack contrast, others are poorly composed, and still others are out of focus. Although Ernest can be criticized for these apparent flaws, they do contribute to defining his distinctive snapshot style.

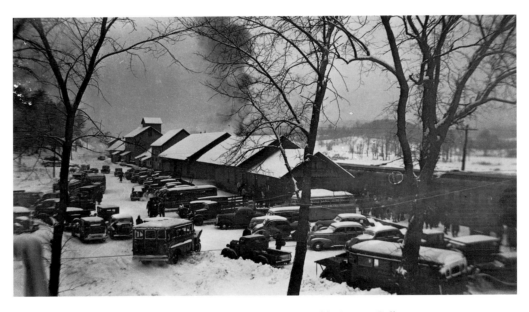

5.31. North Creek Station with ski trains arriving, c. 1935. Board 'n Batten Coll.

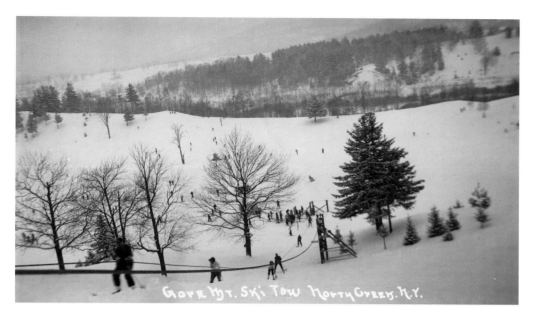

5.32. Rope tow at Gore Mountain, c. 1935. Board 'n Batten Coll.

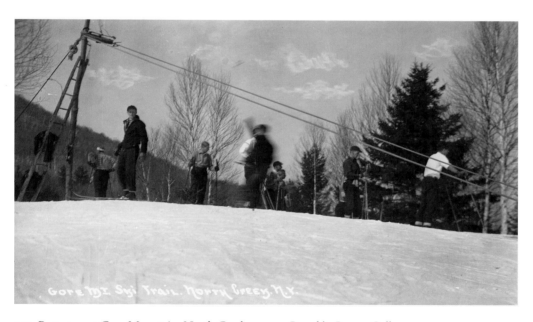

5.33. Rope tow at Gore Mountain, North Creek, c. 1935. Board 'n Batten Coll.

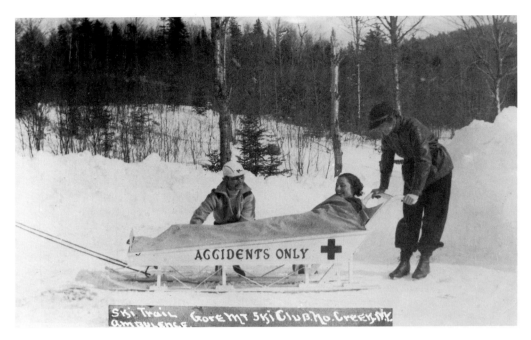

5.34. Ski trail ambulance, c. 1935. Board 'n Batten Coll.

Photography for Ameden was a sideline. He had a limited clientele. The amount of photography varied with the demands of his other store-related duties. As he aged and Ross, his youngest son, took over many of his store chores, Ernest had more time for his photography. Even then he did not devote substantial time to it. By the time the ski industry was starting, Ernest was feeling the effects of old age. John Cornwell had opened a studio in North Creek and, using better equipment and techniques, was taking photographic postcards that cut into Ernest's business.

Few of Ameden's cards incorporate a logo or other identifying marks. Some can be recognized only because they embody his style of composition and printing. Others can be recognized by the style of his handwritten captions. On a small percentage of the cards he marked them with "Ameden" or "Ernest J. Ameden" or "E. J. A." Later in his career, he used rubber stamps: "North River Studio, North River, N.Y. (Adirondack Mts.)" "PHOTO BY ERNEST J. AMEDEN, NORTH RIVER, N.Y. ADIRONDACK MTS." on the address side of the card. But he used his stamps inconsistently. Occasionally, one might find a printed (as opposed to a photo) card identified as having been produced by Ameden, which indicates that he sent some of his photographs to a commercial publisher to produce halftone copies for him.

The Routine, Family, and Reputation

By the late 1920s, Ameden had become a person of habit. He rose at dawn, did chores, went to the store, and developed and printed photographs. This routine was followed by breakfast in the store kitchen, the opening of the shop, and performance of

postmaster and proprietor duties. Long after horse-drawn stagecoaches performed the task, the Amedens and the people in the hamlet still used the expression "the stage" to refer to the motorized vehicle that brought the mail from North Creek in the morning. It was the central event of the day. Not only did it bring people's mail, which required sorting and distribution, but it also brought parcels of goods to stock the store.[8] After it stopped at North River, the stage traveled north to Indian Lake, and then on its way back stopped at the Amedens' store again to pick up the mail.

A little before noon, Ernest and Ella ate lunch in the kitchen in the back. Afterward they did more store work, and then at about two o'clock Ernest took leave of his duties for a thirty-minute nap in a soft chair in the living room of the main house. If the store was not busy or he did not have pressing jobs to attend, he would continue his photography work until dinner. His grandson remembers times when they had to bang on the door of the darkroom to get him to meals. After dinner the store remained open until dusk. Bedtime quickly followed. Sometimes Ernest visited hotels and scenic sites in the area, taking photographs and delivering stacks of finished postcards.

The Amedens did not travel much outside the area. Going to Glens Falls and the town of Lake George was a rare trip. But every Sunday all the family members were required to wear their Sunday best and go for a ride in the family car. They must have been quite a picture themselves, driving down the road in the Packard, all dressed up.

The family is remembered as hardworking. Ella and Ernest and the boys did the chores, maintained the property, and ran the store together. People liked and respected them: they were "real assets to the community," as one person put it. Although they had the admiration of the community and were active in its affairs, they were also regarded as a little different—better off and more cultured than the run-of-the-mill North Riverite. In a place where most people made their living outdoors doing physical labor, the lifestyle of a merchant must have been a little odd, especially if the man of the family did photography. Interestingly, although they lived in North River for many years, had relatives who were born in the area, and had grown up not far away, locals eventually came to believe that Ernest and Ella were from the well-to-do community of Scarsdale in Westchester County. I was told by old-timers that they had moved to North River because Ross had been stricken by polio. A local history of the area states that they came from Scarsdale (Johnsburg Historical Society 1994).

With the exception of their firstborn son, Arch, the Ameden family was close. They cared for and supported each other during easy as well as tough times. Ernest and Ella spent much time with their sons and their grandchildren. They went on outings and had family gatherings. The men fished and hunted together.

Arch Ameden might have contributed to the rumor that they were from Scarsdale. When Ernest and Ella moved to North River, Arch went to New York City to seek his fortune. He struck it rich by establishing an advertising agency. He married Alvina Mussman, who sang professionally at the Keith Orpheum Theater in New York. She

8. Ernest did not deliver the mail. People came to the store to pick it up. It is not clear why there was not rural delivery since that service was a regular feature of the postal service by 1920. Either North River was too rural to be eligible or someone other than Ernest delivered under a special contract with the postal service.

5.35. Howard and Ella Ameden
and dead buck, c. 1930.
Board 'n Batten Coll.

had no affection for the North River wilderness or its inhabitants. They had two sons,
Alden and Kent.

The prosperous couple hired a local North River young woman, Minnie Richard-
son, to come and live with them as a nursemaid. The story of Arch and Alvina's rise
to affluence does not have a happy ending. In 1921, he collapsed at dinner and died of
kidney failure.

Arch Ameden left only a small inheritance. His wife struggled to keep the house and
the family together.[9] Alden, Ernest's grandson, was only six when his father died. Ernest
and Ella had a fondness for children, so to help Alvina they invited Alden to North
Creek for the summer. It became an annual affair for the rest of his boyhood. The young
boy loved the summers in North River hiking with his grandfather and trout fishing
with his uncle Ross. He joined his grandfather on his photographic excursions. Alden
has fond memories of Ernest, Ella, Ross, his wife, Minnie, and their son, Preston, gath-

9. At one time she resorted to selling Spencer corsets door-to-door.

5.36. Ernest, Ella, Ross, and Preston Ameden, c. 1931. Ameden Coll.

ered in the evening for impromptu concerts in the house next to the store. Ella played the piano, Ernest the slide trombone, and Ross the trumpet. As Alden remembers, Ernest was most animated during those times.

Less is known about Howard (John Howard), Ernest and Ella's second son (illus. 5.35). People who remember him are reluctant to go into detail but describe him as a little odd—a loner and never really a part of the community. He married a North Creek woman and for a time resided in New York City with her and a daughter. The marriage ended in divorce. In his early thirties he served in World War I. Afterward he moved in with his parents. He worked around the property but never took on any real responsibilities. Emotionally fragile, he spent time at a state hospital near Utica. At one time Howard had a pet fox that he kept on a leash. Ernest, Ella, and Ross were loyal to him, problems and all.

Ross was Ernest and Ella's last born and only eleven when the Amedens moved to North River. He loved to be in the woods hiking, camping, fishing, and hunting. From the early years onward he could be seen wading, rod in hand, in the Hudson River in front of the store, pursuing trout that lay in the pools. When he was in his early thirties Ross married a local woman, Minnie Richardson, who had worked for Arch and Alvina in New York City. Their only child, Preston, was the first child in the family born in a hospital. In the early twenties they moved to an apartment over the Ameden store where they worked. Preston was the light of the whole family's life and a special joy to Ernest and Ella (illus. 5.36). Ernest took many photographs of the family, and Preston was his favorite subject.

Ernest's Last Years

Ameden continued to take pictures and work in the store through the 1930s, but the last years of that decade were difficult for him. With the onset of the Great Depression, fewer summer tourists came to the area, and although sustaining a store in a small hamlet such as North River was always difficult, it was even tougher in the thirties. The postmaster job did not pay much, and with no social security and Ernest's failing health, they struggled.

When Ella first came to North Creek she was physically active, working long hours in the garden and the store, attending church events, and visiting friends. She suffered an increasingly debilitating disease that seriously affected her in her old age. Although the exact nature of her condition is unclear, her legs swelled. By the time she was in her late fifties her legs were so large she could barely walk. She later became an invalid, confined to the house and its immediate surroundings.

Ernest had his own health problems, including shortness of breath and difficulty getting about. He suffered from chronic nephritis (liver failure) and chronic myocarditis (heart disease). He stopped working in January 1940. In March he was bedridden. At ten o'clock on the night of April 5, 1940, he died at home from a pulmonary edema. He was seventy-seven years old. He had lived in North River the last forty years and had been the postmaster for thirty-nine. The Reverend Donald R. Lewis, pastor of the North Creek and North River Methodist Church, officiated at the services, which were held at home. Ameden was interred in Union Cemetery in North Creek.

After Ernest died, Ella stopped going to the store. She could no longer walk. Women in the town called on her to talk and quilt. Mrs. Ordway, who lived a few houses down, was a good friend and a regular visitor.

Howard Ameden continued to reside on the second floor of the family home while Ella lived downstairs. Ross succeeded Ernest as postmaster, and he and Minnie ran the store, which by then was in decline. Nine years after his father passed away, Ross died of a cerebral hemorrhage at the age of sixty. Minnie became the postmaster and was left to care for Ella alone. Howard died in 1952 at the VA hospital in Albany, leaving Ella to survive all of her children. She died in 1954 of uremia. She was ninety years old.

Minnie remarried and continued as postmaster and manager of the store until the mid-sixties, when the property was sold.[10]

Ernest's Surviving Photographic Postcards

With the exception of a few items that Minnie and Preston's wife wanted, the contents of the house and store were dispersed at auction. At the time of the sale, approximately one thousand of Ernest's glass and celluloid negatives had survived. Neighbors purchased them for a few dollars. They remained in their attic until recently when they were passed on to local antique dealers with an interest in regional history. The nega-

10. Although Minnie continued to operate the post office, it moved from the old Ameden store to a building owned by Mr. and Mrs. Martin Feebern.

tives are now stored safely in their home. Many of the examples of Ameden's work in this book were printed from that collection.

Other than the considerable stock of Ameden negatives from the estate, there are no major holdings of his work. Most postcard dealers do not recognize his name. There are less than twenty postcards identified as Ernest's at the Adirondack Museum. Because his work varied in quality, and because of his casual attitude toward putting his name on his work, his cards are difficult to identify.

North River Today

There are no logs in the upper Hudson in the spring anymore, but in early April large rubber rafts full of urban adventurers ride the swollen river. White-water river rides bring some business and excitement, but nothing like the river drive of bygone days. Five miles south of North River, the town of North Creek is an active community with a number of Adirondack specialty shops and a new inn and restaurant that caters to affluent winter and summer visitors. Now people from North River drive to North Creek to get their groceries at the Grand Union.

It is difficult to recognize the Ameden property today. When a fire damaged the old store, it was torn down. The old residence is still there, and is well kept, but the Victorian porch has been remodeled. Going north, over the bridge across the Thirteenth Lake Creek, on the immediate left is a small frame building in need of repair. Outside is a small sign, "Towne's Grocery." Towne was Ameden's competitor. That store is the last vestige of the North River merchants.

Conclusion

Ernest Ameden had no thriving town to photograph. His world was defined by a nonagricultural rural hamlet, leaving him with limited photographic options. He still documented the community and nearby places and institutions, such as the garnet mines and the North Creek ski operation. He traveled short distances to photograph modest tourist spots, which was in addition to his major photographic work: his immediate area.

Ameden created his photographs when he could find time. His equipment was rudimentary. He was self-taught, did not keep up with new technology, and never had assistants. He was not prolific, and the views he took varied in their quality.

These considerations could be regarded as reasons to have excluded Ameden in this book. But, given his limitations, Ernest's accomplishments are considerable and his snapshot style unique. Furthermore, he is probably one of many small-volume Adirondack hamlet photographers whose work is unknown. He and his counterparts offer us a different view of the North Woods — a more local perspective. North River and its surroundings were not the wilderness to Ameden — they were home. It is that view that is most easily forgotten.

6

Jesse Sumner Wooley
Official Silver Bay Photographer

TWENTY-THREE MILES east of what was Ameden's store, on the northwest shore of Lake George, lies Silver Bay. It is the site of the beautiful and extensive lakeshore campus of the Silver Bay Association that serves as the northeast headquarters of the YMCA. The association was founded at the turn of the century as a Christian youth and missionary conference and training center. From 1908 until 1923, Jesse Wooley (he preferred "Jess") was its official resident summer photographer (illus. 6.1). Photography on the association grounds was his major preoccupation, but he also traveled the lake on steamers, focusing his camera on boats, hotels, summer homes, camps, and other aspects of life along the shore (illus. 6.2, 6.3).

Jess Wooley's relationship with the North Woods was quite different from Ernest Ameden's. Ernest was a year-round resident and made his living encircled by local people. For the fifteen years Wooley worked at Silver Bay, the Adirondacks were his quarters only in July and August. Conference attendees and the assembly of association staff surrounded him. His home, substantive business interests, and civic and family connections were in Ballston Spa, a bustling and prosperous town just south of Saratoga Springs.

There were other differences that set the men apart. Ernest owned a modest store, served as a rural postmaster, and was not active in civic affairs. Jess was a conspicuous Ballston Spa church elder, a civic leader, and a successful businessman. Ameden was a private person who liked to retreat into his photographic pursuits. Wooley was a self-promoter and an effective public speaker who enjoyed the limelight. Ernest was satisfied with his limited rural existence; Jess was well traveled and had cosmopolitan aspirations.

Lake George, where Wooley took his postcards, was distinct from all other Adirondack locations. The thirty-two-mile-long recreational lake lies in the southeast corner of the Adirondack Park, closer to Albany, the state capital, and the major population centers along the U.S. northeastern coast than any other area in the park. It was always the easiest to reach by all modes of transportation—boat, train, or car—which accounts for its being the area's earliest settled, most visited, and, at its southern end at least, most commercialized spot (Terrie 1997, 22). The region was not an official part of the park until 1931, when, under the regime of then-governor Franklin Delano Roosevelt, the

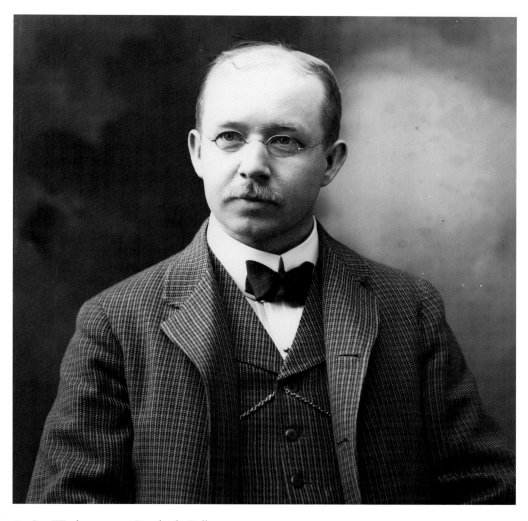

6.1. Jess Wooley, c. 1902. Brookside Coll.

6.2. Silver Bay Association from the south. Expansive view of grounds, c. 1912. Silver Bay Coll.

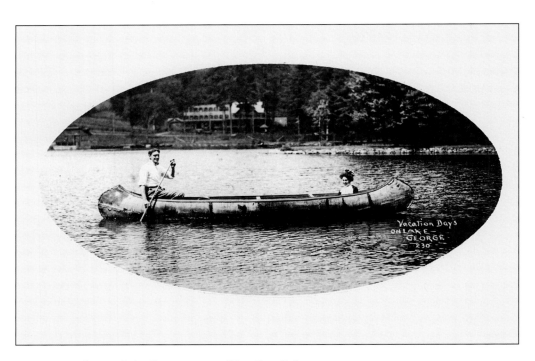

6.3. Vacation days on Lake George, c. 1911. Silver Bay Coll.

park boundaries were expanded. Although parts of the lake remained uncluttered, wilderness purists have disparagingly referred to the southern section as the Coney Island of the North Woods (D'Elia 1979, 34).

A series of municipalities lie south of the village of Lake George: Glens Falls, Saratoga Springs, and Ballston Spa. Their early development as industrial, commercial, transportation, health, and tourist centers placed Lake George within easy reach of America's earliest vacationers.

Ballston Spa and Saratoga Springs were the first major tourist destinations in the state. What drew visitors to the area were the natural springs whose waters were believed to both prevent and cure disease. Ballston Spa was the first to lure health seekers but was soon eclipsed by Saratoga Springs. By the 1790s, Saratoga had become a premier summer retreat for wealthy Americans.

In the mid–nineteenth century, the health resort added horse racing and casino gambling as attractions, increasing its draw. Soon some of those frequenters of Saratoga began moving north, looking for a tranquil substitute for the bustling resort town. By the 1870s, the number of hotels clustering around the southern end of the lake had reached twenty. The grandest was the mammoth Fort William Henry Hotel, which at one time could accommodate nine hundred guests (Schneider 1997, 183). In the latter part of the nineteenth century and early part of the twentieth, the western shore of Lake George as far north as Bolton Landing was a prime spot for the wealthy to build summer homes. It became known as "millionaires' row."

The Family Line and Early Years

Jesse Sumner Wooley was born on May 23, 1867, in the town of Wilton in Saratoga County, approximately six miles southeast of what is now the Adirondack Park. His family genealogy in the United States can be traced to the 1600s and the early settlers of Rhode Island. Some migrated to Saratoga County and first resided around Schuylerville, east of Saratoga, before moving to nearby Wilton. They, like Jess's parents, Edmund R. and Emma Winney Wooley, were farmers.[1]

Jess had three siblings, but only his youngest sister, Mabel, survived to adulthood. Jess spent his boyhood attending the local one-room school in rural Wilton.

In 1879, when Jess was twelve, the family moved to the Geysers in Saratoga Springs.[2] Soon after, in 1880, Wooley took a summer job as an errand boy at the partnership of Baker and Record, Saratoga photographers and daguerreotype artists who had a thriving gallery that courted locals and tourists. He returned to school in the fall and continued to work part-time. The next year he left formal education to join the company as a regular employee. An energetic and observant worker, Wooley advanced through an informal apprenticeship from general assistant in 1881 to an assistant photo printer in 1883. During this period, the establishment was reorganized as Record and Epler, and Wooley found himself working with another hired hand, the photographer T. J. Arnold.

Arnold observed Wooley's ambition and skill firsthand. In 1885, when he launched his own studio in nearby Ballston Spa, he made Jess an offer he could not refuse: Arnold would pay Wooley seven dollars per week to join him. Jess moved out of his family home into a boardinghouse near the studio. Arnold's shop was on the top floor of the Luther Block, on the corner of Front and Low Streets. Wooley was given more responsibility than he had in his previous position, allowing him to hone a variety of photographic and business skills (illus. 6.4).

In July 1887, Arnold decided to move back to Saratoga as the business partner of one of his former bosses, Epler. Arnold was fond of the young Wooley and confident of his ability, so he offered Jess the opportunity to buy the business. Wooley borrowed fifteen hundred dollars and, at the age of twenty, became a self-employed photographer with his own gallery. As Arnold had, Jess fashioned his business as a "gallery." On the printed backs of his cabinet card portraits he called himself an "Artistic Photographer." Cabinet card and carte de visite portraits were the mainstays of the business, as they were for most photographers of the time. In an attempt to find a place in the marketplace, he advertised "instantaneous portraits of children, a successful specialty," as well as scenic views. Although the photographic business was competitive in the Ballston Spa area, Wooley was confident in his photographic and entrepreneurial skills. His business prospered, and in a short time he hired an assistant. Jess became a well-known young man about town.

1. Jess's father was born in Wilton in 1835, and his mother in 1838 in Saratoga.

2. Sometime after the move, Jess's father changed occupations. In the 1890 census he is listed as an oil dealer.

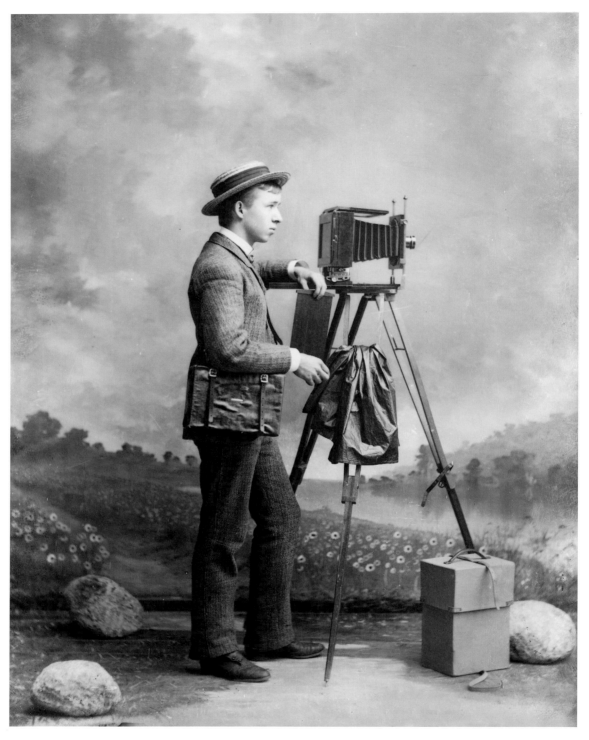

6.4. Jess Wooley as a young photographer, c. 1885. Brookside Coll.

Marriage and the Family

Soon after he launched his business, Wooley met his future wife, Susan Arnold (illus. 6.5). Susie, as she was called, was working at T. C. Kelly's milliner shop when she and Jess began their short courtship. She was two years older and had at least one more year of schooling than her husband-to-be. She was a poised and attractive young woman with a keen eye for fashion. According to his May 8, 1890, obituary in the *Saratoga Springs Saratogian,* Simeon D. Arnold, her father, was a highly respected and prominent Ballston Spa dentist. Susie was above Jess, the farmer's son, in status, but he had already revealed the characteristics of a young man who would rise above his modest beginnings.

On September 18, 1889, Jess and Susie married in the home of the bride's parents, and "the presents were numerous and costly," according to the marriage notice in the *Ballston Journal.* On the evening of the wedding, the couple left by railroad for a ten-day holiday in New York City and Brooklyn.

6.5. Susan Arnold Wooley, Jess's wife, c. 1900. Brookside Coll.

6.6. Composite of Jess, the building that housed his gallery, and the inside of his studio, c. 1896. Brookside Coll.

The Wooleys began their married life on McMaster Street, moving in 1890 to an apartment in the new Sans Souci Opera House block on Monument Square. Jess's studio was directly across the street (illus. 6.6).

Both Jess and Susie were attentive to their appearance. They were always in vogue and impeccable. Jess posed Susie many times before his camera outfitted in fine apparel, striking fashionable poses. Although the handsome couple shared dress style, they had different personalities. She was quiet and calm and played a backstage role to her flamboyant, energetic husband. Wooley's gregariousness overwhelmed his wife's serene presence. In the historical record he looms so large that she is hardly acknowledged.

During the first year of their marriage the Wooleys' first child, Marion (also known as Eleanor), was born. Carl Sumner, their son and last child, was not born until nine years later.[3] Wife and mother were Susie's primary roles. Before their marriage Jess began a pattern of frequent travel that started as local trips but eventually expanded well be-

3. Marion married John Franklin Killer on June 6, 1917. Carl married Catherine Mary Languor on September 17, 1923.

yond Ballston Spa. Similar to Henry Beach, it was not uncommon for Jess to leave his family and be away for months, while Susie stayed at home with the children. He was the family patriarch, making the decisions about business and social matters without his wife's participation (Puckhaber and MacMillin 1978).

Seneca Ray Stoddard and Magic Lanterns

A few months before his marriage and two years after he established his studio, Jess took his first photographic trip. In April 1889, accompanied by an assistant, he boarded a train to New York City to photograph the Washington Centennial Celebration honoring the inauguration of the country's first president. When he returned home, the photographs sold briskly.

Seneca Ray Stoddard, the best known of all photographers of the Adirondacks, maintained his studio in Glens Falls (DeSormo 1972; Crowley 1982; Horrell 1995; Adler 1997). Stoddard was already a famous cameraman, guidebook writer and mapmaker, and North Woods tourist promoter when he and Wooley teamed up in the 1890s. Stoddard was twenty-four years Wooley's senior. Like Jess, he was born in Wilton. Given Stoddard's renown and seniority, one might conclude that Wooley was Stoddard's assistant (Adler 1997). Whether Stoddard hired Wooley or they formed a partnership, in August 1893 the two men toured the Adirondacks together on a photographic excursion.

Their trip occurred after Stoddard had presented his well-known lantern slide-show lecture (also known as a stereopticon lecture or lantern slide show) to the New York State Assembly as part of a lobby for the Adirondack Park bill (Adler 1997, 28) and immediately before the North Woods state land was officially declared "forever wild" by the New York State Constitution.[4] Wooley and Stoddard photographed Saranac Lake, Lake Placid, Tupper Lake, Long Lake, and Keene Valley, producing popular magic-lantern slide shows. This was the start of a short but active working relationship (illus. 6.7).[5]

In September 1893, Wooley and Stoddard embarked on a different type of a trip, to the great Chicago Centennial Exhibition, the World's Fair. The trip resulted in a lantern slide illustrated lecture called "The Great White City" through which Wooley shared with his Ballston Spa neighbors the fair's technological innovations that would come to define the twentieth century (Ley 1997). Additional tours of New York and Vermont followed until 1897 when Wooley and Stoddard traveled together for the last time.

4. Stereopticon lectures had become an important form of entertainment and education in the 1890s. They consisted of a series of hand-colored photographic glass slides projected on a large screen accompanied by a talk. The "magic lantern" shows were the predecessors of motion pictures. Churches and community lecture halls sponsored shows with paid lecturers. Money was to be made from giving shows, but in addition the public presentations promoted the lecturer's name; for photographers, that advertising translated into more business.

5. Apparently, Wooley was involved with lantern shows before he began traveling with Stoddard. Wooley gave one in Ballston Spa Baptist Church in April 1893, before his first trip with Stoddard.

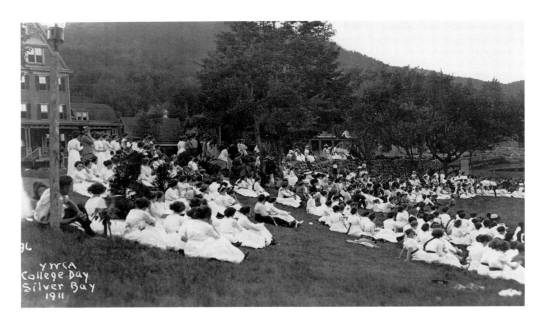

6.22. YWCA College Day on the lawn, 1911. Silver Bay Coll.

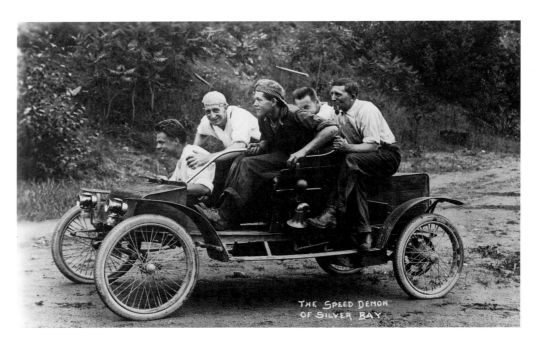

6.23. "The Speed Demon," c. 1912. Silver Bay Coll.

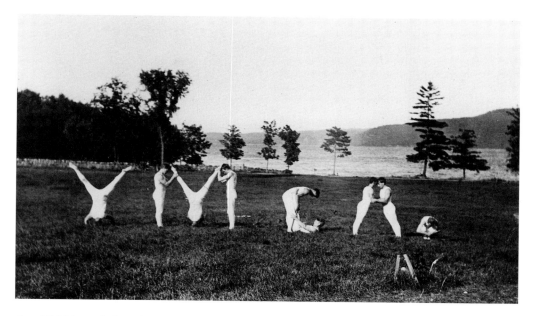

6.24. YMCA, spelled out by Silver Bay gymnasts, c. 1910. Silver Bay Coll.

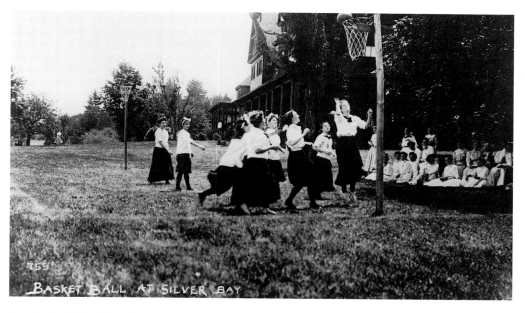

6.25. Basketball at Silver Bay, c. 1911. Silver Bay Coll.

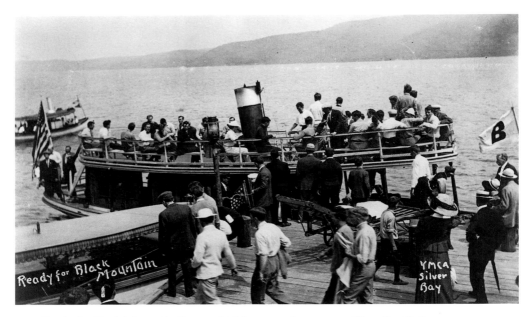

6.26. Ready for Black Mountain. Boat and hiking excursion, c. 1910. Silver Bay Coll.

6.27. Diving from platform, c. 1910. Silver Bay Coll.

6.28. Human pyramid on Silver Bay dock, c. 1910. Silver Bay Coll.

The summer conference season was punctuated with festive campuswide events, such as sporting competitions, fairs, carnivals, and mock circuses. The Silver Bay Association rallied together and generated a level of enthusiasm to make these times memorable. Although some were merely public athletic competitions and activities that were a normal part of campus life (illus. 6.29), others involved colorful costumes and outrageously out-of-character behavior and dress (illus. 6.30, 6.31). The events were a release from life as usual, a break in routine, and a temporary easing of status roles.

Jess was also on-hand for one-of-a-kind events. For example, when the aging Lake George steamship the *Horicon* was replaced in 1911 by a new vessel, the poshly decorated and furnished *Horicon II,* Wooley photographed its maiden voyage (illus. 6.32). Visits by dignitaries sometimes called for special arrangements by conference attendees and staff. Never was this truer than when the governor of New York State, Charles Evans Hughes, came to Silver Bay in August 1909. When he arrived on his launch, the *Pocahontas,* he pulled up to the dock and was greeted by two lines of young Christian men who formed a human corridor extending from the shore to the main building (illus. 6.33, 6.34, 6.35). There were other formal receptions and patriotic gatherings throughout the years of Wooley's tenure, and he captured them all (illus. 6.36).

With each person in the picture a potential customer, group pictures always sold well. Wooley took these in postcard format, but, like other contemporaries, he ventured into the panoramic business as well. Wooley's son, Carl, reportedly delighted in appearing in such pictures twice, which he accomplished by running behind the camera after his father had clicked it and reaching the other end before the lens had finished panning the crowd.

6.29. Acrobatic display at county fair, Silver Bay, c. 1910. Silver Bay Coll.

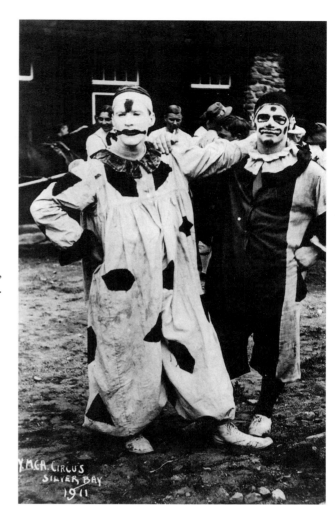

6.30. YMCA circus clowns, 1911. Silver Bay Coll.

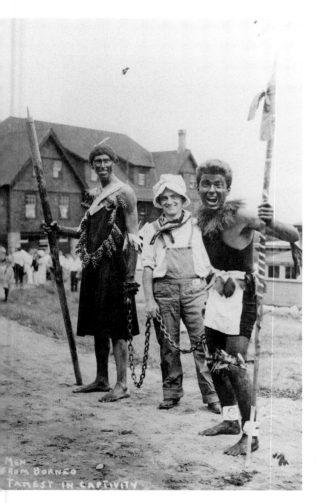

6.31. "Wild men from Borneo," 1911. Silver Bay Coll.

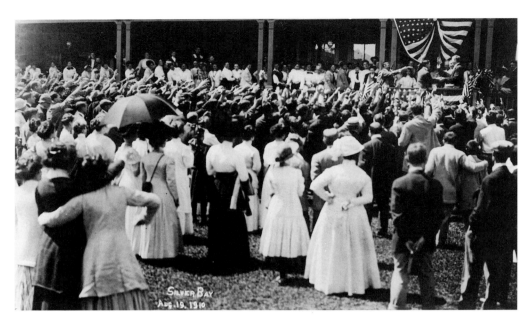

6.36. Gathering in honor of visiting dignitaries, 1910. Silver Bay Coll.

Although the photography display book at Wooley's Silver Bay establishment was dominated by views of the association grounds and visitors, it also featured an assortment of pictures of Lake George steamers and small boats, as well as the shore. Wooley used Silver Bay as a base of operations for photographic excursions and business. He rode the steamers up and down the lake, photographing the hotels, selling his products to the proprietors, who in turn sold them to guests and other tourists. In addition, he created postcard views of summer homes and made arrangements with the managers of at least three children's camps. The pictures are of higher-end establishments that catered to the more well-to-do. There is no evidence of the roadside honky-tonk businesses pictured by Ameden and the Eastern Illustrated and Publishing Company photographers discussed later. This emphasis on the moderately well-to-do is partly because of the physical surroundings in which Jess found himself. Businesses and dwellings on the northern west end of the lake were not easily accessible by road and served a wealthier clientele, but his subject matter was also a function of the customers Wooley courted and felt comfortable with. He favored the more affluent, the upper middle class, over the masses.

There are few photographs in Wooley's Lake George portfolio of local people. In the early years, Silver Bay maintained contact with its surrounding neighbors because the association's general store was open to them. When automobiles were introduced into the area, the Silver Bay store was one of the first places to sell gasoline (Silver Bay Association 1992, 32). Otherwise, locals were not often present on the association campus, and Wooley did not stray far from the affluence of the lakeshore. The association hired

some locals to work in the kitchen, do housekeeping, and work on the grounds, but generally the staff consisted of Christian leaders (or leaders in training), the college-age children of parents with association connections, and young people affiliated with YMCA and YWCA chapters.[10] People with ties to the Silver Bay Association refer to the "Silver Bay Family" in pointing to their common bond. Part of the closeness was produced by the rotation of summer jobs among members and the passing down of jobs through the generations. More than a few supporters of the association met their spouses while they were "emps" (an insider's word for "employees") at Silver Bay.

Quasi-wilderness religious camps and conference settings such as the Silver Bay complex were successful in part because of the widespread association of the forest with spiritual renewal. To retreat to the shores of Lake George was not merely to have a frivolous vacation; it was also a place for the Christian middle class to go to fortify their commitment to the Lord and prepare themselves to do God's work. To go to Silver Bay was to take a sojourn into a world of like-minded people of similar backgrounds. It was a world set on the edge of the forest, but isolated from the people who lived there. That world was what Wooley captured in his postcards.

Later Life

In 1915, when Wooley was only forty-eight years old, he sold the photography part of his business in Ballston Spa to Howard L. Humes. Jess retained and continued to work the gift-shop portion of the operation with the help of his son. In that year he also began printing color postcards from his photo postcards. Apparently, this endeavor succeeded. Wooley eventually sold his printed postcard business to C. W. Hughes of Mechanicville. Although Carl, Jess's son, worked with his father in the store and took some photographs, he did not carry on his father's photography business.

Wooley continued to operate his photography store and studio at Silver Bay two months a year and his Ballston Spa gift shop during the rest of the year until 1923. Then, at the age of fifty-six, he gave up his position at Silver Bay, turned the Ballston Spa shop over to Carl, and retired. Under Carl's management, the store went downhill, eventually becoming an antique shop.

In the late 1920s and through the 1930s, Jess and Susie Wooley spent many of their winters enjoying their retirement and traveling in Florida. On these trips Jess shot photographic postcards.[11] In one collection there are 320 photographic postcards produced by him from 1929 to 1935.[12] Most are of Florida's cities. Miami was their favorite destination.

On September 18, 1939, when Jess and his wife were in their midseventies, they put an announcement in the *Saratogian* that they were having an open house and reception at their Pleasant Street home. The occasion was their fiftieth wedding anniversary. It

10. Approximately 10 percent of the staff were local residents.

11. It is unknown whether Wooley sold these postcards or took them for his own enjoyment.

12. The photographs are in a box labeled "A Partial Photographic Record of Trips through the Southland with a Kodak, Photos Taken by J. S. W. 1929–1935," now in the archives of the University of Florida at Coral Gables.

produced quite a turnout and was one of their last public appearances. Susan died on January 16, 1942. Jess had suffered a stroke in 1940 and died three years later, on April 30, 1943. He and his wife are buried in the Ballston Spa Village Cemetery.

The Remains of Wooley's Work

Wooley was a prolific photographer. Although he took photo postcards in other areas of the North Woods, I have concentrated on his photographs of Silver Bay.[13] They are a significant part of his photo postcard legacy, but his views of the Ballston Spa area undoubtedly outnumber them. Many of Wooley's cards of Ballston Spa have much in common with the views taken by village photographers such as Mandeville and Kollecker. However, Jess was more mobile than those two photographers and serviced villages and hamlets within a fifty-mile radius of his studio.

There are many private collectors of Wooley's photo postcard views who have extensive collections. The Silver Bay Association has many examples of his work, including his sample book. The Brookside Museum in Ballston Spa is probably the largest single depository of Wooley's photography. In addition to a large, well-preserved collection of his postcards (many are of Silver Bay and Lake George), the museum houses a comprehensive collection of Wooley's negatives, lantern slides, and other photographs.

In the 1960s, what had been Wooley's store, on the corner of Milton and Washington, was sold. The person who bought it did not have restoration or preservation in mind. The bulldozers arrived for demolition. A longtime Ballston Spa resident who knew that there were boxes of Jess's negatives in the building rushed to the site. Bribing the crew with donuts and coffee, he was allowed to carry a few boxes to safety. The rest were buried in the rubble and carried away to a landfill. A gas station was built on the spot. A decade later it was leveled to make room for another structure. The property, located at a busy intersection where vehicles pass through the village, heading toward the Northway, an interstate highway, was a perfect location for a self-service gas station and minimart.

Conclusion

Jess Wooley was the most well-to-do, the best-known, and one of the more business-oriented photographers we are considering. His close affiliation with the Silver Bay Association and the limited contact he had with Adirondackers, tourists, and others outside the Christian retreat produced an in-depth documentary of a limited and self-contained part of the wilderness. He produced pictures that captured the conference attendees and staff the way they wanted to appear, busy in their activities and among the splendor of the lakeside retreat. He reinforced their view of the wilderness and their place in it.

13. Photo postcards that Wooley took in the Speculator area and at Lake Pleasant survive. I have not aggressively pursued locating examples of his work outside the Lake George area. The Adirondack Museum has few examples of his work.

7

Rudolph Herman Cassens
The Eastern Illustrating and Publishing Company

IN 1909, Rudolph Herman Cassens established the Eastern Illustrating and Publishing Company (known simply as "Eastern"), a company in Belfast, Maine, that produced photographic postcards exclusively (Harding 1982) (illus. 7.1). The most prolific photo postcard studios could manufacture thousands of cards a year, but Cassens put together an organization that in its peak years published a million per annum. He claimed his company was the largest manufacturer of photo postcards in the United States. His approach to photography emphasized large-scale production.

With a few exceptions, photo postcard producers covered limited areas within a convenient drive of their homes. Cassens's company employees took photographs and sold photo cards all over nonurban New England and New York, including the Adirondacks. Eastern rivaled Henry Beach in the number of photo postcards produced of the North Woods.

The company's photographers traveled roads of the Northeast by car, taking pictures and making sales (illus. 7.2). They did not stray far from the main thoroughfares. They courted small-town merchants as well as businesses that catered to tourists and photographed some of the very roadside gas stations, eateries, hotels, and tourist cabins where they bought fuel, took meals, and spent the night (illus. 7.3, 7.4, 7.5). In addition, they captured children's summer camps on cards.

7.1. Rudolph Herman Cassens, c. 1902. Jardine Coll.

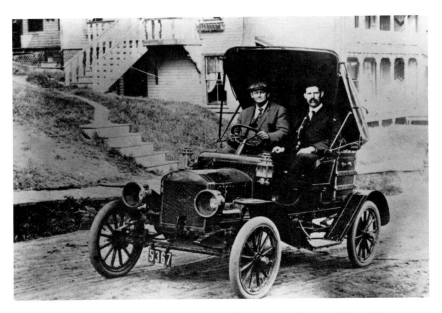

7.2. Herman Cassens (right) with photographer Horace Ellingwood in early automobile, 1909. Harding Coll.

7.3. Red, White, and Blue Filling Station, M. A. Flansburg, Wilmurt, N.Y., c. 1930. Adirondack Museum.

7.4. Jack's Camp, Elizabethtown, N.Y., c. 1928. Adirondack Museum.

7.5. Little Bayou tourist rest, Old Forge, N.Y., c. 1928. Adirondack Museum.

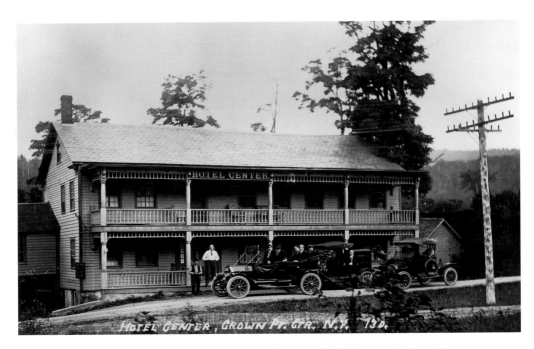

7.6. Hotel Center, Crown Point, N.Y. An Eastern vehicle is parked closest to the hotel, between two cars, c. 1913. Adirondack Museum.

Eastern's staff worked the sparsely settled areas because that is where there was a niche in the postcard market. Some places they served were too insignificant for printed postcard manufacturers to court. The market was too small. When the large companies did supply the smaller population areas, Eastern could compete because they offered a larger variety of views. Furthermore, some people preferred photo cards to printed ones. Local photographers were not available to serve all areas, and when they were, Eastern could vie with them for customers by producing high-quality products at competitive prices. Eastern representatives also earned a reputation for being dependable, congenial, and prompt in filling orders. The traveling photographers were small-town folks like their customers, and, when they returned season after season, they were treated as regulars. The highways of the Adirondacks became an important part of their market (illus. 7.6).

Herman's Early Years

Herman Cassens (he preferred Herman to Rudolph) was born to a poor family on December 14, 1875, on the coast of Maine, twenty miles south of Belfast in Rockland. His father, Cassen F. Cassens, a German immigrant, labored on ships and wharves all of his working life. His mother, Hannah E. Webb Cassens, was born in Deer Isle, a small island off the Maine coast. Herman had two brothers, Carl and Fred, and a sister, Lottie. Herman's mother died when he was young, and his father remarried.

Herman left school at the age of sixteen and began learning the printing trade by working for Robbins and Otis Publishers, the publishers of the *Rockland Opinion: An*

Independent Democratic Newspaper. In the late 1890s, he moved forty-five miles inland to the town of Waterville where he worked as a printer. He moved to Belfast in 1898 where Cream Publishing employed him. Cream produced a monthly magazine similar to the contemporary *Readers Digest.* Cassens began courting Lillian E. Hanson, the daughter of Edgar F. Hanson, the owner of Cream and a prominent Belfast businessman and civic leader.

Hanson had risen from poverty through imaginative business practices, hard work, and zeal. He started with a carriage manufacturing business and eventually became a partner in Dana's Sarsaparilla, a patent medicine company. Hanson was involved in several publishing and printing ventures and owned and operated citrus and avocado orchards in Florida. He was a ball of fire who was the Democratic mayor of Belfast for eleven years. Lillian grew up in a large house on Northport Avenue in Belfast.

On March 5, 1900, Herman and Lillian married in a grand wedding in Belfast (illus. 7.7). Although Herman was from common origins, Lillian's father appreciated Herman

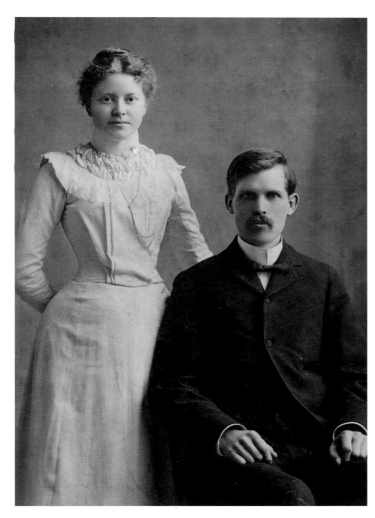

7.7. Lillian and Herman Cassens, c. 1902. Jardine Coll.

for his determination, organizational savvy, and common sense. He employed Herman and included him in his business ventures.

Herman and Lillian started their married life in Belfast. Their first child, Rudolph, was born in 1902. The next year, the couple followed Lillian's family to Chicago, where Hanson owned and operated Nutiola, a patent medicine firm. Herman worked for Hanson but was also employed by a newspaper. In Chicago, in 1905, Lillian gave birth to their first daughter, Geraldine. Three years later, Herman and Lillian and the Hansons moved back to Belfast where Herman worked for his father-in-law at the *Waldo County Herald* newspaper. Their last child, Dorothy, was born in Belfast in 1908 (illus. 7.8).

Eastern's Early Years

Probably with the help of capital provided by his father-in-law, Cassens, in 1909, at age thirty-three, established the Eastern Illustrating and Publishing Company. Although he started the business to produce photo postcards, because of his background in printing he wanted to leave his options open to expand into other products. He picked a good item to start with. Postcard sales had skyrocketed, and large manufacturers were focused on the printed postcard part of the market. Most photo postcard production remained a local enterprise, and launching a business that might compete in multiple local markets was promising but not without risk. Cassens was the right person in the

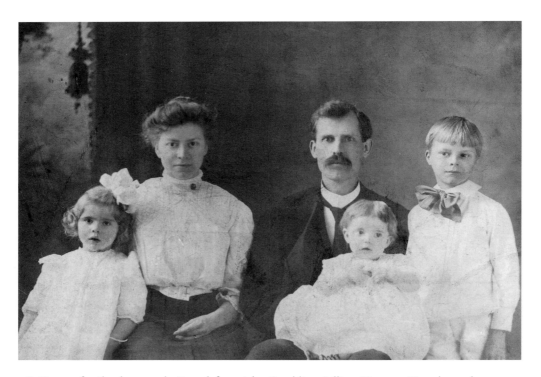

7.8. Cassens family photograph. From left to right: Geraldine, Lillian, Herman, Dorothy, and Rudolph, c. 1910. Jardine Coll.

right business, at the right time. Automobiles had become affordable, and improved roads were making travel feasible to rural New England and upstate New York.

The success of the company was clearly a result of Cassens's thoroughness and organizational skills. He was a good manager and had a good eye for photographs. The business prospered. Within a short time, Eastern became the largest manufacturer of photo postcards on the East Coast, if not the United States. Cassens struggled to keep up with the demand.

How Cassens picked up his photographic knowledge and skill is unknown. There is no evidence that he ever worked for a commercial photographer or operated his own studio. Likely, he came in contact with photographers during his newspaper and printing company days. By the 1890s, photographers were joining these establishments. The development of the technology for easily turning photographs into printed pictures had made engravings obsolete and halftone printed photographs in newspapers, brochures, and books standard. Cassens began taking scenic and street views before he established Eastern; in fact, some of the company's early issues were pictures taken by him prior to 1909.

In the first years of Eastern, Cassens did much of the photography himself, but as the company expanded he hired photographers to do the traveling. Even when he had photographers on staff, he continued to take pictures but did not stray far from Belfast where he ran the office and oversaw the printing.

Herman

Good-natured Herman stood about six feet tall but looked taller because of his lean build and straight posture. He sported a dark, heavy, handlebar mustache and typical Belfast business attire consisting of a dark suit, stiff collar, and tie. In some pictures he wore a felt hat that was a small rendition of the hats cowboys wore in the movies. Looking at photographs of this tall, thin, muscular, good-looking man, with his striking mus-

7.9. Herman Cassens walking on dirt road, c. 1909. Harding Coll.

tache and western hat, one sees a man more like a Hollywood gunfighter than a New England businessman (illus. 7.9). Like his father-in-law, Herman was a Democrat who liked to argue politics. His reading consisted of fiction, in particular the work of Edgar Rice Burroughs, the creator of Tarzan, and he regularly consumed newspapers as a way of keeping abreast of political affairs.

Cassens worked hard at his business when he was in Belfast, and although he was always present at the frequent and large extended family gatherings, he was not a homebody. His three children worked in the business during the summers when they were young, as did some of their school friends. Herman liked to frequent the Masonic temple and sit with friends and talk and smoke cigars.

Although Cassens took photographs, "photographer" was not his primary identity: "businessman" was. Others considered him a businessman first as well. In his obituary in the *Belfast (Maine) Republican Journal* on June 17, 1948, "photographer" was not mentioned; owner, founder, and manager of Eastern were given. Cassens took a few photos of his own family, but otherwise photography was more a business than a pleasure. He was not seen on the streets of Belfast carrying a camera, hoping to catch the right moment to shoot a street scene. Business and consistent quality work were his focuses.

On the Road for Eastern Illustrating

The position of the traveling photographer and sales representative was at the heart of Eastern's business. Those photographers who went on the road were given modest traveling expenses and paid a salary, but to make decent livings they also had to earn commissions. The good Eastern photographer had to be assertive and willing to work long days, travel that extra mile, and produce views that pleased the customer. Each man—they were all men—was assigned to a different region. He revisited customers to see if they wanted additional views and solicited new customers. Once he sold them on

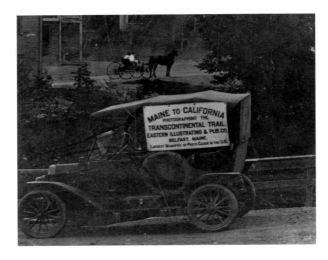

7.10. Eastern vehicle with sign, c. 1914. Harding Coll.

7.11. Eastern vehicle parked in front of store, c. 1914. Harding Coll.

the idea of handling Eastern cards, he took pictures and sent exposed plates and order sheets to Belfast by railway express. The factory staff immediately started on the order and shipped it back to the customer within days.

Sales representatives either were provided with company vehicles or used their own (illus. 7.10, 7.11). The company automobiles were recognizable by the large trunks for equipment mounted to a luggage rack on back. Some of the vehicles had an eye-catching sign that read "Eastern Illustrating and Publishing Company" on each end of the trunk.

The company provided photographic equipment, including a tripod and large, wooden, boxlike view cameras shaped about a foot square that used glass plates. Later cameras were outfitted for celluloid film, but photographers used five-by-seven-inch glass plates until the mid-1920s.

The company's photographer-salesmen left Belfast in late spring. They kept large clothbound sample books, a book for each region they covered. The majority of the early views were never considered out-of-date, so they remained in the books. In some rural villages many scenes changed slowly, so the cards had a long shelf life. New views were added each year as photographers returned to old haunts and expanded their territories. Eastern even supplied metal circular postcard display racks for merchants to feature the cards. Postcards typically retailed in the early days for two for five cents and later for five cents each.

The Photographers

There is no record of all the people who served the company as representatives. There were no more than four photographers on staff at a time. From 1911 to 1913, Cassens hired Loranus Covell, a photographer from Orange, Massachusetts, who had been a calendar manufacturer. In 1913, Horace Ellingwood of Winterport, Maine, became a

photographer and salesman. He had the reputation of taking wonderful views of the Maine coast. Herman's son, Rudolph, was a traveling photographer for the company for a time.

Herman's older brother, Fred W. Cassens, traveled through the small towns of Vermont and New York, taking pictures and making sales for the company. He was the mainstay photographer of the company, working for it the longest and doing some of the better views. Most of the Adirondack photo postcards by Eastern we admire today where taken by Fred.

Fred did well enough in commissions that he did not have to work during the seasons that the company was closed. He lived in Rockland with his wife, Etta, and children. He was extremely conscientious, well organized, and careful about his work and rarely made mistakes. His pictures are well composed, well exposed, and clearly focused. He used the same formula for similar scenes—buildings centered and shot straight-on from chest height—giving his work a uniformity that is easy to recognize.

A teetotaler, Fred Cassens was against liquor in any form. He declined to enter establishments that sold the stuff. Looking through the stock of Eastern's cards taken in the Adirondacks, one only rarely finds a liquor or beer advertisement or a photograph of a bar, restaurant, or store that sold intoxicants.[1] Some people said that Fred's avoidance of establishments that sold beer and liquor hurt the business—after all, many of the places he boycotted were prime places for selling cards. But he delivered on sales as well as anyone on the road, and Herman never complained.

Company staff claimed that Fred Cassens embellished scenes by hiring children to hold cut tree branches in the foreground. The story is part of Eastern folklore, but there is no evidence of the practice in his postcards.

Not all Eastern cards were captioned accurately. Titling on negatives was done on the emulsion side, which meant the lettering had to be done backward, right to left. Herman's sister and his two daughters did the titling. They used washable jet-black ink because some pictures, the more generic ones, could use multiple titles. For example, a card showing a sunset over a lake could serve as "Sunset over [any body of water]." A picture of a seagull at Lake Champlain was sold as a view with more than one coastal town's name attached. Other wildlife, lakeshore, and beach scenes were used similarly. Another trick was to print a picture taken during the day darkly and label it as a night scene. Such deception was common practice among firms as they strove to stretch the number of different views for sale.

The company did not always hire trained photographers. Some were just good salesmen who were given instructions in picture taking from the staff.[2] In the thirties and forties, Roger Rhoades, Herman's nephew, taught the men the basics. Cassens and the other employees sometimes joked that it was much easier to make a good photographer out of a salesman than a salesman out of a good photographer.

1. None of the Eastern cards in the Adirondack Museum show liquor, and only one shows beer. Prohibition was enforced during thirteen of the years Fred was active (from 1920 to 1933), which could also account for the booze-free cards.

2. This policy was truer in the later years of the company than during the first two decades.

Eastern's Adirondack Views

Although they took other scenes as well, Eastern documented the development of the modern roadside tourist industry in the North Woods best. Fred Cassens could be found at campgrounds, tourist homes, cabins, snack bars, gas stations, and roadside bathing beaches.

When early motor travelers wanted a place to sleep, they stopped by the roadside and camped using their own primitive tents and other early forms of outdoor gear. In an effort to control the growing number of camping tourists, villages and hamlets began designating areas for motorists to camp free of charge. Soon private campgrounds, where, for a small fee, motorists could stay for the night, were available. Water and basic sanitary facilities were supplied (illus. 7.12, 7.13). By the mid-1920s, New York State was well on its way to developing a string of public campgrounds in the North Woods (Brown 1985, 151–52). In the early 1930s, with federal government assistance through the Civilian Conservation Corps, large, congested public camping was becoming part of Adirondack life (illus. 7.14, 7.15). Some private campgrounds extended their facilities to include general stores selling groceries, sundries, and souvenirs on the premises as well as restaurants (illus. 7.16). Tourist cabins began springing up alongside tenting accommodations (illus. 7.17, 7.18, 7.19). Although some tourists sought the rustic and inexpensive environment offered at campsites and in small cabins, others preferred rooms in tourist homes (illus. 7.20, 7.21). Thanks to Cassens and his staff, we have pictures of it all.

7.12. Warner's Camp, Upper Jay, N.Y., c. 1925. Adirondack Museum.

7.13. Camp Comfort, Piseco, N.Y., c. 1926. Adirondack Museum.

7.14. Fish Creek Pond Camp Site, Upper Saranac, N.Y. State campground. View of camp ranger's station at entrance. Fish Creek was one of the earliest camping areas developed through the Civilian Conservation Corps, c. 1933. Adirondack Museum.

7.15. Fish Creek Pond Camp Site, Upper Saranac, N.Y. Camping along the shore, c. 1933. Adirondack Museum.

7.16. Office and dining room, campground, Mooers, N.Y., c. 1918. Adirondack Museum.

7.17. Williams Tourist Cabins, Otter Lake, N.Y., c. 1933. Adirondack Museum.

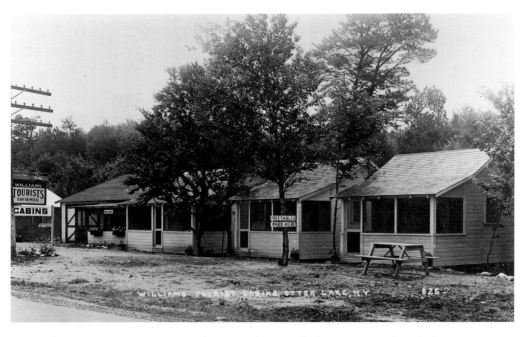

7.18. Williams Tourist Cabins, Otter Lake, N.Y. Close-up of cabins, c. 1933. Adirondack Museum.

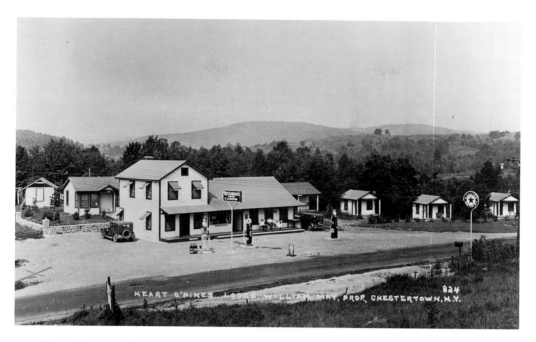

7.19. Heart O'Pines Lodge, Chestertown, N.Y. William May, proprietor, c. 1928. Adirondack Museum.

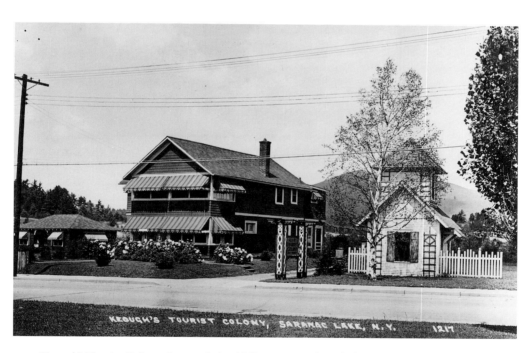

7.20. Keough's Tourist Colony, Saranac Lake, N.Y., c. 1934. Adirondack Museum.

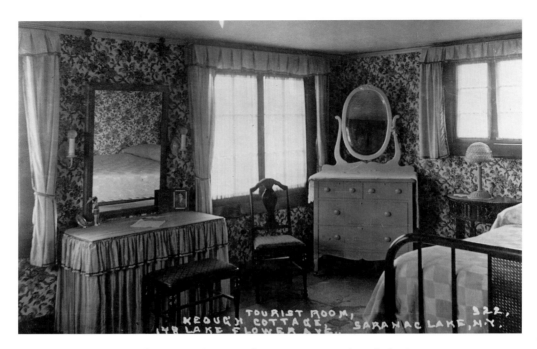

7.21. Tourist room, Keough Cottage, Saranac Lake, N.Y., c. 1934. Adirondack Museum.

Owners of establishments that sold gasoline were one of Eastern representatives' prime customers, and pictures with gasoline pumps are abundant in Eastern's stock. Gas stations, or service stations, did not appear overnight: they evolved from livery stables and general stores, which were the first to add automotive products to their inventories. Large drums with hand pumps were the first gasoline dispensers. Later, they were replaced with motorized pumps and underground tanks. Some establishments began specializing in fuel and called themselves filling or service stations (Margolies 1993) (illus. 7.22, 7.23, 7.24). But even these places seldom relied on gasoline as their only source of income. Typically, Adirondack small-business entrepreneurs combined services so that customers could fill up their tanks and eat at one stop (illus. 7.25, 7.26, 7.27).

Fred Cassens visited some roadside establishments year after year, leaving a time-sequenced photographic account of particular spots. This practice was true with Coughlin's Midway Bathing Beach, a few miles north of Port Henry (illus. 1.7 and 7.28). Apparently, Coughlin's offered bathing facilities, camping, furnished cabins by day or week, a store, and a restaurant that served both renters and passersby. In the two cards used as illustrations, the only change at Coughlin's from one year to the next was the location of one of the signs.

In addition to roadside merchants, Eastern representatives nurtured relationships with children's camp owners and directors. Eastern had a clientele in those facilities that were privately owned and managed rather than camps affiliated with religious and civic organizations such as the YMCA and the Boy Scouts and Girl Scouts of America. Those organizations likely had their own photographers. The private children's camp market

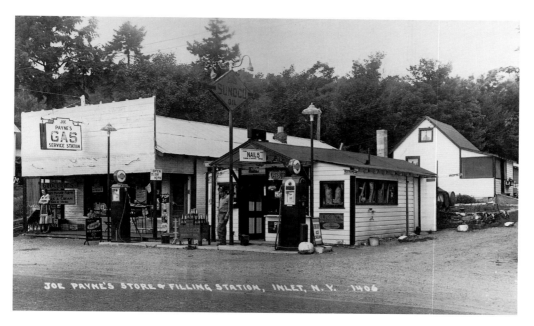

7.22. Payne's Store and Filling Station, Inlet, N.Y., c. 1930. Adirondack Museum.

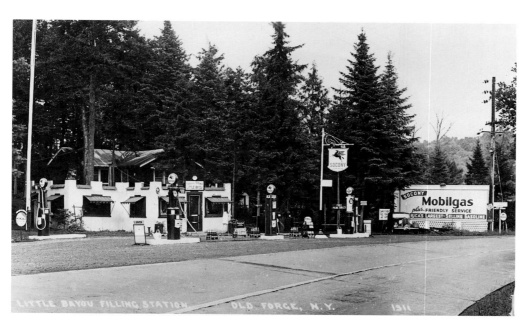

7.23. Little Bayou Filling Station, Old Forge, N.Y., c. 1930. Adirondack Museum.

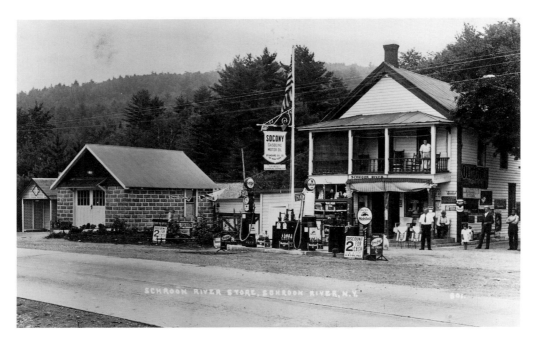

7.24. Schroon River Store, Schroon River, N.Y., c. 1930. Adirondack Museum.

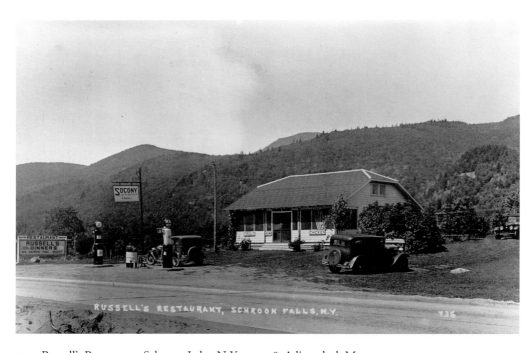

7.25. Russell's Restaurant, Schroon Lake, N.Y., c. 1928. Adirondack Museum.

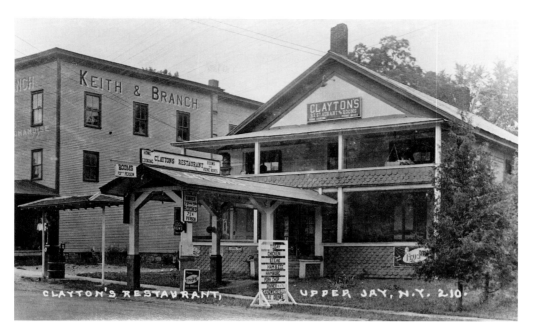

7.26. Clayton's Restaurant, Upper Jay, N.Y. Although Clayton's was primarily a restaurant, there was a Texaco pump to the left of the entrance, and rooms were available to rent, c. 1928. Adirondack Museum.

7.27. Twin Crow Tea Room, Eagle Bay, N.Y. Tearooms were restaurants with limited menus—more like snack bars. They were often women-run, home-based establishments, c. 1930. Beiderbecke Coll.

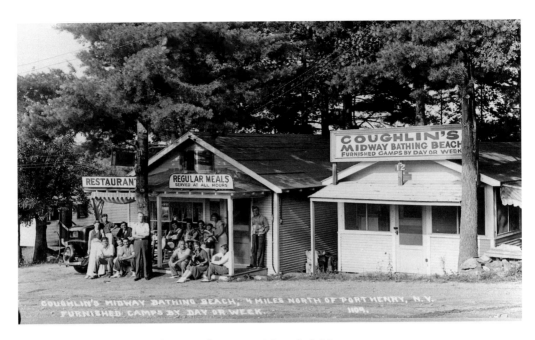

7.28. Coughlin's Midway Bathing Beach, c. 1930. Adirondack Museum.

seems to have been overlooked by other photographers. Because they were easily accessible by road and open to the postcard business arrangements that the traveling representatives proposed, Cassens's company left a record of the children's camping movement, an aspect of the North Woods experience absent from most other photo postcard photographers' portfolios.[3]

The favorite shots for summer camp views were children engaged in activities. Organized recreation from horseback riding (illus. 7.29) to baseball (illus. 7.30), with the most popular being water sports (illus. 7.31, 7.32), was covered. Many of Cassens's pictures capture the regimen of camp life, including morning calisthenics (illus. 7.33) and the simple living arrangements (illus. 7.34, 7.35, 7.36). Also present in the views are the special institutions of camp such as the infirmary (illus. 7.37) and the camp theater where amateur performances dominated (illus. 7.38). Many young people were introduced to the Adirondacks through their summer camp experiences and returned as adults to vacation and buy summer homes. Children's camps are one of the untold stories of Adirondack life, and Eastern's documentation provides a starting point for exploration.

3. In my search through various archives and collections, I found summer camp postcards from only one other photographer, Jess Wooley. His views of children's camps are limited to the Lake George area. Although they were not as extensively photographed as they were for Eastern, Wooley's camp scenes are excellent. See the Brookside Collection in Ballston Spa.

7.29. A riding group at Camp Redwing, Schroon, N.Y., c. 1930. Adirondack Museum.

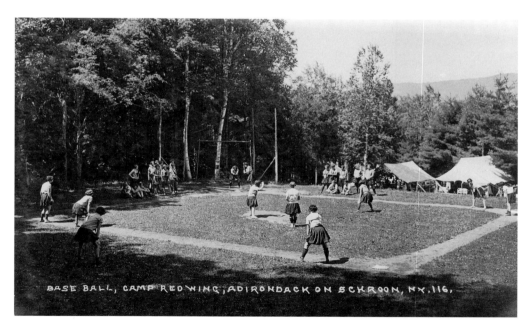

7.30. Baseball at Camp Redwing, Schroon, N.Y., c. 1930. Adirondack Museum.

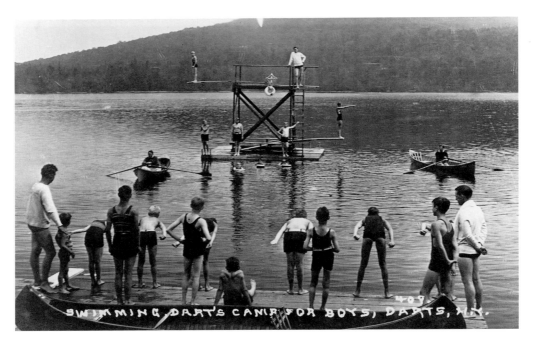

7.31. Swimming at Dart's Camp for Boys, Darts, N.Y. The camp's name was later changed to Camp Gorham, c. 1930. Adirondack Museum.

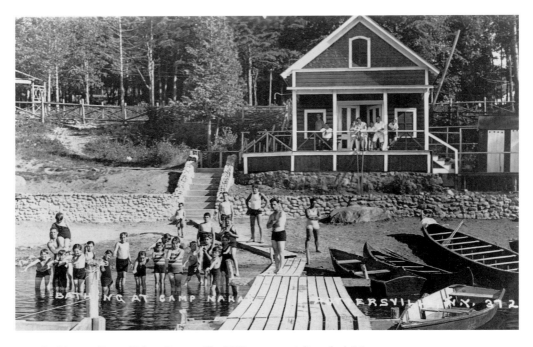

7.32. Bathing at Camp Nahar, Pottersville, N.Y., c. 1930. Adirondack Museum.

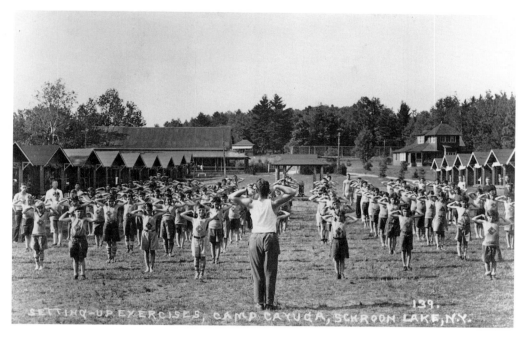

7.33. Exercises at Camp Cayuga, Schroon Lake, N.Y., c. 1930. Adirondack Museum.

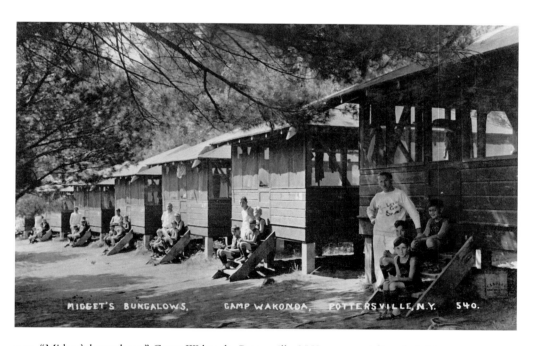

7.34. "Midget's bungalows," Camp Wakonda, Pottersville, N.Y., c. 1930. Adirondack Museum.

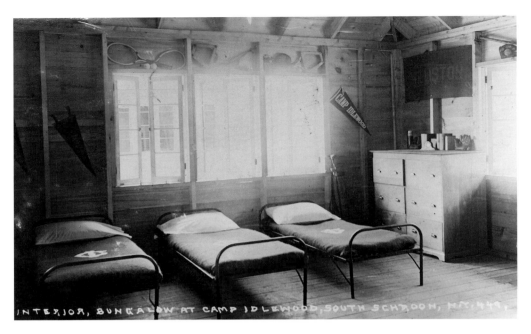

7.35. Interior of bungalow at Camp Idlewood, South Schroon, N.Y., c. 1930. Adirondack Museum.

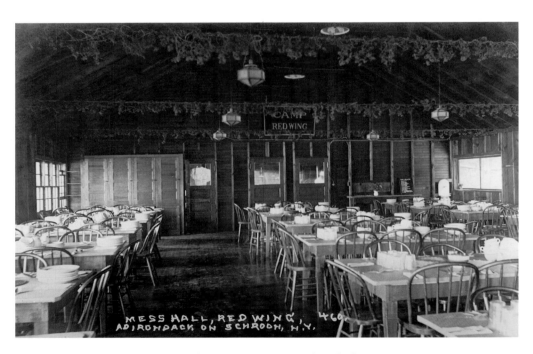

7.36. Mess hall at Camp Redwing, Schroon, N.Y., c. 1930. Adirondack Museum.

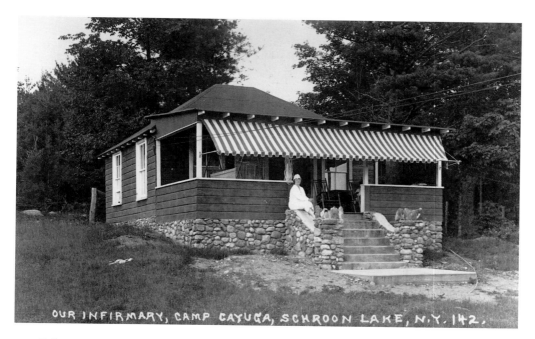

7.37. Infirmary at Camp Cayuga, Schroon Lake, N.Y., c. 1930. Adirondack Museum.

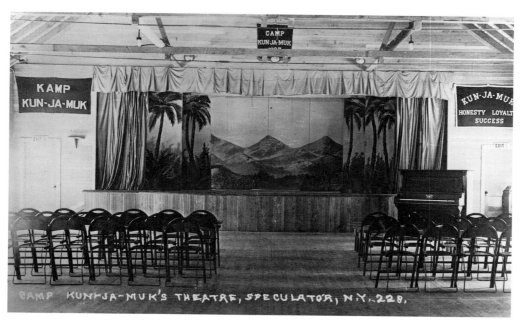

7.38. Camp Kun-Ja-Muk's theater, Speculator, N.Y., c. 1930. Adirondack Museum.

The Factory

The sales reps were at the heart of the business, but the company's success depended on the efficient and effective processing of the exposed plates and film and the large-scale production of prints. The factory staff always outnumbered the photographers by at least five to one. With the exception of perhaps Henry Beach's operation in Remsen, most Adirondack-related photo postcard manufacturers processed and printed in small lots in the cramped quarters in the backs of their studios and stores. In contrast, Eastern's Belfast operation was large and much like an assembly line with no salesroom and no portrait studio. The staff focused entirely on the mechanical production of the cards.

The printing was done on precut postcard stock. It came in packages of 500 with 10,000 ordered at a time from the manufacturers. Defender Photo Company brand "Argo" and Eastman's "Velox" and "Azo" dried well and were preferred. Print runs were anywhere from 25 to 1,000 but most commonly were from 250 to 500. The negatives were kept in storage and reused as orders warranted. Some of the most popular images remained in production twenty years or more.

Photographic printing machines allowed the company to produce large quantities of cards. Although it is unclear when Eastern started using these machines, it was probably around 1912. At one time there were four operating in the factory. After studying the negative or performing test runs using various settings, the machine operator placed the negative in position, adjusted the exposure lights and the timing dial, and pressed the "start" button.[4] The machine fed postcard stock on top of the negative, exposed it to light, and fed it out the other end. Once the adjustments on the machine were made to ensure the correct exposure, the machines could expose large numbers of the same view quickly. On runs of more than a hundred cards, the cards were checked periodically because changes in electrical current (until a current stabilizer was installed) could create lighter or darker tones. Thunderstorms could produce wide variation, resulting in many discards. But many orders were small lots, and achieving the correct setting for a series of small runs was tedious.

Although printing was handled by the machine, many other aspects of the production were labor intensive. After the paper had been exposed, it was placed in the developer, the stop bath, the fixer, and finally the wash. Moving the cards from one eighty-gallon vat to another was accomplished with large wooden paddles. Prints were then dried, trimmed, cleaned, and packaged before they could be shipped.

The Eastern Company was first located in the Waldo County Harland Building on Bridge Street in Belfast. It later moved to a white clapboard dwelling on High Street that looked more like a house than a factory. During the 1920s, when the company was at the High Street location, the business hit its peak production. Cassens employed twenty to twenty-five people, including Thad Stewart, his brother-in-law (who had

4. The illumination for the earliest printing was sunlight. By the time postcards were invented, the photographic paper was sensitive enough that gaslight could be used. Eventually, all printing was done using electric lights.

married Herman's sister, Lottie), who was in charge of the darkroom. The Bridge Street location did not always have enough space to accomplish all the steps in the printing process on the premises. Workers had to carry wet prints across the street to an unfinished work area above the old Shute and Shorey Garage to spread them out to dry.

Charlotte Thompson, who printed postcards during the 1927 and 1928 seasons, remembers working twelve-hour days with a half hour for lunch and making eleven dollars a week. Herman's sister, Lottie, and her husband took care of the business side of the operation year-round, even in the winter when Herman was in Florida at his citrus groves and the factory was closed.

In 1931, Herman Cassens bought and renovated a spacious barnlike building on Waldo Avenue and moved the company there. The production of postcards was conducted in much the same way it had been in the other buildings, though now there was plenty of room to spread out. The company remained in that location until Cassens's death.

Roger Rhoades, Herman's nephew (his wife's sister's son), worked in production at the Waldo Avenue factory for twenty years. Roger, who began work when he was still in high school, made seven dollars a week for fifty or more hours. The factory operated on more or less the reverse schedule of the schools: open in summer and closed during the school year. When Roger started with the company, postcards had passed the golden age, and the country was in the depression. Annual production had been cut back from one million to half as many, and the staff had been reduced to less than ten.

When one entered the factory on Waldo Street there was a door in the center of the long side of the rectangular building. The overall dimensions of the building were approximately sixty-five by thirty-five feet. To the right was a small business office where Georgie Hanson ("Gram"), the widowed second wife of Lillian's father, worked processing the orders and doing other office work. On the left was a long darkroom about eighteen by thirty feet (the windows were boarded up). The rest of the downstairs was a storage area for supplies and excess prints. There was a separate building to store the thousands of glass plate negatives. Upstairs were the shipping room and a large finishing room, with extra drying space in the attic. Several times a day, large kettles of washed cards were brought upstairs where the workers spread them on the drying sheets facedown. The wet cards were placed on large wooden frames with cheesecloth stretched over them and stacked in racks that rose to eye level. They were left to dry and then were cleaned, trimmed, sorted, and packed for shipping. At the end of each day the packages were taken to the post office.

Card Backs

Prior to 1913, Eastern cards were not distinguished by any particular logo. The upper portion of the backs of the cards issued from 1913 to about 1915 was dominated by a large, ornate printed emblem that incorporated the phrase "Genuine Photographs from Studio of Eastern Illustrating & Publishing CO." From 1915 to well into the 1930s, a less fancy and smaller trademark was used with the phrase, "Photograph Post Card from the Studio of Eastern Illustrating Co." In the late 1930s, the company dropped the logo

and moved to simpler backs. For a while they continued to issue cards with backs that contained the name of the company, but into the forties and the fifties they used plain Kodak postcard stock that had no company identification.

Although the great majority of the cards Eastern produced before 1935 can be identified by these markings, some cards had no trademark or other identification except for the style of the written titles and series numbers. One can only guess that these cards were produced in the peak season when the company ran out of its customized stock and had to use generic paper.

Other Businesses

Eastern was Cassens's main source of income. It provided enough to adequately support the family. They lived in a midsize house that they had built on Northport Avenue in Belfast, and Herman drove a midpriced car. He entered other business ventures, some successful and others not, including an ill-fated company that manufactured safety razor sharpeners. After 1915, he began traveling south. His father-in-law owned land near Fort Pierce, Florida, and was in the citrus business. Early in the U.S. involvement in World War I, Herman bought a Cirkut panoramic camera and visited military training camps in Florida and Georgia, taking and selling eight-by-thirty-inch prints for one dollar apiece to recruits. He did a brisk business, coming home at night with his pockets bulging with bills.

In 1921, Cassens bought land near Indian River, Florida, and became a gentleman orange-plantation owner. As he entered middle age, he and Lillian began spending their winters there and summers in Belfast where he continued to run Eastern. Although his son, Rudolph, took some interest in the business, he too moved to Florida and stayed. Other family members shuttled back and forth between Florida and Maine, working at Eastern in the summers.

The End of Eastern and Cassens

A heart attack in 1945 caused Cassens to settle into a less active life. Even with failing health, he held on to the company and remained its chief executive until 1947. Realizing he was no longer up to the task, he sold the building, equipment, stock, and the name for seven thousand dollars to Alton H. Crone.

Early on a Saturday morning in the first week of June 1948, at the age of seventy-two, Cassens died of heart failure at his home on Northport Avenue, in Belfast. He was buried in the Grove Cemetery, in Belfast.

At the time of Cassens's death the photo postcard business was well past its prime. The new owner of Eastern hired Roger Rhoades, who continued to work summers and was in charge of production. The company manufactured photo cards through the 1950s. In an attempt to stoke the business, they moved to the brightly colored, machine-manufactured chrome cards, which are presently the industry standard. The company changed hands three times before 1974.

In the late 1960s, the company's stock of the old photo postcards was sold. An antique dealer sold some of the company's New York State display books to the York State Museum at Albany. The Adirondack Museum bought others. Another dealer bought the bulk of the company's postcard stock (Harding 1982). Many of the New England views were allegedly acquired by *Yankee Magazine*.

Conclusion

Cassens's goal was to expand Eastern Illustrating and Publishing from coast to coast. He never accomplished that ambition, but the size of the region he served became substantial. Cassens produced more photo postcard views of New England and New York than any other single photographer or firm. The automobile allowed him to broaden his territory and successfully compete in the Adirondack market. His itinerant, commercially oriented photographers had a roadside view of the Adirondacks.

Eastern representatives traversed the North Woods for a longer period than many of the other photographers featured. Consequently, the Eastern views capture the more populous, commercial Adirondacks. By the thirties, the North Woods had become a more traveled territory. The other photographers stopped postcard production or were ending their careers by then, which is not the only reason for Eastern's roadside subject matter. Because of their blitzkrieg approach to the business and their tendency to remain close to the highways, they customarily focused on commercial roadside establishments and other venues that catered to the transient. Moreover, the Eastern business profited from large-volume sales, and the roadside is where the nickels and dimes were.

With the exception of photos of merchants in front of their establishments, Eastern photographers did not take pictures of local people at work.[5] They did not sell views from off the beaten track and never sold cards that depicted anything other than the busiest tourist season, the summer.

Eastern's pictures are not alone in confronting us with the changing, commercialized North Woods. All the photo postcard photographers captured some of the changes ushered in by the automobile. In the other photographers' work, the roadside is present, but it only encroaches on the older Adirondack ideal of the tranquil, unspoiled retreat of the nineteenth century. The abundance of Cassens's roadside images, and the repeated presence of road signs, gas pumps, automobiles, diners, and a different sort of commercialism, is confrontational, assaulting our image of the pristine wilderness most directly.

5. However, there is a portrait of a guard standing at Crown Point Park that an Eastern representative took.

8

Conclusion
A Closer Look at Postcards

The photographers I have profiled produced images in and around the Adirondacks during the first part of this century. Using a popular format, in their own style and way, they produced pictures of the North Woods. By telling their stories and showing you their pictures, I have declared that they and their work are important. I conclude by being mindful of why we should take notice as well as commenting on their representations of the Adirondacks.

The Value of Photo Postcards

Why should we pay attention to the photo postcards that these men produced? Simply put, these cards are an opportunity. They rejuvenate our imaginations by giving us a chance to think about who we are and where we have come from. Not that we can ever get to the bottom of these mysteries, but the photos spark our historical imaginations, providing an occasion to conjure up the past with concrete visual references. When we look at William Mandeville's images of the storefronts, the solemn Memorial Day parades, and the spirited Daughters of the American Revolution picnic, we are brought back to a village on the edge of the Adirondack Park. Henry Beach's scenes of toiling woodsmen and portraits of aging hotel owners help us contact working people of the Adirondack past. William Kollecker's photographs of the stoic TB patients or the festive winter carnival help us visit his singular town in the North County during its heyday. Ernest Ameden's portrayals of the dramatic river and the first skiers at Gore Mountain allow us to visualize excitement in a bygone Adirondack hamlet. Jess Wooley's shots of the visitors' merriment at Silver Bay and their attentive preparations for a governor's visit cause us to pause and take note of a Christian community on the shore of a magnificent North Woods lake. Herman Cassens's views of the early roadside life and children's camps bring us closer to another North Country.

Photo postcards allow us to imagine what it felt like to be there. They do not allow us to duplicate our predecessors' experiences, as there is no true substitute for having been there. Neither are they a replacement for firsthand accounts, written records, or other documents. But the photographs, combined with other textual material, help

us construct a larger portrayal and assist in getting us closer to seeing how others might have experienced life in the Adirondacks.

Photo postcards offer us not just a broad sense of the past: the details in the prints also provide something else. When we examine a photograph section by section instead of as a whole, the nitty-gritty emerges. Looking carefully (perhaps using a magnifying glass) at clear, well-focused photographs of a specific place (close-ups as well as slightly broader views) gives us a detailed inventory of bygone days, both heirlooms and practices. In Kollecker's and Mandeville's pictures we can peek in store windows at the merchandise and the advertising. Beach's photos allow us to be voyeurs in a logging camp where we can snoop about how the food was prepared, the table set, and the arrangements made and about the food itself. The details of early skiing and the work of mining garnet are brought to life in Ameden's work. With Kollecker's cards we can observe the spectator stands at winter sports events while prying into the particulars of who attended their affairs and the seating patterns. Wooley's pictures allow us to bear witness to the details of recreational practices at the shore, how people dressed and behaved at a place such as Silver Bay. With Cassens we see the text of roadside advertising, what was featured and the techniques of persuasion employed, as well as the precise arrangements of the pumps and merchandise. Other images tell us exactly how people hunted, fished, and displayed their catches. Of course, there are nonphotographic sources for this information also, but the photo postcard provides amplification and missing pieces, artifacts and routines overlooked. They help clarify and add life to the written record and oral tradition.[1]

As Beach's exaggeration cards illustrate, photographs can also tell lies—not that we should discard dubious or obviously manipulated pictures. A discerning eye is necessary. One has to interrogate the image to learn whether it is a source of understanding of how images can mislead, or can be manipulated, or whether it reveals abiding historical facts.

In addition to providing a general feeling of what it was like to have been there and the details of history, photo postcards present visual anomalies that challenge our grasp of the way it was. Beach's fabricated picture of the man fighting the bear on the Adirondack mountain snaps us out of our normal frame of complacency and causes us to look at that card differently. A similar experience occurs when something in a picture is not quite right—not outrageously wrong, or fabricated, but nonetheless unexpected or contradictory to our erroneous notions. This discord with the ordinary is an opportunity to gather insights and a deeper understanding of former life as well as our assumptions about it. For example, Wooley's iconoclastic images of people posing as wild men in the circus and dressed as exotic foreigners caused me to wonder about the early culture of Silver Bay and how it may have reinforced colonial practices. Kollecker's TB patients and winter carnival floats, especially those of the patients, and various aspects of cure cottage and sanatorium life jarred my concept of the social isolation of institutional-

1. For example, I found it difficult to follow Hochschild's description of the skidway in logging until I saw Beach's detailed postcard of one in use.

ization. Pictures of hunting, especially where children are juxtaposed with the kill, accosted my sensibilities while contesting my notions about childhood and the meaning of death. Ameden's pictures of North River with open pasture confronted me with something I had read about but not visualized: much of the land in the Adirondack Park had at one time been cleared. Last, Cassens's view of roadside stands, gas stations, and campgrounds provides a strong assault on my imaginings of the wilderness. What I expected to see in postcard pictures of the forest were pristine landscapes, bubbling brooks, mountain views, and wildlife, not roadside entrepreneurs' establishments cluttered with advertising.[2]

Do my points about the use of photographs apply only to photo postcard images? No, the opportunities are present in a range of pictures (Lesy 1982), but photo postcards provide unusual advantages. They were remarkably popular, so they were produced in great numbers, many more different images than any other form of photography. Because of their compact size, uniformity, and durability, they were easily stored and preserved, providing us with vast collections of postcards to peruse. Serious postcard collecting began when postcards were first produced. The practice continues today; in fact, antique card collecting is one of the best-organized and fastest-growing hobbies in America. With so many fanciers, and so many collections, people can easily gain access to postcard images.

Consumers in a broad range of social positions bought photo postcards. Because they were cheap and accessible to the common person, they capture places and people that the more elite forms of representation do not. More so than other picture takers, postcard photographers were in every nook and cranny of America, pointing their cameras at every conceivable subject. Although there were untold amateurs out there as well, snapshot photographs were technically inferior to professionally produced postcards, and fewer amateur images survived. Competent photographers took the majority of photo postcards, so they are well focused and have all the other characteristics of a quality image. Moreover, because they have been forgotten or ignored by most historians, photo postcards are a nearly untapped resource. They are more than a preferred resource: they are a find.

Postcard photographs do not tell us only about what is in the print: they also tell us about the picture taker. Imagers place themselves in particular locations, point their cam-

2. There are other uses of the photo postcards of the Adirondacks. For example, many pictures are of people who are willing subjects of the camera. They smile, hold their bodies in particular ways, dress up, and in other ways pose and prepare themselves to be captured on film. Pictures are often social affairs; certain people are included, and they group themselves in particular ways. The photograph is often a contrived reflection of the subject's identity and a mirror reinforcing social arrangements. We can gain insight about how people saw themselves and about their relationships with others by studying carefully posed individual and family portraits as well as the group shots of workers and tourists. We must be cautious in jumping to conclusions; although what we see and what the subject intended are often different, photographs can provide useful hunches. Another omission in my discussion has been looking at photographs as a way of revealing the tensions within a culture as well as what people thought was important. Photographs are not merely pictures of a culture but are also part of a culture (Lesy 1982).

eras at specific views, choose how to compose their shots, know when to click and what negatives to print, and do much more in the manufacture of photographs. They select what we see. Of course, they are not always conscious of their choices, and their decisions are not always matters of free will. They bring their training, skill, competence, aesthetic sense of beauty, perception of the audience, social position, and personal biographies to the loaded camera. Although each photographer is in some way unique and his or her pictures are the expressions of individual choices and circumstances, each also operates within the visual conventions of his or her culture. The photographers' backgrounds, combined with their geographic and sociological circumstances, as well as the traditions and technology of their trade and the aesthetics of their time, confine the range of possibilities and narrow the lens of opportunity. However, when many works of a particular photographer are studied, they help divulge the photographer's story.

This book has been not only about photographic images but also about imagers. Pictures drew me to this project, but by studying the lives of the photographers I came closer to members of a particular trade who, for the most part, had been left out of Adirondack history. By studying photographers' pictures we find out about them and are led to the places in the North Woods that outsiders have not seen before.

I have profiled the lives of six Adirondack postcard photographers and pointed out the relationship between their biographies and the photographs they took. Mandeville, a typical small-town photographer, focused on life around him in a small population center on the edge of the park. Beach was a wanderer, taking photographs along main thoroughfares as well as primitive woods roads. Kollecker was a town photographer of sorts, but his Adirondack community was unique and his vision broad. Ameden lived and photographed in and around a small North Woods hamlet and had a local perspective. Wooley's cards capture the more affluent tourist and conference attendees to the Adirondacks. Cassens and his Eastern Illustrating and Publishing Company photographers had a more commercial orientation and photographed the Adirondack roadside.

Whose Wilderness Do You Prefer?

On my first visit to North River, I had breakfast at the home of a longtime North River resident who lived close to the Ameden store when she was growing up. As I pulled into the driveway on a clear day in August, she came outside to greet me. We talked about the weather, and then I made a comment about how beautiful the area was. To my surprise, my host said, "It used to be a lot nicer." She explained that when she was growing up, in the twenties, the surrounding land was much more open, with meadows and not so many trees blocking the view. She also talked fondly about the Ameden store and the North River garage. As we spoke, some of Ameden's postcards came to mind. When he took them there were in fact more fields and land with low brush, so the mountainous surroundings were more visible. His views included his store and the garage. The way Ernest showed the area was the way my elderly companion preferred it.

Although the woman I met that morning was not a postcard collector, many eld-erly Adirondackers are. In researching this book I reviewed collections with their own-ers by my side. At first I considered many of the postcards as depicting an undesirable, commercialized, and exploited forest. My North River friend and other old-timers led me to appreciate that other people saw the cards differently. Some people judge post-card views of the land with less forest cover, lumbermen aggressively cutting timber, and small local businesses scattered along the roadside as pictures of a better time. Of course, they do not all agree.

I tell about my visit to North River and about the tastes of postcard collectors to point out that although at first glance it might seem easy to assert which views of the Adirondacks are most preferred, it is not. Which way of depicting the Adirondacks do you prefer? Perhaps you have no favorite among the photographers considered and like them all. Or maybe you like some more than others or you like none of them. Perhaps you think these are silly questions. I ask them to point out that the photographers dis-cussed here offer us different versions of the Adirondacks. By studying their pictures it becomes clearer that there is not one preferred way of seeing or one way of depict-ing the North Woods. Your favorite view of the wilderness does not match the choice of others.

In 1912, Jess Wooley was at Silver Bay photographing young Christians lined up by the shore wearing period swimsuits that covered most of their bodies. Fifteen miles down Lake George, Alfred Stieglitz was also taking pictures (Szarkowski 1995). His were of his partner, Georgia O'Keeffe, frolicking naked in the water. Cloud formations over the lake were another favorite subject of Stieglitz.

Although Stieglitz's photographs were taken near his summer home at Bolton Land-ing on Lake George (Eisler 1991, 219), no one looking at them (without knowing his bi-ography and work) could tell where they were from. Stieglitz, an intellectual from New York City who was an ardent advocate of the "photography is art" movement, was doing what he called "art." He issued limited editions of his work and displayed them in New York galleries. Wooley was making photo postcards on demand and selling them to the summer conference attendees at the Silver Bay Association store. Juxtaposing Wool-ey's and Stieglitz's Adirondack photography provides an extreme illustration of a sim-ple point but one that many people forget. What is most significant about what is photographed, how it is taken, and how it is consumed, is who takes the picture and for whom it is taken.

Although there are similarities in the photographers' photo postcards, I have pointed to the differences. These differences are not as striking as those between Stieglitz and Wooley, but they are differences nonetheless. There are different Adirondacks, and there are many ways of exposing the North Country. How the wilderness is depicted is re-lated to how the photographers lived their lives and what their visions of wilderness were. But the pictures that come to designate the Adirondacks and its people are related to the politics of representation.

In many regions of the country, and specifically the Adirondacks, the twentieth cen-tury is not as interesting to regional partisans as is the nineteenth century. Theirs is

the romantic notion of the wilderness, and the photographs that sustain that view are the ones they favor. The photographs by famous photographers such as Seneca Ray Stoddard and Edward Bierstadt define the wilderness. Some photo postcards capture the nostalgia of the North Country, but others confront us with a more working-class, materialistic, or populist picture of the North Woods. The postcard photographers' lives and the pictures they took present other ways of thinking about the Adirondacks. As we enter the twenty-first century we must explore more fully why photo postcards have not been embraced as transcending visual representations of New York's North Woods and reconsider them.

REFERENCES
INDEX

References

Adler, J. W. 1997. *Early Days in the Adirondacks: The Photographs of Seneca Ray Stoddard.* New York: Harry N. Abrams.

Automobile Blue Book Publishing. 1916. *The Automobile Blue Book: Touring Information for the Year 1816.* New York and Chicago: Blue Book Publishing.

Baeder, J. 1982. *Gas, Food, and Lodging.* New York: Abbeville.

Baer, L. 1993. "Postcards Are Research." *Postcard Collector* (July): 82.

Battani, M. 1997. "Striking the Artist's Pose: The Emerging Field of Photographic Practice in the Nineteenth-Century United States." Ph.D. diss. Davis: Univ. of California.

Beach, E. T. 1923. *Beach in America: Containing General Information Regarding the Three Brothers, Richard Beach, John Beach and Thomas Beach, Planters in the Original Settlements of New Haven Colony, Wallingford Colony and Milford Colony, Connecticut, 1638 to 1641, and Genealogical Record on a Portion of the Descendants of Richard Beach, Together with Notes on Pioneer Beaches of Michigan, and an Index of All Known Male Descendants of Planter Richard Beach, Signer of the Fundamental Compact of New Haven Colony, 1638.* Kalamazoo, Mich.: Ihling Bros. Everard.

Bethke, R. D. 1981. "Get Ot the Bush!" *Journal of Forest History* (Jan.): 5–13.

Blake, J., and J. Lasansky. 1996. *Rural Delivery: Real Photo Postcards from Central Pennsylvania, 1805–1835.* Lewisburg, Pa.: Union County Historical Society.

Bolton, R., ed. 1989. *The Contest of Meaning.* Cambridge, Mass.: MIT Press.

Bond, H. E. 1995. *Boats and Boating in the Adirondacks.* Syracuse: Adirondack Museum/Syracuse Univ. Press.

Borsavage, K. 1979. *L. L. McAllister: Photo-Artist.* Burlington, Vt.: Robert Hull Fleming Museum.

Bowen, G. B., ed. 1970. *History of Lewis County, New York, 1880–1865.* Willard, N.Y.: Board of Legislators of Lewis County.

Brandon, C. 1986. *Murder in the Adirondacks.* Utica, N.Y.: North Country Books.

Brayer, E. 1996. *George Eastman: A Biography.* Baltimore: Johns Hopkins Univ. Press.

Brown, E. F. 1985. *The Forest Preserve of New York State.* Glens Falls, N.Y.: Adirondack Mountain Club.

Burleson, C. W., and E. J. Hickman. 1986. *The Panoramic Photography of Eugene O. Goldbeck.* Austin: Univ. of Texas Press.

Burns, S. B. 1990. *Sleeping Beauty: Memorial Photography in America.* Altadena, Calif.: Twelve Trees Press.

Caldwell, M. 1988. *The Last Crusade: The War on Consumption, 1862–1854.* New York: Athenaeum.

———. 1993. *Saranac Lake: Pioneer Health Resort.* Saranac Lake, N.Y.: Saranac Lake Free
 Library.

Caudell, R. 1996. "Photographer Captured Region on Rare Negatives." *Plattsburgh Press
 Republican,* Apr. 11.

Cobb, T. L. 1990. *The Adirondack Park and the Evolution of the Current Boundary.* The
 Adirondacks in the Twenty-First Century, Technical Report. Albany: Commission on
 the Adirondacks.

Cronon, W. 1996. "The Trouble with Wilderness; or, Getting Back to the Wrong Nature."
 In *Uncommon Ground: Rethinking the Human Place in Nature,* edited by W. Cronon,
 69–91. New York: W. W. Norton.

Crowley, W. 1982. *Seneca Ray Stoddard: Adirondack Illustrator.* Blue Mountain Lake, N.Y.:
 Adirondack Museum.

Darrah, W. C. 1981. *Cartes de Visite in Nineteenth-Century Photography.* Gettysburg, Pa.:
 W. C. Darrah.

D'Elia, A. N. 1979. *The Adirondack Rebellion.* Onchiota, N.Y.: Onchiota Books.

DeSormo, M. C. 1972. *Seneca Ray Stoddard.* Saranac Lake, N.Y.: Adirondack Yesteryears.

Donaldson, A. L. 1921. *A History of the Adirondacks.* Vol. 1. New York: Century.

———. 1977. *A History of the Adirondacks.* Harrison, N.Y.: Harbor Hill.

Dotterer, S., and G. Cranz. 1982. "The Picture Postcard: Its Development and Role in
 American Urbanization." *Journal of American Culture* 5, no. 1:44–50.

Duquette, J. J. 1986. "Remembering the Heyday of the Algonquin Hotel." *Adirondack Daily
 Enterprise,* Dec. 30, 4.

———. 1987a. "Ed Lamy, Best Every." *Adirondack Daily Enterprise,* Feb. 13, 10.

———. 1987b. "Historian Looks Back at Early Winter Carnivals Featuring Skating on Pontiac
 Bay and Fireworks." *Adirondack Daily Enterprise,* Feb. 13, 7.

———. 1992. "William Kollecker, Photo Historian of the North Country." *Adirondack Daily
 Enterprise,* Dec. 5, 1.

———. 1993. "Taking an In-depth Look at Lower Saranac Lake." *Adirondack Daily Enterprise,*
 Jan. 16, 1.

Eisler, B. 1991. *O'Keeffe and Stieglitz: An American Romance.* New York: Doubleday.

Fine, G. A. 1998. *Morel Tales: The Culture of Mushrooming.* Cambridge, Mass.: Harvard
 Univ. Press.

Fox, D., and C. Lawrence. 1988. *Photographing Medicine: Images and Power in Britain and
 America.* Westport, Conn.: Greenwood Press.

Gallos, P. L. 1985. *Cure Cottages of Saranac Lake: Architecture and History of a Pioneer Health
 Resort.* Saranac Lake, N.Y.: Historic Saranac Lake.

Geary, C., and V. Webb. 1998. *Delivering Views: Distant Cultures in Early Postcards.* Washington,
 D.C.: Smithsonian Institution Press.

Gilborn, A. 1988. "Heart to Heart: A Placid Affair." *Guide-Line: Adirondack Museum Newsletter*
 6:3–7.

Goldberg, V. 1991. *The Power of Photography.* New York: Abbeville.

Hale, T., et al., eds. 1984. *Camp Dudley: The First Hundred Years.* Westport, N.Y.: Camp
 Dudley.

Harding, R. B. 1982. *Roadside New England, 1800–1855.* Portland, Maine: Old Port Publishing.

Henderson, J. 1997. "Noted Postcard Archives: The East Coast and Southern United States." In
 Postcard Collector 1887 Annual, edited by J. Hoppensteadt, 6–17. Dubuque, Iowa: Antique
 Trader Publications.

Higby, R. C. 1974. *. . . A Man from the Past.* Big Moose, N.Y.: Big Moose Press.

Hochschild, H. K. 1952. *Township 34.* New York: privately printed.

———. 1962a. *An Adirondack Resort in the Nineteenth-Century: Blue Mountain Lake, 1870–1800, Stagecoaches and Luxury Hotels.* Blue Mountain Lake, N.Y.: Adirondack Museum.

———. 1962b. *Life and Leisure in the Adirondack Backwoods.* Blue Mountain Lake, N.Y.: Adirondack Museum.

———. 1962c. *Lumberjacks and Rivermen in the Central Adirondacks, 1850–1850.* Blue Mountain Lake, N.Y.: Adirondack Museum.

Horrell, J. L. 1995. "Seneca Ray Stoddard and the Adirondacks." Ph.D. diss. Syracuse: Syracuse Univ.

Hough, F. 1883. *History of Lewis County.* Syracuse: D. Mason.

Jakle, J. A. 1985. *The Tourist: Travel in Twentieth-Century North America.* Lincoln: Univ. of Nebraska Press.

Johnsburg Historical Society. 1994. *River, Rails and Ski Trails: The History of the Town of Johnsburg, an Adirondack Town Founded in 1805.* Johnsburg, N.Y.: Johnsburg Historical Society.

Kaiser, H. H. 1982. *Great Camps of the Adirondacks.* Boston: David R. Godine.

Kaplan, M. 1991. "The North Creek Ski Trains." *Adirondack Life* 22 no. 66/67:66–70.

Knott, C. H. 1998. *Living with the Adirondack Forest: Local Perspectives on Land-Use Conflicts.* Ithaca, N.Y.: Cornell Univ. Press.

Kudish, M. 1996. *Railroads of the Adirondacks: A History.* Fleischmanns, N.Y.: Purple Mountain Press.

Landon, H. F. 1932. *The North Country: A History, Embracing Jefferson, St. Lawrence, Oswego, Lewis and Franklin Counties, New York.* Indianapolis: Historical Publishing.

Lesy, M. 1982. *Bearing Witness: A Photographic Chronicle of American Life, 1860–1845.* New York: Pantheon.

———. 1997. *Dreamland: America at the Dawn of the Twentieth Century.* New York: New Press.

Ley, J. 1997. "Jesse Sumner Wooley and the Chicago World's Fair, 1893." *Grist Mill* 26, no. 1:1–6.

Light Work. 1983. *Penny Publishing: Photographic Postcards of Central N.Y., 1805–1820.* Syracuse: Light Work.

Lord, T. R. 1987. *Stories of Lake George: Fact and Fancy.* Pemberton, N.J.: Pinelands Press.

Mackintosh, J. 1996. "From Collodion to Kodachrome." *Adirondack Life* (Sept./Oct.).

Marder, W., and E. Marder. 1982. *Anthony, the Man, the Company, the Cameras.* Amesbury, Mass.: Pine Ridge.

Margolies, J. 1981. *The End of the Road.* New York: Penguin.

———. 1993. *Pump and Circumstance: Glory Days of the Gas Station.* Boston: Little, Brown.

———. 1995. *Home Away from Home: Motels in America.* Boston: Little, Brown.

———. 1998. "Once Upon a Time in the Adirondacks: When Theme Parks Ruled the Roadside." *Adirondack Life* 29, no. 3:50–58.

Margolies, J., and E. Gwathmey. 1993. *Signs of Our Time.* New York: Abbeville.

McKibben, B. 1995. *Hope, Human and Wild.* St. Paul, Minn.: Hungry Mind Press.

Mellinger, W. M. 1992. "Representing Blackness in the White Imagination: Images of 'Happy Darkeys' in Popular Culture, 1893–1917." *Visual Sociology* 7, no. 2:3–21.

Mihalyi, L. 1998. "Special Delivery: George Burke and the Red Mail Sled." *Adirondack Life* 29:10–14.

Miller, G. 1991. "The 'Golden Age' of American Postcards." In *Postcard Collector Annual,* 1. Iola, Wis.: Joe Jones Publishing.

Miller, G., and D. Miller. 1976. *Picture Postcards in the United States, 1883–1818.* New York: Crown.

Morgan, H., and A. Brown. 1981. *Prairie Fires and Paper Moons: The American Photographic Postcard, 1800–1820.* Boston: David R. Godine.

Mullen, N. 1994. *The Ameden Story.* N.p.: privately printed.

National Postcards. 1997. *Hand Tinted Real Photograph Post Cards.* Macon, Ga.: National Postcards.

Nickel, D. R. 1998. *Snapshots: The Photography of Everyday Life, 1888 to the Present.* San Francisco: San Francisco Museum of Modern Art.

Nye, D. E. 1985. *Image Worlds.* Cambridge, Mass.: MIT Press.

Parnass, B. 1996. *Sweeping Views: Photographs by William F. Kollecker.* Saranac Lake, N.Y.: Saranac Lake Free Library.

Provenzo, E. J., and W. E. Brown. 1994. "From Ice and Snow to Flowers and Fruit: Jesse S. Wooley's 1896 Tour of Florida." Coral Gables, Fla.: University of Miami.

Puckhaber, B. C., and A. MacMillin. 1978. "J. S. Wooley, Pioneer Photographer." *Grist Mill* 12, no. 1.

Rothman, S. M. 1994. *Living in the Shadow of Death: Tuberculosis and the Social Experience of Illness in American History.* New York: Basic Books.

Schneider, P. 1997. *The Adirondacks: A History of America's First Wilderness.* New York: Henry Holt.

Seidenstein, B. 1997. "Reflections of a Jewish Kid in an Overwhelmingly Christian Town." *Adirondack Daily Enterprise,* Aug. 29.

Sekula, A. 1989. "The Body and the Archive." In *The Contest of Meaning,* edited by R. Bolton. Cambridge, Mass.: MIT Press.

Shaughnessy, J. 1967. *Delaware and Hudson.* Berkeley, Calif.: Howell North.

————. 1997. *Delaware and Hudson.* Syracuse: Syracuse Univ. Press.

Silver Bay Association. 1992. *Silver Bay Association: A Pictorial History, 1800–1835.* Silver Bay, N.Y.: Silver Bay Association.

Smith, J. H. 1880. *History of Chenango and Madison Counties, 1784–1880.* Syracuse: D. Mason.

Stoddard, S. R. 1915. *Picturesque Trip Through the Adirondacks in an Automobile.* Glens Falls, N.Y.: Stoddard.

Sullivan, J. 1927. *History of New York State.* N.p.

Szarkowski, J. 1995. *Alfred Stieglitz at Lake George.* New York: Museum of Modern Art.

Tagg, J. 1988. *The Burden of Representation: Essays on Photography and History.* Amherst: Univ. of Massachusetts Press.

Taylor, R. 1986. *Saranac: America's Magic Mountain.* Boston: Houghton Mifflin.

Teller, M. E. 1988. *The Tuberculosis Movement: A Public Health Campaign in the Progressive Era.* New York: Greenwood Press.

Terrie, P. G. 1997. *Contested Terrain: A New History of Nature and People in the Adirondacks.* Syracuse: Adirondack Museum/Syracuse Univ. Press.

Timm, R. 1989. *Raquette Lake: A Time to Remember.* Utica, N.Y.: North Country Books.

Trudeau, E. L. 1951. *An Autobiography.* Garden City, N.Y.: Doubleday.

Vanderwood, P. J., and F. Samponaro. 1988. *Border Fury: A Picture Postcard Record of Mexico's Revolution and U.S. War Preparedness, 1810–1817.* Albuquerque: Univ. of New Mexico Press.

VanValkenburgh, N. J. 1979. *The Adirondack Forest Preserve.* Blue Mountain Lake, N.Y.: Adirondack Museum.

White, W. C. 1985. *Adirondack Country.* Syracuse: Syracuse Univ. Press.

Yepsen, R. 1990. "Our Forest Home: Camp and Lodge Life." In *The Adirondack League Club, 1880–1880,* edited by E. Comstock, Jr., 19–65. Old Forge, N.Y.: Adirondack League Club.

Index